THE JOHNS HOPKINS STUDIES IN NINETEENTH-CENTURY ARCHITECTURE

THE JOHNS HOPKINS STUDIES IN NINETEENTH-CENTURY ARCHITECTURE

GENERAL EDITOR

PHOEBE B. STANTON

ADVISORY EDITORS

PETER COLLINS

HENRY-RUSSELL HITCHCOCK

WILLIAM H. JORDY

NIKOLAUS PEVSNER

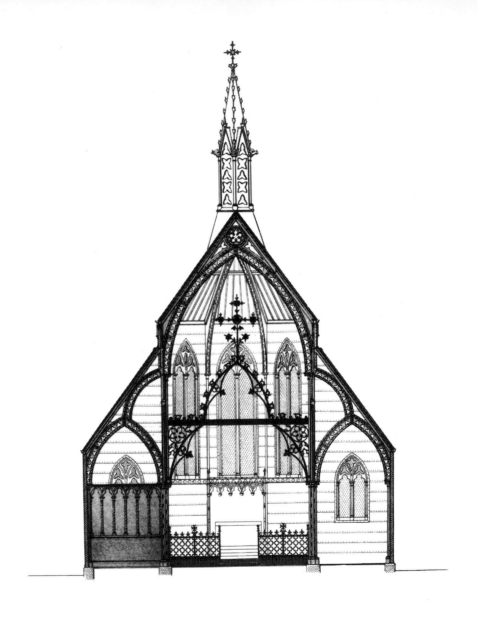

GEORGE L. HERSEY

HIGH
VICTORIAN
GOTHIC

A STUDY IN ASSOCIATIONISM

THE JOHNS HOPKINS UNIVERSITY PRESS · BALTIMORE & LONDON

THIS BOOK WAS DESIGNED BY VICTORIA DUDLEY.
IT WAS COMPOSED IN CALEDONIA TEXT AND TORINO
AND AMERICANA DISPLAY BY THE MONOTYPE COMPOSITION COMPANY,
PRINTED ON 60-LB. DECISION OFFSET BY THE MURRAY
PRINTING COMPANY, AND BOUND BY MOORE AND COMPANY.

THE FRONTISPIECE REPRESENTS THE INTERIOR SECTION
OF A PROJECT FOR A CAST-IRON CHAPEL, DESIGNED
BY WILLIAM SLATER IN 1853–56 AND PUBLISHED IN
Instrumenta ecclesiastica.

TO
VINCENT SCULLY

CONTENTS

LIST OF FIGURES

PREFACE

In his indispensable book on the subject, *The Gothic Revival* of 1872, Eastlake says that R. C. Carpenter's St. Mary Magdalene "was perhaps the last church of any note erected in London before the Revival became sensibly, though by no means universally, affected by certain new doctrines of taste—doctrines that were proclaimed from an unexpected source, and which at one time bade fair to revolutionise and reform those very principles of design that Pugin had recently laid down with so much care."

Eastlake's comment has often been repeated. But strangely enough, with all that has been written about Victorian architecture, the unexpected source of these doctrines has never been explained, the doctrines themselves have never really been analyzed, and the new style they produced—High Victorian Gothic—has not been related to them. Yet this style involves work by major figures, including G. E. Street and William Butterfield. It was important, at times dominant, not only in Britain but throughout much of the English-speaking world from about 1855 to about 1875. To this day it gives shape, color, and texture to any number of Anglo-Saxon cities.

More important, behind the style lay a forgotten mode of perception by which the observer created elaborate mental responses to architecture. The imagery of these responses was odd. Two of the most common images were that of the building as a living creature and, to give it a modern name, that of the communications appliance. While such notions are preserved in nineteenth-century writings, their force and significance have been underestimated by later generations. The first modern scholar I know of who recultivated them was Vincent Scully in his brilliant monograph, *The Shingle Style* (1955). Scully, perhaps unconsciously influenced by his source material, often evokes creaturely, affective qualities in buildings. His evocations can reach the point where a dramatic encounter occurs between building and observer or building and landscape. Such relationships will be a central theme of the present study.

Even before Scully, however, an allied notion had been proposed by John Summerson. In 1945 he identified sadomasochistic qualities in Butterfield's architecture. Summerson's ideas were taken up in the same year by Goodhart-Rendel, and appeared more incidentally in 1963 in an article by Paul Thompson (who now seems to have abjured them). When, as with these authors, a building can suffer or cause suffering, there is the implication that it is alive, or at least active—that it is an injured or malevolent being. But such ideas go back well before Summerson. Like Scully's, they are part and parcel of Victorian thought. A sign of their continued vitality is what I will call the invective tradition in writings about Victorian architecture: I know of no other style to whom its historians have been so unkind. Earlier in the history of art, when a style was out of favor it was ignored; people wrote about what they admired. But at least from Pugin on, whole books and essays have been devoted to architectural excoriation. Reginald Turnor, John Gloag, R. Furneaux Jordan, and Summerson are modern cases in point, and there are plenty of Victorian examples as well.

These writers, like Scully, react emotionally to architecture, whatever their urbanity of pose. A more recent group, however, has emphasized cool detachment and has concentrated on architecture's intellectual, message-sending capacities.

Meaning in Architecture (1970), edited by Charles Jencks and George Baird, seeks to "read" buildings by applying French structuralist principles. Details, volumes, and other features become codes. But, once again, close Victorian parallels exist, as I will make clear in the following pages. In any case, the communications appliance can also be creaturely and the "message" emotional; there is never an absolute separation.

I think most people would agree that these are arresting, even bizarre, notions. But as I noted above, they have not been analyzed. Summerson's sado-masochistic interpretation and Scully's dramatic encounters are presented purely as personal insights, and Baird, Jencks, and their colleagues do not explore the history of the linguistic parallels that have been made with architecture.

The present study attempts to show that the creature and machine metaphors are branches of an aesthetic doctrine known as associationism. The book begins with two chapters surveying associational writings from the mid-eighteenth to the mid-nineteenth century. The third chapter illustrates how the Ecclesiological Society converted this associational theory into High Victorian Gothic practice. In the fourth chapter I attempt a series of associational interpretations of major High Victorian Gothic monuments. With the help of contemporary critics, I discourse with architectural creatures and decode their messages. (If my language occasionally becomes overwrought, I apologize. It is not my intention to be vulgar, but to translate Victorian conceptions into modern terms.) The final chapter goes into the events that led to High Victorian Gothic's dissolution.

Perhaps it would be prudent to add a short list of things my book is not intended to be. It is not a survey of High Victorian Gothic; it makes no attempt to deal with all the important monuments or practitioners of the style. Nor does it set out to deal fully with each monument it does include. Buildings are discussed only insofar as they contribute to the elaboration of my ideas. And because I think books like this should be short, I even omit whole classes of buildings, such as houses, as well as the minor arts. I am convinced, however, that further study in these areas would substantiate the conclusions I come to.

A word of thanks is due to a number of people who have been helpful along the way: first, the late Carroll L. V. Meeks, and to his name I would add those of Robert Bush, Peter Collins, John Cutler, Bobby de Kerdrel, Philip Foster, John Harris, Robert L. Herbert, Henry-Russell Hitchcock, George Kubler, J. R. Lambeth, Walter Langsam, Douglas Richardson, Vincent Scully, Phoebe Stanton, Paul Thompson, and George Toufexis. Jean Owen, Margot Schutt, and Victoria Dudley of The Johns Hopkins Press have been most patient and resourceful. I must also thank Yale for a Morse Junior Faculty Fellowship which permitted me to spend the academic year 1966–67 in Britain. Parts of Chapter I appeared in the *Architectural Review* and in *Eighteenth-Century Studies,* and I thank their editors for permission to reprint the passages here.

HIGH
VICTORIAN
GOTHIC

I·PRE-VICTORIAN ASSOCIATIONISM

The Building as Sexed Creature: Boffrand, Blondel, Ledoux

Architectural treatises often describe buildings as though they dealt in facts and emotions, or even as though a building could be a discoursing creature of sorts. As everyone knows, Vitruvius endowed the orders, and even entire buildings, with bodily and sexual qualities. He equated Doric with manliness, and with temples to Minerva, Mars, and Hercules; Ionic with matronliness, and with Juno, Bacchus, and Diana; and Corinthian with girlishness, and with Venus, Flora, the nymphs, etc.[1] One could say that for Vitruvius temples were sexed beings, and that through their sexuality they conveyed information to the observer.

Renaissance theorists increased this bodily and personality symbolism in architecture. Francesco di Giorgio's analyses of columns, and even whole façades, as statements about or even images of immured human figures are well known.[2] To Filarete buildings could be even more anthropomorphic. They were in fact

[1] Vitr. *De architectura*, 1.1.5, 3.1.2–3, 4.1.6–11.

[2] Henry Millon, "The Architectural Theory of Francesco di Giorgio," *Art Bulletin* 40 (1958): 257–61; Gunter Hellmann, "Proportionsverfahren des Francesco di Giorgio Martini," *Miscellanea bibliothecae hertzianae* 16 (1961): 157–66.

conceived in Adam's image and were to be considered as actual living men, he says, human in proportions and parts, and even in variety and distribution. Architecture as a whole was a kind of demography, and even ugliness and nondescriptness were as unavoidable in it as in the human race.[3] The passive sexuality that buildings have in Vitruvius can become, in Filarete, an erotic relationship between the patron and his creation: "Building is nothing else than a sensuous pleasure, as when a man is in love."[4]

But Filarete also implies that these qualities and pleasures are only felt by the initiate, e.g., by those who had read his book and who could then, while "reading" or communing with a building, be guided by his interpretations. The qualities Filarete says exist in buildings are in this sense messages that have to be decoded. They constitute intellectual and emotional information, as with Vitruvius, but now this is heightened in force and its possible meanings are widened.[5] In the later eighteenth and nineteenth centuries, in Britain, such meanings would have been called "associations," i.e., mental predispositions on the observer's part upon which the building had to act before its aesthetic value could be established.

But nineteenth-century British associationism was even more akin to the way architecture was perceived by certain eighteenth-century Frenchmen. For example, here is Germain Boffrand in his *Livre d'architecture* of 1745: "An edifice, by its composition, expresses as on a stage that the scene is pastoral or tragic, that it is a temple or a palace, a public building destined to a specific use, or a private house. These different edifices, through their disposition, their structure, and the manner in which they are decorated, should announce their purpose to the spectator."[6] Here buildings are differentiated according to the requirements of a dramatic genre, as with Serlio's tragic, comic, and satyr scenes. But with Boffrand the genres apply to actual architecture rather than stage scenery, while at the same time their function is made more explicit. Boffrand then adds to the content of architecture by saying that it should also arouse emotions: joy, sadness, love, hate, even terror. The emotions, like the functional ex-

[3] Filarete, *Trattato*. Biblioteca nazionale, Florence, MS Magl. II.I.140. 1.4r, 5v, 6r.

[4] *Ibid.*, 2.8r. Filarete also measures columns in human heads, letting the tallest be the equivalent of a giant, the next normal, and the squattest a small person (1.3v, 4r). These he makes, respectively, Doric, Corinthian, and Ionic. He also likens the patron to the father and the architect to the mother of a building, while the preliminary wooden model is the fetus (2.7v).

[5] To mention only one of the many other Renaissance architects who indulged in such anthropomorphism, cf. Michelangelo's letter fragment in which he says that architectural members derive from the human body and that he who cannot draw the figure cannot understand architecture (James Ackerman, *The Architecture of Michelangelo*, 2 vols. [London: Zwemmer, 1961], 1:1–8).

[6] P. 16.

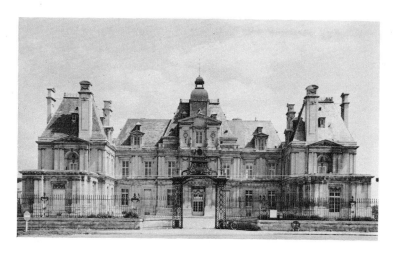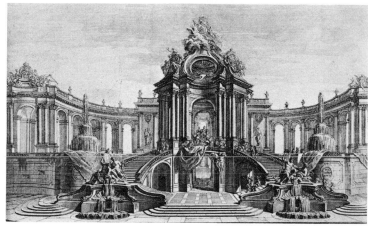

pression, must be appropriate: anything else is *"désordre."*[7] Under this rule many other emotions besides love or sexual attraction are generated by buildings, and all sorts of observers besides the patron can be involved. As to the force of these ideas, they are no mere metaphorical garnish. Boffrand states that when they come into conflict with traditional abstract rules—symmetry, unity, etc.—the expressive rather than the abstract rules shall prevail.[8]

Jacques-François Blondel in his *Cours d'architecture* (1771–73) restates several of Boffrand's ideas but generally uses the word "character" to cover the latter's concept of the denotative and emotional charge on a building. A related concept is *"convenance,"* which constitutes a more imperative functional expression than anything in Boffrand: "One says that a building has *convenance* when one has remarked that the exterior composition and the main parts of its decoration are *absolutely* relative to its purpose" (my italics). Blondel also deals more specifically than Boffrand with emotion or emotionally felt qualities: churches should cause emotions connected with decency (i.e., decorum), royal palaces with magnificence, public buildings with grandeur, fortifications with solidity.[9]

I–1. (left) *Château Maisons-Lafitte.*
François Mansard. 1642–51.
Photo Wayne Andrews.

I–2. (right) *Project. J.-A. Meissonnier. 1740.*
Meisonnier, Oeuvre, ca. 1740.

[7] *Ibid.*, p. 9.

[8] *Ibid.*, p. 10. Not only can the orders be grave (Doric), delicate and feminine (Ionic), and magnificent (Corinthian) but, as they rise from basement to attic in their normal superimposition, Doric, Ionic, Corinthian, they express a range of genres from the rustic to the sublime (*ibid.*, p. 24).

[9] *Cours*, 1:389–90, 2:229–32.

Then Blondel shows how style must vary to accommodate content. This stems from Boffrand's ideas about expressive genres, but once again Blondel's message is more detailed:

> In all the productions of architecture, the style proper to the project is one of the first merits of art. It is through style that the genre chosen is regulated in accordance with the building's function. Style, in the arrangement of façades and decoration of apartments, constitutes the poetry of architecture: a coloration contributing to the true interest of an architect's compositions. It is style, appropriate to different ends, that leads to this infinite variety among various types of buildings. In a word, style as defined here, like the style of eloquence, enables the architect to create a sacred genre, a heroic one, a pastoral one: there is no doubt that, aided by the rules, by reason, and by taste in art, one can achieve the true style which assigns to each edifice its proper character, and indeed only thus can one produce masterpieces.[10]

Thus style, as distinct from "rules," becomes the individual personality of each structure, a unique combination of its emotional force and intellectual content.

In line with this greater diversification and emotional energy, there is for Blondel a wider sexual force in a building. He not only senses maleness in Doric, or an erotic relationship between patron and structure, but also sees sexuality as permeating whole buildings by taking possession of certain formal characteristics. Buildings that consist of "rectilinear masses," such as the Luxembourg, Maisons-Lafitte (Fig. I–1), and the Portal of St.-Gervais, are "male." Conversely, "female" architecture, made up of "sinuous partis," is characteristic of fountains, villas, baths, and the like.[11]

One sees what Blondel means, I think, when one contrasts Maisons-Lafitte with a fountain project published by Meissonnier in the 1740s (Fig. I–2). The "maleness" of the Château is implicit in the reinforced right angles, the repetition of paneled planes, the sense of reserve power or unseen forces that climaxes in the frontispiece. The "female" character of the fountain is, on the other hand, explicit: its shape is akin to that of a female body. The elliptical sweep of the double stair down to the fountains, and the play of this curve against the enclosing semicircle of the colonnade, is patently anthropomorphic, or rather

[10] *Ibid.*, 4:liv–lv.

[11] *Ibid.*, 1:411–13,·419–21. Also *ibid.*, pp. 373–447, where he speaks of architecture that is sublime or soul-raising, and of the emotions that must go with it. For Blondel see Robin Middleton, "Jacques-François Blondel and the *Cours d'architecture.*" Blondel's ideas led to other discussions of architecture and sensibility, for instance, Nicolas Le Camus de Mezières's *Le Génie de l'architecture* (1780), where Doric is a nobly shaped man, Ionic a beautiful matron, Corinthian an elegant and slender girl (p. 22). For further writings on the subject see the bibliography in the recent University of St. Thomas catalogue, *Visionary Architects* (Houston, Texas, 1968).

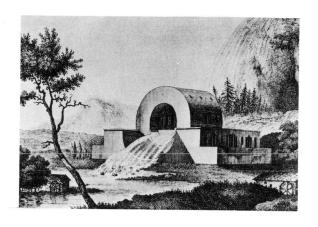

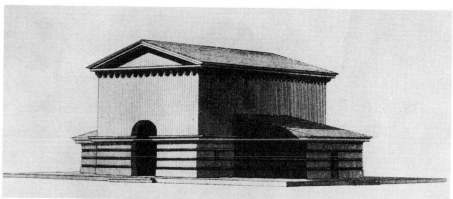

gynomorphic. And, in contrast to Maisons-Lafitte, Meissonnier has designed an open structure, pouring forth its abundance, with many avenues of access, and topped by disheveled curls. Everything evokes an eighteenth-century woman with her divided hoop skirt, tight bodice, and towering wig.

Not only is there sexuality in the two structures, thus compared, but the two sexualities are different in kind—that is, they have different dramatic roles. The male is moral and abstract, as male thinking and male resoluteness were conceived to be. The female architecture is, on the other hand, ornamental and erotic. Working together, "character," "*convenance*," and "style" create dramatic polarities of gender between the two designs.

Blondel's ideas on intellectual, emotional, and sexual expression seem to have influenced his pupil Ledoux. The designs in the latter's *Architecture considérée sous le rapport de l'art, des moeurs, et de la législation* (vol. 1, 1789; vol. 2, 1804) are sculptural odes, each unique. "Variety," says Ledoux, "gives to each edifice the physiognomy proper to it, and multiplies and changes this physiognomy in accordance with the surroundings, and with the sweep of land to the horizon; and from one satisfied desire, innumerable others blossom."[12] As

I–3. (left) *House for the directors of the Loüe irrigation system. C.-N. Ledoux. 1804. Ledoux*, Architecture, *1804.*

I–4. (right) *Customhouse. C.-N. Ledoux. 1804. Ledoux*, Architecture.

[12] Claude-Nicolas Ledoux, *L'Architecture considérée sous le rapport de l'art, des moeurs, et de la législation*, p. 10. Cf. also Marc Soboya, "Claude-Nicolas Ledoux et son utopie sociale," *Information de l'histoire de l'art* 15 (1970): 136–38.

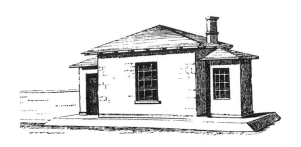

I-5. Dwelling for a man and his wife.
J. C. Loudon. 1833.
Loudon, Encyclopaedia, *1833.*

I-6. The dwelling as a cattle shed.
J. C. Loudon.

[13] Ledoux, *Architecture,* p. 12.
[14] *Ibid.,* p. 3.

with Filarete this variety is like that of individuals in a population. And, says Ledoux, not only do buildings have topographical variation and sexuality; even the force or presence that bestows such qualities, i.e., decoration, has it: "This clever coquette, aided by the sweet arts of civilization, plays all roles; she is alternatively severe or easy, sad or gay, calm or passionate. Her attitude imposes or seduces; she is jealous of all, can support no surroundings that dim her light nor any comparison that would destroy her charms. Ceaselessly surrounded with desires that align themselves with her radiance, she isolates herself from the world."[13] Here is an extraordinary anticipation of the supposed action of Victorian architecture. Decoration is a magnet, attracting meanings from its setting and then irradiating the observer's mind with them. Nor is the variety of emotional and cognitive expression in such a building limited to simple types, churches or halls of justice, as with Blondel. It is an infinitely capable language. Buildings may take any shape appropriate to their function or—to use a more appropriate word—dramatic role. Serlio's stage with its three genres has become the world, a wider stage that can support unlimited variety.

For Ledoux the purpose of all this is to supervise and reform human behavior. Buildings are not only creatures but appliances to channel and define activity. They raise the appropriate intentions in the soul and exert a necessary charm or issue a summons to good conduct: "The character of monuments, like their nature, serves the propagation and the purification of manners. In one place theaters are raised under the progressive form which makes humanity equal; in another there are arches of triumph, which deify it; further on are cemeteries, where it is engulfed."[14]

To put it differently, Ledoux fashions devices intended first to create knowledge and then to produce the emotions needed to act on that knowledge. This explains the strange shapes of his buildings, from the sawyers' villa with its log columns to the famous Oikéma, the temple for communal love liturgies, shaped in plan like an erect penis with testicles, or the house for the supervisors of the Loüe irrigation system (Fig. I–3), which is a giant section of pipe with the

waters rushing through it, set into a stepped plinth. The house of the directors of waters itself directs waters, serving as a continual example, majestic, didactic; indeed, "example is the most powerful of lessons."[15] Even Ledoux's less extraordinary conceptions, like some of the customhouses or *"propylées"* for Paris, can be seen as sculptured or embodied functions: in Figure I–4 the arch swallows, the gabled parallelepiped processes, the wings store, the back expels. Thus do the "less extraordinary" designs become extraordinary when perceived in Ledoux's spirit. He says, for example, that the *propylées* should have the illusionism of the theater and much diversity of form. Some must boast trophies of victory, while others are "transplanted mountains"; this diversity in turn "raises the thirst of desire," summoning the observer's emotion to heighten his public-spiritedness.[16]

I–7. The dwelling as a mausoleum. J. C. Loudon.

Early Forms of Associationism

These highly charged descriptions are what Blondel would call the poetry of architecture.[17] Ledoux not only creates, in the building, the object of our thoughts and feelings: he tells us in literary form what those thoughts and feelings must be. His definition of an architect is in fact one who "describes buildings." This may be taken to mean that the architect should write about his designs, should poeticize them, "raising the soul of the reader" and begetting in him thereby a controlled and heightened response.[18]

This phenomenon is central to much artistic creation and criticism in the nineteenth century. It involves an attitude or description that has earlier been implanted in the observer's mind and that is automatically elicited when the object is seen. The implanted description controls, or perhaps even constitutes, his response to the work of art. It accretes to it, covering it with a layer of observation. The idea may well not be unique to associationism, but it flourished in the Victorian period—as one would expect in an age of criticism.

An example of Ledoux's proto-associationism will be the conduit house (Fig. I–3), whose unusual shape and siting would surely provoke a considerable emo-

I–8. The dwelling as a chapel. J. C. Loudon.

[15] *Ibid.,* p. 2.

[16] *Ibid.,* pp. 17–18.

[17] *Cours,* 4:liv.

[18] Ledoux, *Architecture,* p. 16.

tional reaction—of surprise, at least—on the observer's part. This becomes the basic energy output of the transaction. But this original impulse is too undifferentiated. There is nothing, or not enough, about the object itself, divorced from its nest of explanatory and hortatory writing, to communicate the architect's intention. That can be grasped only when the observer checks the object or its image against Ledoux's description: "the abundant rivers of Olympia liberate the space wherein their fruits and treasures may be channeled through numerous tubes. . . . Already the torrents of the earth fill it up, and abundance floods the fields transformed with water. . . . Neptune awakes, and constructs for his children, on these humid rocks, a palace of supervision that will be cleansed by art."[19] Only from this sort of thing can we know the purpose of the building, and its metaphorical and actual relation to the irrigation system. Only from this do we see the structure's relation to its landscape, that of a begetter; only from this do we see the appropriateness of a mechanical-artistic channeling of natural and unnatural rivers, or fancy the inhabitants of the house as Neptune's offspring, or, to be more elaborate, dwell on Ledoux's hyperbolization of the art of hydraulics. On reading the passage we reinject into the building the emotions emanating from it, and adjust our reaction accordingly. The poetic associations in this sense monitor the physical object. The observer is part of a reciprocation; he initiates the "feedback," or reverse flow. Nor is there any reason why, now that he is part of the system, the observer cannot bring into play associations of his own, in addition to or even in place of those provided by the artist. Indeed, this is one way of understanding certain kinds of criticism.[20]

Other "revolutionary architects" held similar opinions. Thus Boullée writes: "Our buildings, above all the public buildings, ought in some fashion to be poems. And the images they offer to our senses must excite in us sentiments analogous to the functions to which the buildings are devoted."[21] Throughout his manuscript Boullée provides verbal associations à la Ledoux to accompany his designs.[22] He also suggests, as does Ledoux, that buildings possess a physiognomic or anthropomorphic being, so that the associations often constitute conver-

[19] *Ibid.*, p. 51.

[20] In this sense the reaction modifies the work's behavior, since it conditions the grounds of its acceptance. The associations may even be formalized into another work of art. Thus is Keats's *Ode on a Grecian Urn* an associational reaction to a real, imagined, or composite artifact.

[21] Etienne-Louis Boullée, *Boullée's Treatise on Architecture*, p. 26.

[22] Usually under the rubric of "*caractère*." But his talk of the poetry of architecture seems to mean something more like *ut pictura poësis* than what I call Ledoux's feedback.

sations with objects resembling our own bodies and faces.[23] Both with Ledoux and Boullée we see how important are the assumptions both of creatureliness and of informativeness in architecture; these establish the personal relationships on which their system depends.

I do not know whether these French notions were consciously borrowed by English theorists in the early nineteenth century, but in Britain the Picturesque movement was already producing its own preliminaries to Victorian associationism, though, paradoxically, these were less marked than in France. Nevertheless, beginning as early as Reynolds[24] and continuing with Payne Knight,[25] Price, and others, certain writers do discuss informational, emotion-arousing architecture. Thomas Whately, in his *Observations on Modern Gardening* (1777), speaks of buildings primarily as adjuncts to landscape but endows them with affective powers:

The same structure which adorns as an object, may also be expressive as a character. . . . it may be grave, or gay; magnificent, or simple. [Buildings] raise and enforce a character already marked: a temple adds dignity to the noblest, a cottage simplicity to the most rural scenes; the lightness of a spire, the airiness of an open rotunda, the splendor of a continued colonnade, are less ornamental than expressive: others improve cheerfulness into gaiety, gloom into solemnity, and richness into profusion.[26]

Whately, who here echoes Shenstone, also stresses the more orthodox information supplied by ornament, e.g., statues and inscriptions, and by mythological and historical paintings. But these, he says, are emblematic rather than expressive in the best sense, since they require examination and reflection on the observer's part. Through the imitation of familiar shapes, on the other hand, communication can be more direct; and what he calls "original" character is best of all, for this requires no discussion or discernment: the message is understood instantaneously.[27] Thus does Whately move away from an elitist position, as in Filarete. While any understanding of Picturesque writing in terms of associationism or the "poetry of architecture" must be vague, these writers' emphasis on

[23] Boullée, *Treatise*, p. 34, quoting Locke. Boullée adds that beautiful objects are those we feel to be most like ourselves. At this point one must raise the question of *architecture parlante*, a concept attributed to Ledoux by the *Magasin pittoresque* (20[1852]:388). The phrase itself apparently post-dates Ledoux. By 1852 it only meant buildings that are direct symbols of their occupants, for example, winemakers living in a cask-shaped house. Evidently the doctrine still had adherents in the mid-nineteenth century.

[24] See especially Discourses 8 and 13 and *Idler*, no. 82, November 10, 1759.

[25] However, none of the main writings on Knight discuss associationism much. See J. J. Mayoux, *Richard Payne Knight et le pittoresque*; Nikolaus Pevsner, "Richard Payne Knight"; and S. Lang, "Richard Payne Knight and the Idea of Modernity," in John Summerson, ed., *Concerning Architecture: Essays on Architectural Writers and Writing Presented to Nikolaus Pevsner*, pp. 85–97. For the Picturesque in general, and architecture, see Peter Collins, *Changing Ideals in Modern Architecture, 1750–1950*, pp. 42–58.

[26] Pp. 69–70.

[27] *Ibid.*, pp. 83–87.

[28] Dugald Stewart, *Works*, 2:252–347; William Hamilton, "On the Philosophy of Common Sense"; J. F. Ferrier, "Reid and the Philosophy of Common Sense"; James Seth, *English Philosophers and Schools of Philosophy*, pp. 208–17, 227–318; G. A. Johnston, ed., *Selections from the Scottish Philosophy of Common Sense*; Walter John Hipple, Jr., *The Beautiful, the Sublime, and the Picturesque in Eighteenth-Century British Aesthetic Theory*, pp. 149–81; and Jean M. Mandler and George Mandler, *Thinking: From Association to Gestalt*, pp. 70–131.

[29] At least six editions were printed in Edinburgh between 1790 and 1817, and there were innumerable American editions up through about 1870. The *Essays* assumed new importance in their own period with the review (by Francis Jeffrey?) in the *Edinburgh Review* 18 (May 1811):1–46, and in Jeffrey's article on beauty in the 1815 edition of the *Encyclopaedia Britannica* (Supplement, 1816, s.v. "beauty"). See the obituary by George Gilfillan, *Hogg's Weekly Instructor*, n.s. 2 (1849):193; Martin MacDermot, *A Critical Dissertation on the Nature and Principles of Taste*; C. Fedeles, "Versuch über Alison's Ästhetik, Darstellung und Kritik: Ein Beitrag zur Entwicklungsgeschichte der englischen Ästhetik im XVIII Jahrhundert"; Leslie Stephen, *History of English Thought in the Eighteenth Century*, 2:46–70; E. F. Carritt, *Philosophies of Beauty*, secs. 28, 29, 33, 34; Morton Dauwen Zabel, "The Romantic Idealism of Art, 1800–1848," pp. 212–14; and Samuel H. Monk, *The Sublime: A*

architectural variety, and even ugliness, will be important in the Victorian period. In particular, Whately's emphasis on the instant communication of meaning will reappear, for example in the ecclesiologists' mission program.

The Building as Informational Appliance: Alison and Knight

Victorian associationism shared much with these earlier theories, but none of the writers mentioned so far has actually explained *how* objects provide information or arouse emotion. We must make do with the assumption of creatureliness, whereby responding to architecture is like conversation, drama, or social behavior. But true associationism, as opposed to these preliminary forms of it, attempts to clarify the process itself. True associationism was elaborated by the Scottish Common Sense philosophers, a school that originated under the influence of Hume and Hutcheson and was developed by Dugald Stewart and Thomas Reid.[28] The main associational treatise on aesthetics, *Essays on the Nature and Principles of Taste* (1790), is the work of a fifth Scot, Archibald Alison.[29]

Like other Scottish rationalists Alison held that beauty is not intrinsic in objects but exists in the mind of the beholder.[30] On seeing a work of art a simple emotion—admiration or cheerfulness—grips him. Urged on by it, he makes mental associations, and if these are sufficiently numerous, well-related, and novel, the object to him is fully beautiful. Conversely, if the associations do not come the object is not beautiful, at least not for that beholder. "Imagination" is the power of a given mind to call up the associations[31] and "expression" the power of an object to evoke them.[32] The purpose of education is to equip the minds of men with many potential associations, i.e., to develop imagination. The artist in turn must strive to create works that are as "expressive" as possible.

Alison illustrates his theory copiously. Take, he says, an ordinary, common scene. By itself, as a mere collection of forms, it may be "little beautiful." But if we know it as "the residence of any person, whose memory we admire . . . the delight with which we recollect the traces of their lives, blends itself insensibly

with the emotions which the scenery excites; and the admiration which these recollections afford, seems to give a kind of sanctity to the place where they dwelt, and converts every thing into beauty which appears to have been connected with them." Similarly, Runnymede is beautiful not so much because of its physical character as because of its history. Even the loveliness of the Valley of the Vaucluse really impresses because Petrarch once lived there,[33] and the very Alps, no matter how sublime they may seem to the eye alone, are made more so by the knowledge that Hannibal marched across them:[34]

And what is it that constitutes that emotion of sublime delight, which every man of common sensibility feels upon the first prospect of Rome? It is not the scene of destruction which is before him. It is not the Tiber, diminished in his imagination to a paltry stream, flowing amid the ruins of that magnificence which it once adorned. It is not the triumph of superstition over the wreck of human greatness, and its monuments erected upon the very spot where the first honours of humanity have been gained. It is ancient Rome which fills his imagination. It is the country of Caesar, and Cicero, and Virgil, which is before him. It is the mistress of the world which he sees, and who seems to him to rise again from her tomb, to give laws to the universe. All that the labours of his youth, or the studies of his maturer age have acquired, with regard to the history of this great people, open at once before his imagination, and present him with a field of high and solemn imagery, which can never be exhausted. Take from him these associations, conceal from him that it is Rome that he sees, and how different would be his emotion![35]

Such trains of association match Blondel's architectural poetry, but Alison's associations are implanted facts brought forward in the mind by the sight of an object. They are not verbal directions given by the architect for the guidance of the beholder. They are formed during one's education and belong to personal experience, especially in childhood and youth. They can even lie dormant for long periods before being brought into play.

Despite all this, Alison does not ignore formal values in objects. Indeed, he speaks at length of an intrinsic "beauty of forms."[36] He had a chaste and correct

Study of Critical Theories in XVIII-Century England, pp. 148–53.

[30] *Essays*, 1:4–7. For Alison, it should be said at the outset, the Picturesque was only a subdivision of the Beautiful, not an alternative aesthetic category (e.g., *ibid.*, p. 23). He speaks here of the "beauty" of one's birthplace, nursery, or school. But the Sublime *is* a separate category (e.g., Essay 1, "Of the Nature and of the Emotions of Sublimity and Beauty").

[31] *Ibid.*, pp. 8–22.

[32] *Ibid.*, pp. 5, 69–172, esp. pp. 158–65.

[33] *Ibid.*, pp. 289–94.

[34] *Ibid.*, p. 25.

[35] *Ibid.*, p. 27.

[36] *Ibid.*, pp. 41–42.

37 *Ibid.*, 2:56–205.

38 *Ibid.*, pp. 184–85.

39 *Ibid.*, p. 126. Thus in *ibid.*, 1:xxvii, Alison says that he will base his demonstration on "common nature, and the experience of common men" and ignores the fine arts as direct evidence. But this is because the latter are imitations of Nature, and the original should be studied before studying the thing derived from it.

40 Quoting Gilfillan, *Hogg's Weekly Instructor*, p. 193. Alison had considerable influence on literature, e.g., on Burns, Crabbe, Byron, and Keats (probably through Hazlitt). See James R. Caldwell, *John Keats' Fancy*, pp. 51–89, and Ian Jack, *Keats and the Mirror of Art*, which describes something like what I am calling feedback. See also René Wellek, *A History of Modern Criticism*, 4 vols. (New Haven, 1955–65), 1:112, and, for Alison in America, Ralph N. Miller, "Thomas Cole and Alison's Essays on Taste," with other bibliography. Jeffrey in his *Edinburgh Review* article stresses the complete relativism implicit in Alison, while Coleridge remarked: "in Alison etc., much has been said well and truly; but the principle itself is too vague for practical guidance.—Association in philosophy is like the term stimulus in medicine; explaining everything, it explains nothing; and above all, leaves itself unexplained" (*Biographia Literaria*, ed. J. Shawcross, 2 vols. [Oxford, 1907], 2:222).

41 For Knight vs. Alison, see Mario Rossi, ed., *L'Estetica dell' empirismo inglese*, 2:918–22.

Neoclassical taste, but his justification for this taste was functional. As with Boffrand and Blondel, interior spaces according to their shape and size produce different emotional "characters," such as gaiety, simplicity, solemnity, grandeur, magnificence, and the like.[37] The ability of the spaces to project the emotions is judged as machines are judged. Thus, says Alison, when we talk of beauty of proportion, or of scale and composition, what we really do is ask whether the building is fit for its purpose, and whether that fitness is expressed. Without knowing the function of an object no aesthetic judgment is possible: "we can never discover the Proportion, until we previously discover the principle of the Machine, or the Means by which the End is produced."[38] With a proper knowledge of function, on the other hand, any man can make a valid judgment.[39] Thus, whatever Alison's personal taste, his functional tests prepared the way for eclecticism and relativism.

Alison was read throughout the Victorian period and frequently received credit for opening up these possibilities. The *Eclectic Magazine* in 1849 pictures Alison as the creator of a clear version of earlier writers' vague thoughts: "To Alison be the praise of first announcing, in a popular form, the astonishing conceptions, which had passed before the reveries of half-insane poets and philosophers, that the universe is a great mirror to the mind of man . . . and that, in contemplating the fairest scenes, we are ourselves half-creating their loveliness."[40]

Other authors developed similar ideas, though less consistently than Alison. In 1805 Payne Knight[41] stressed how eclecticism could produce a greater associational eloquence than stylistic purity:

In the pictures of Claude and Gaspar, we perpetually see a mixture of Grecian and Gothic architecture employed with the happiest effect in the same building; and no critic has ever yet objected to the incongruity of it: for, as the temples, tombs, and palaces of the Greeks and Romans in Italy were fortified with towers and battlements by the Goths and Lombards in the middle ages, such combinations have been naturalized in that country; and are, therefore, perfectly in harmony with the scenery; and

[are] so far from interrupting the chain of ideas, that they lead it on and extend it, in the pleasantest manner, through different ages, and successive revolutions in tastes, arts, and sciences.[42]

The same is true of Gothic castles that have been "Grecianized" by moderns. A mixture of styles tells a rounder and more circumstantial story. Knight thus becomes one of the earliest to suggest that for informational and emotional purposes classical and medieval architecture can be mixed in the same building. By this means Gothic can become almost the aesthetic equal of classical. It even has certain superior formal virtues: it produces, says Knight, "effects more imposing . . . than are, perhaps, to be found in any other works of man."[43] But it was the associational justification that came to be the main support for eclecticism.

The corollary that Gothic was, because of its historical associations, the specifically Christian architecture has often been credited to Pugin.[44] However, perhaps as early as 1815 Mary Anne Schimmelpenninck expressed the same idea at length. With her, in fact (as had not been true for Alison), associationism was chiefly moral and religious: "It is obvious that Beauty, considered as a symbolic language, must be traced up to its source in the laws of inherent association. From this point of view, inherent association becomes to us the basis of a system of correspondences between the external world and man's moral nature."[45] Schimmelpenninck takes up other implications in Alison's theory, stressing that beauty and deformity are actually allied, since the struggle against sin must warp ideal form. She admires the forms of the Picturesque, with its delight in the ruinous, the old, and the damaged, but she likes these qualities because they record the battle of ideal beauty against time and man's vandalous nature. She constantly implies that buildings are suffering organisms and that they may triumph over their suffering to achieve a moral beauty transcending and replacing any mere physical beauty they have lost.[46]

Seven years later the Earl of Aberdeen again raised the question of the

[42] Richard Payne Knight, *An Analytical Inquiry into the Principles of Taste*, p. 157. See also *ibid.*, pp. 94–312, which depends on Reid more than Alison. Knight's main intention apparently was to replace Uvedale Price's formalist Picturesque with an associational version. For Price and associationism, see his *Essays on the Picturesque, as Compared with the Sublime and the Beautiful*, 2:247–50.

[43] Knight, *Inquiry*, p. 175.

[44] Kenneth Clark, *The Gothic Revival: An Essay in the History of Taste*, p. 164; Reginald Turnor, *Nineteenth Century Architecture in Britain*, p. 60; Alexandra Gordon Clark, "A. W. N. Pugin," in Peter Ferriday, ed., *Victorian Architecture*, pp. 141–42.

[45] *The Principles of Beauty as Manifested in Nature, Art, and Human Character, with a Classification of Deformities, an Essay on the Temperaments with Illustrations, and Thoughts on Grecian and Gothic Architecture*, p. 15. I say "perhaps" because I have not been able to collate the earlier and later editions of this book (London, 1815 and 1859).

[46] *Ibid.*, pp. 392–93.

building as a creature. In the midst of an attack on Burke's *The Sublime and the Beautiful* he lists Burke's criteria for beauty—smallness, smoothness, variety in direction of parts, parts not angular but melted into each other, delicacy of frame, etc.—and says,

It must be evident that the properties and qualities considered by Mr. Burke as essential to every species of beauty, have been principally, if not entirely, collected from the female form. . . . the real source of their attraction [is in] the sexual affections and sympathies implanted in our nature. . . . it would seem a little whimsical to maintain that feminine graces, feminine delicacy, and feminine proportions, ought to constitute beauty in a tree or in a house.[47]

The Earl feels he is damaging Burke's case, but of course we have just seen that this very idea had been seriously defended. It will be elaborated by the Victorians.

John Claudius Loudon

In the 1830s the main development, following Alison, was of the mechanical-cognitive side of these theories. Creatureliness was temporarily set aside, and the appliance emerged. The new contributions came mainly from the noted horticulturist John Claudius Loudon, who mentions Whately, Aberdeen, and Schimmelpenninck in his bibliography. But by far the greatest influence on him was Alison.[48] Loudon's *Encyclopaedia of Cottage, Farm, and Villa Architecture* of 1833 in fact contains a systematic application to architecture of Alison's ideas.[49]

Loudon believed that "expression of fitness for the end in view"—i.e., Alison's principal associational test—was a supreme architectural law. On this basis he invented specific meanings for architectural elements, making associational "signifiers" out of windows, doors, chimneys, etc., saying that these expressed truths about the building's interior, its purpose, the nature of its occupants, its relation to the surrounding landscape, and even its role in local and national

[47] George Hamilton-Gordon, fourth earl of of Aberdeen, *An Inquiry into the Principles of Beauty in Grecian Architecture*, p. 10.

[48] For Loudon see the *DNB*; Edward Buckton Lamb, "Memoir of the Late J. C. Loudon, Esq., Read before the Royal Institute of British Architects on Dec. 18, 1843"; notice by Mrs. Jane Loudon in her *Self-Instruction for Gardeners* (London, 1844); "Biographic Sketches. John Claudius Loudon," *Chambers's Journal,* n.s. 1 (January-June 1844):284–86; Zabel, "Romantic Idealism," pp. 210–11; Anon., "Beau Ideal of a Hundred Years Ago," *Architectural Review* 87 (April 1940):117–20; Anon., "Modern Style 1850," *ibid.*, 95 (May 1944):xlv; Nikolaus Pevsner, "Early Iron 2. Curvilinear Hothouses"; my own "J. C. Loudon and Architectural Associationism"; and John Gloag, *Mr. Loudon's England. The Life and Work of John Claudius Loudon and His Influence on Architecture and Furniture Design.* Loudon's *Encyclopaedia* went through innumerable editions. In them the original text was added to with supplements at the end. His ideas also received an airing in his *Architectural Magazine* during the 1830s, and *The Builder* (1[1843]:22) agreed with *The Times* that no other single work had so influenced rural domestic architecture as the *Encyclopaedia.*

[49] See pp. 52–54, and 1114–22 of the *Encyclopaedia.*

life.[50] Other information was communicated by ornament, i.e., by the "expression of architectural style," but this was a less important mode than that of fitness or use.[51] Loudon concludes that his three tests—fitness, the expression of fitness, and the expression of style—are all that is needed for judging architecture.

He gives many examples of what he means. "In dwelling-houses," he says, "the expression of use is indicated, in a decided manner, in all cold countries, by their having a number of chimney tops or other outlets, for permitting the escape of smoke from separate fires." Windows and entrances are other functional symbols associated with domestic life. A cottage with one bedroom, a living room, and a closet ought to express these three facts by using windows of three appropriately distinct sizes. Windows can also express regularity or irregularity of floor level, the presence of stairs, and other aspects of the plan. Turrets and projections, on the other hand, express "commodiousness and convenience; it being supposed that their object, in houses, is to supply closets and cabinets." Similarly, "porticoes, colonnades, verandas, and balconies are all expressive, more or less, of comfort and elegant enjoyment on the part of the occupant." Comfort and elegant enjoyment may *exist* in an unarticulated building, but there is no beauty until these truths are *expressed* by irregular masses, varieties of materials, and irregular openings.[52] Thus through associationism did the purely formal configurations of the Picturesque have functional meanings applied to them.

Loudon illustrates the expression of fitness throughout the *Encyclopaedia*. One finds it in a one-room cottage with an entry on the left and a washhouse on the right (Fig. I–5). Here "fitness for the end in view" is proclaimed by the windows, door, and roof. By varying these elements the associations can be changed and the building made to express fitness for other purposes: "Remove the windows and chimney top, leaving the entrance opening without a door (Fig. I–6), and it might be taken for a cattle shed and yard. Remove the roof, and replace the door (Fig. I–7), and it might pass for a place of burial. Restore the glass windows, increase the height of the principal one, and replace the roof with a little alteration, adding on its summit a turret and bell (Fig. I–8), and

I–9. Exterior, house for Charles Barclay, Bury Hill. John Perry. 1833. Loudon, Encyclopaedia.

[50] *Ibid.*, pp. 1112–13.
[51] *Ibid.*, pp. 1114–24.
[52] *Ibid.*, pp. 1112–13.

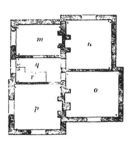

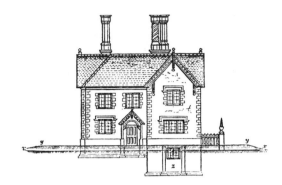

(left to right)

I–10. Plan, Barclay house. John Perry.

I–11. Second-floor plan, Barclay house. John Perry.

I–12. Front elevation, Barclay house. John Perry.

[53] *Ibid.*, pp. 28–31.

[54] *Ibid.*, pp. 1113. But see also p. 568, where Loudon suggests that a kiln may take the form of the Temple of the Winds, etc.

[55] *Ibid.*, p. 1112.

[56] *Ibid.*, pp. 418–34.

this structure might be mistaken for a chapel." [53] Thus do openings and enframements tell the story. It is perhaps only coincidence that Loudon's illustrations recall some of Ledoux's (Fig. I–5). However, such associational statements must always be honest, says Loudon: "A barn disguised as a church would afford satisfaction to none but those who considered it as a trick. The beauty of truth is so essential to every other kind of beauty, that it can neither be dispensed with in art nor in morals." [54] Here he runs directly counter to earlier Picturesque practice, where disguise was so frequent.

In the design of farmhouses and farm buildings a greater range of functional expression is required than with cottages. Loudon lays it down that in such groups the purpose of each building should be absolutely clear to the knowing eye. [55] He seldom provides the sort of complete reading for farm complexes that he does for cottages, but keeping his directions in mind, we can ourselves produce Common Sense associations.

Let us take the bailiff's house designed for a farm owned by Charles Barclay at Bury Hill, near Dorking. It was designed by John Perry of Godalming (Figs. I–9-I–15), [56] and was to be of sandstone with brick trim. In the perspective a tall, cross-gabled, two-story block is shifted forward from the wider, squatter paral-

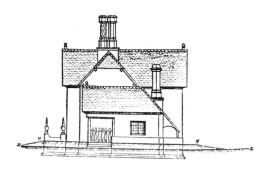
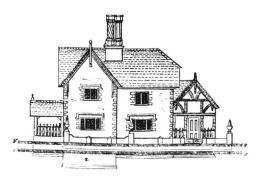
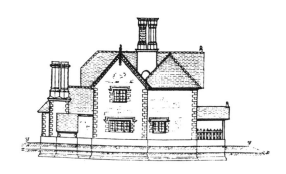

lelepiped forming the rest of the building. With its acutely raked, pronged roof, its wide, three-light Tudor windows on the ground floor, with generous two-light windows above, we can easily believe that this part of the house contains an important first-floor room and an important second-floor chamber. Looking at the plan we see that this is true: it houses the parlor and one of the four major bedrooms (Figs. I–10-I–11). By the same token the porch (Fig. I–9) is equally expressive of interior space, since it continues the deep slot of the hall and stairs (Fig. I–10), while the upper hall and a small bedroom (Fig. I–11) are appropriately lighted and are truthfully signified on the exterior by their smaller windows.

There are more general significations. The parts containing reception and living spaces are high-walled and shallow-roofed, with big windows and considerable ornament. Work and storage spaces, on the other hand, are low-walled and high-roofed, with small windows or none, and without ornament. The storeroom, the pantry, and the scalding room are on the north side of the house. On the east, at the back, are the dairy proper, the drying room, and the oven. These latter, the most workaday of the rooms, are in their own separate lower mass with its separate roof. Rustic detailing prevails here, i.e., the revealed half-timbered

(left to right)

I–13. East elevation, Barclay house. John Perry.

I–14. South elevation, Barclay house. John Perry.

I–15. North elevation, Barclay house. John Perry.

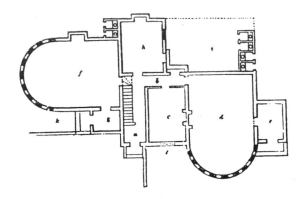

I–16. (left) *Design for a schoolhouse.*
E. B. Lamb. 1833. Loudon, Encyclopaedia.

I–17. (right) *Plan, schoolhouse. E. B. Lamb.*

[57] The same principles are applied to "model farmeries," where we must also be able to tell what every part is for. The farm is indeed a self-treatise, i.e., it is designed to "embody principles in tangible shape" (*ibid.*, p. 354).

[58] *Ibid.*, pp. 727, 757–58.

structure and the tree-trunk columns of the drying-porch (Figs. I–14-I–15). The roof of this wing sweeps to the ground in an unequivocal gesture of humility.[57] By extracting all these general and particular meanings from the design, meanings derived from seeing the engraving plus reading the descriptions, we put together the proper associational train in our minds. Further, where Ledoux's cluster of associations was provided entirely by him, and where Alison's was provided entirely by the observer, here with Loudon the associations come partly from the observer and partly from the published description.

Such associational expression, says Loudon, is a moral duty in any building, but it is particularly necessary in buildings of a specifically moral nature, such as schools. "In the choice of a Situation for an infant school," he says, "the first consideration is, the physical health of the children; and the next, their moral health."[58] A design by E. B. Lamb—reminiscent, incidentally, of Wright or even Richardson—displays these things clearly (Figs. I–16-I–17). The plan is intended, with its two imposing low apses lighted by quasi-strip windows, to provide sunlight all day long for both the boys' and the girls' classrooms. The sexes are

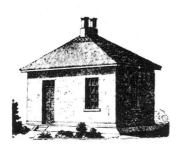 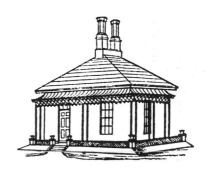

physically segregated by being at opposite ends of the building, each classroom with its own separate entrance porch with a separate roof. We can even read (Loudon does not say this) a special appropriateness in the part of the building that performs this separation—the tall, contrasting mass of the master's and mistress's quarters and infant school, with its combination of openness and angular rigor. The façade of the former, with its gable and balconied second-floor window, proclaims itself as at once domestic and watchful, while the infant school is included within, thrust behind—embraced by, as it were—the master's and mistress's block. The whole might be said to signify vigilance and innocence standing between instinct and temptation, a theme that could well have been set a Victorian painter. Meanwhile, the detailing is simple and harsh—like school life.[59]

Style and Language

For most of Loudon's predecessors "style" meant one of several traditional, mutually exclusive formal languages. For Loudon it seems to have meant a single

I–18. (left) *Dwelling for a man and his wife. J. C. Loudon. 1833. Loudon, Encyclopaedia.*

I–19. (middle) *Plan, dwelling. J. C. Loudon.*

I–20. (right) *Dwelling with veranda and terrace. J. C. Loudon.*

[59] An even heavier associational burden is placed on inns, which stand for "high civilization, and the consequent intercourse of society by public roads, rivers, or canals" (*ibid.,* p. 675). The inn of the future, says Loudon, will be to democracy what the palace and the monastery have been to privilege: they will provide gardens, pleasure grounds, parks, forests, sports, and "all the games and exercises that have been known to contribute to human gratification" (*ibid.,* p. 676).

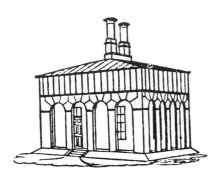

(left to right)

I–21. Dwelling with trellis. J. C. Loudon.

I–22. Dwelling with castellated jacket. J. C. Loudon.

I–23. Dwelling with monastic jacket. J. C. Loudon.

I–24. Dwelling with Elizabethan jacket. J. C. Loudon.

I–25. Dwelling of two rooms for a man and his wife. J. C. Loudon. 1833. Loudon, Encyclopaedia.

I–26. Dwelling with Indian jacket. J. C. Loudon.

[60] *Ibid.,* p. 1114.

[61] *Ibid.,* pp. 74–80.

but ordered storehouse for motifs from every age and country. The older sense of the word had implied a built-in rhetoric and grammar. But we have seen that even as early as Blondel "style" was also a poetry of architecture, a "coloration" that could lead to infinite variety. For Loudon the dissolution of the structural integrity of the different styles, and their integration into a single, looser system, was furthered by expression, which established itself *sur place* through the interaction of observer and object. Nonetheless, the "expression of architectural style" is the least important of Loudon's three architectural principles. In fact, he denies that there is any need for style at all, since beauty is essentially a matter of fitness and expression. For Loudon, style had become an ironic or poetic mask, useful only until mass education on Common Sense principles ruled it out.[60]

He makes this point in a series of diagrams illustrating how a utilitarian cottage can be dressed up in different ornamental jackets (Figs. I–18-I–25).[61] Normally the cottage consists of a cube with a hipped roof and central chimney. Its occupant is a shoemaker or other craftsman who works in one room while his wife keeps house in the other (Fig. I–18). The other rooms are, respectively, a bedroom and a storage space. So much for the prose associations: the building is

sufficiently, if not eloquently, expressive of fitness. In order to enrich the meanings of this modest object, to add poetry to the prose, Loudon suggests that a false second story and roof be built out of trelliswork (Fig. I–21), which would be designed to resemble masonry joints. Fruit vines could then be grown over it, and eventually the cottage would become a kind of habitable hedge. Loudon suggests that in warm climates the false wall could extend further out from the cottage, making a veranda (Fig. I–20). Other alternatives are medieval (Figs. I–22-I–24): in these a real second story is added and a more solid porch—a kind of cloister—is built. Another cottage gets two alternative treatments, one Italian and the other Indian (Figs. I–25-I–26).[62] I will assume that such additions would have to be associationally appropriate to the occupant.

In Loudon's pages these outer jackets make the houses into appliances or even three-dimensional signs. They reduce buildings to pure communication. Loudon in fact comes close to saying that this is the function of style. "It may appear improbable to some," he concludes, "that a person purposing to build so small a dwelling, should think of applying any of these styles to it." But, he explains, such a cottage can serve as a landmark, a reminder, a solace.[63] And it is precisely this landmark quality, this sense of a simple, memorable display, that

[62] *Ibid.*, pp. 76, 82.

[63] *Ibid.*, p. 80. Loudon puts associationism to similar uses when discussing the style of villas. The best styles are those that summon the richest associations, i.e., the most familiar. But classicism has a place, for the longer a style is in use the more associations it calls up. In the future, therefore, Grecian and Roman may become as beautiful as Gothic and Elizabethan are now; but by that time the latter will have become even more beautiful, and classicism will never actually catch up (*ibid.*, p. 774). British styles are also useful for émigrés (*ibid.*, p. 80), and this and other styles will awaken a love of history in the minds of illiterates. Finally, style, though essentially frivolous, can be used to tempt the landed class to erect comfortable dwellings for their villagers. Aristocrats have been unfitted by their education to appreciate the real beauties of fitness, so they

Loudon's examples of "architectural style" possess. They are cores with ideographic jackets.

To conclude: architectural theorists from Vitruvius on have often assumed a metaphorical creatureliness in architecture. This endows individual buildings with sex and personality and casts them into social or dramatic relationships with the observer. These relationships can possess both informational content and emotional pull. Boffrand, Blondel, and Ledoux developed the affective-creaturely side of the idea, Ledoux going so far as to say that buildings need poetic descriptions by the architect in order to guide the observer's reaction, a reaction which could have great artistic value and was a kind of completion of the artistic transaction.

Alison's associationism concentrated on buildings as informational appliances, and provided an explicit mechanism to show how the transactions might take place. In creating this mechanism Alison gave the observer a larger role than he had previously had. Meanwhile, Knight and Schimmelpenninck increased the expressive range of form so as to include eclecticism and even ugliness. Loudon climaxed the pre-Victorian development by inventing a denotative language for architecture, which even further undermined the ideal of stylistic purism.[64] It might seem that the creaturely-sexual interpretation in the first part of this chapter is unrelated in spirit to the informational, mechanical things that buildings become for Alison and Loudon. But, as Martin Price has pointed out, both readings concentrate on what might be called the lower bodily functions of architecture. Ledoux's sex organs are in this sense quite comparable to Loudon's self-dramatizing drying-porches.[65]

must (pending the arrival of true democracy) be given the false beauties of style (*ibid.*, p. 649).

[64] Sutherland Lyall (*Architectural Review* 144 [October 1968]:308) has disagreed with my conclusions. He says that if Loudon had really been an associationist he would have developed the idea consistently throughout his book; that the essay at the end, where associationism is discussed, is simply "tacked on for show"; and that Loudon's use of the subtitle "Buildings in various Styles" shows that contrary to what I say Loudon did take style seriously. Lyall also criticizes me for making my own associations from the designs, rather than simply quoting Loudon's. The answers to these criticisms are as follows. First, there is no reason why Loudon should discuss theory systematically outside that part of the book devoted to the subject. His critical essay is in no sense tacked on but is long and integral. Second, in any case Loudon does discuss associationism, in passing, throughout: almost every design has a paragraph analyzing the building's "expression." Third, style *was* important to Loudon—my point being that it was less so than functional expression. In any case, the subtitle, far from giving importance to style, means in context something more like "miscellaneous." Last, as to my having made my own associations, this is exactly what the *Encyclopaedia* constantly exhorts the reader-observer to do.

[65] Martin Price, Introduction, *Eighteenth-Century Studies* 4 (Fall 1970):2–3.

II·VICTORIAN ASSOCIATIONISM

Early Ruskin

The forms of associationism just discussed, with their mixtures of the creaturely and the machinelike, the male and the female, etc., were richly developed during the period after 1837. The main figure in that development is Ruskin, but other writers such as George Wightwick, William White, E. B. Lamb, and G. E. Street exemplified narrower aspects of Victorian associationism. Once we have glimpsed the main outlines of the problem through these men, I will discuss separately two important themes: biological progress in the Gothic, a concept which, in turn, is made possible by the continued assumption of architectural sexuality.

Ruskin, a protégé of Loudon's, began contributing to the latter's *Magazine of Natural History* in 1834. His first book-length work, *The Poetry of Architecture*, appeared serially in Loudon's *Architectural Magazine* in 1837–38.[1] The title is just conceivably borrowed from Blondel, and it is true, too, that Ruskin dramat-

[1] John Ruskin, *Works*, 1:97–196.

ically revived the creature metaphor. But on the whole his associationism is thoroughly British. Indeed, his earlier writings constitute a kind of moral gloss on Alison and Loudon.[2]

Like Loudon, Ruskin begins with the simple associations of cottages, but already he is energizing their emotional content. A certain hovel in Switzerland, for example, was "the loveliest piece of architecture I ever had the felicity of contemplating; yet it was nothing in itself, nothing but a few mossy fir trunks, loosely nailed together, with one or two grey stones on the roof: but its power was the power of association; its beauty, that of fitness and humility."[3] Ruskin continually returns to this theme, either denying that forms could have intrinsic beauty or, conversely, saying that if formal beauty exists it is superficial. True beauty and majesty, he says, depend less on pleasing "certain prejudices of the eye [than] upon . . . rousing certain trains of meditation in the mind." Above all, *feeling* is the great thing.[4]

This kind of thing was not uncommon by 1837: however, Ruskin then proceeds to investigate the associational possibilities of architecture in relation to its inhabitants and to its landscape setting in a way that very probably had not been done before. Not only should a cottage be the compacted expression of its setting, but the meanings of different settings can themselves be codified. There is a lexicon of landscapes. Woody scenes express ideas of conservativeness, reverence for antiquity, and melancholy. There can also be a grotesque element, by which the buildings become active creatures, "innumerable beings," in the manner of Ledoux.[5] In line with this biomorphic outlook, cottages should also express the character of their builders—and here, as Schimmelpenninck does, Ruskin stresses how rot, ruin, defacement, stains, and dismemberment can add beautiful narratives to the cottage's artistic sum.

Ruskin also provides associational vocabularies of form à la Loudon. He has a "Chapter on Chimneys" that illustrates how these objects tell of the different nations in which they were built, and even of the different regions of their countries (Fig. II–1). Chimneys *a*, *b*, and *c*, he says, are quintessentially English, as

[2] For the best text, see *ibid.*, 1:1–88. For Ruskin as aesthetician and critic, see W. G. Collingwood, *The Art Teaching of John Ruskin*, a more or less systematic restatement of Ruskin's ideas—esp. pp. 113–48; Henry A. Ladd, *The Victorian Morality of Art: An Analysis of Ruskin's Esthetic*, pp. 83–109; Lester C. Dolk, *The Aesthetics of John Ruskin in Relation to the Aesthetics of the Romantic Era*, which misstates the principles of associationism; Francis G. Townsend, *Ruskin and the Landscape Feeling*, esp. pp. 6–25; Martin Price, "The Picturesque Moment"; John Unrau, "A Note on Ruskin's Reading of Pugin"; and George P. Landow, "Ruskin's Refutation of 'False Opinions Held Concerning Beauty,'" which anticipates my Alisonian reading of Ruskin.

[3] Ruskin, *Works*, 1:31.

[4] *Ibid.*, p. 5. Robert Kerr, in "Ruskin and Emotional Architecture," claims that Ruskin was the first [Englishman?] to perceive architecture primarily in this emotional way.

[5] Ruskin, *Works*, 1:68–69.

are most of the other roughhewn examples, with *a* being unmistakably from Cumberland. On the other hand (being more formal and with a stiffly architectural double arch), *q* is unmistakably Swiss.[6] In style these rough, shadowy little engravings are a far cry from Loudon's mechanical diagrams. Ruskin exaggerates the rough textures and the broken surfaces of the masonry, dwelling on willful irregularities and endowing the shapes with a certain organic resilience. Many of the chimneys look like parts of bodies or plants, their edges, moldings, and trim converted into stamens, corollas, and glands. Even the *mise en page* of the eighteen varieties "as found in nature" resembles the illustrative technique of a text on natural history or anatomy. This technique will reappear in Ruskin's later work. It links him with the earlier artists and illustrators of the Picturesque and betokens, in contrast to Loudon, his more organic, "creaturely" perceptions.

Ruskin is more strictly Loudonian in his treatment of the villa, which he casts in a quite different role from the cottage.[7] But he is far from sharing Loudon's anti-aristocratic radicalism and at the same time is able to do more with the villa's associations. For Ruskin the cottage is mainly devoted to natural feeling and landscape, while the villa is the vehicle of human passion and concentrates on the character of the inhabitants. A good architect in fact makes his villa a portrait of the client, unbeknownst to the latter.[8] Along these lines Ruskin announces a book (it remained unwritten) on the homes of great men, "showing how the alterations which they directed, and the expression which they bestowed, corresponded with the turn of their emotions, and leading intellectual faculties."[9]

Ruskin gives a number of examples of such expression of personality. A window of "mixed and corrupt architecture, at Munich" (Fig. II–2) is supplied with two variants, one expressive of an imaginative inhabitant (Fig. II–3) and the other of an intellectual one (Fig. II–4)—the original window, meanwhile, being appropriate to "a man of feeling." This first window "depends upon the softness with which the light is caught upon its ornaments, which should not have a single hard line in them; and on the gradual, unequal, but intense, depth

[6] *Ibid.*, pp. 54–65.

[7] *Ibid.*, p. 73. Ruskin gives reasons why greater degrees of "nationality" can be expressed by churches and less by villas, since the latter are places of relaxation and should be bright, ethereal, and *spirituel*. At the same time peoples endowed with much imagination, like the Italians, will have more nationality in their villas, while unimaginative peoples, like the English, will have less (pp. 76–78).

[8] *Ibid.*, pp. 133–35. Cf. *The Seven Lamps of Architecture* (*ibid.*, 8:228–29): "I would have, then, our ordinary dwelling-houses built . . . with such differences as might suit and express each man's character and occupation, and partly his history . . . and it would be well that blank stones should be left in places, to be inscribed with a summary of his life and of its experience, raising thus the habitation into a kind of monument."

[9] *Ibid.*, 1:78.

II–1. Varieties of chimneys.
John Ruskin. 1837.
Ruskin, Poetry of Architecture, *1837.*

[10] *Ibid.,* pp. 136–38.

[11] *Ibid.,* p. 114.

[12] *Ibid.,* p. 142.

of its shadows." The imaginative man's window, on the other hand, "should have all its forms undefined, and passing into one another, the touches of the chisel light, a grotesque face or feature occurring in parts, the shadows pale, but broad; and the boldest part of the carving kept in shadow rather than light." The third window, for the intellectual man, "should be hard in its lines, strong in its shades, and quiet in its ornament."[10] I think Ruskin has actually achieved something like this in his engravings, though "pale shadows" do not appear in Fig. II–3. But certainly Fig. II–2 with its bushy topnot does have some arbitrariness (if not corruption) and is "mixed" in the sense that moldings and foliage are crudely unintegrated. The imaginative man's window (Fig. II–3) is perhaps only oddly, where the first is tritely, designed. But I suppose the bugle-like bellflowers emerging from the sides of the outer frame, their lack of exact symmetrical correspondence, and the rustic concave pediment add up to imaginativeness, at least in this context. Surely the intellectual man's window (Fig. II–4) has a rigor and subordination of parts that suggest more of a mechanical or geometrical process than do the other two. Supporting brackets clearly declare themselves; the sense of a lintel-like structure in the upper part, of a relieving arch in the pediment, and even of imposts or cramps in the outer parts of the "ears" are all quite expressive.

Other features or traditions in villa design are equally personal in their associations. The tower bases in Italian villas, for example, have few or no windows because under "the ancient system of Italian life . . . every man's home had its dark, secret places, the abodes of his worst passions; whose shadows were alone intrusted with the motion of his thoughts."[11] There are even associational parameters in materials: brick houses can express their owners' vulgarity and disgustingness but not foolishness or foppery.[12]

In *Modern Painters I* (1843) Ruskin leaves behind some of this Loudonian influence, though there is still associationism of a sort. Thus his geological-meteorological analyses of Turner's pictures often constitute an almost Keatsian associationism; i.e., new works of art are created as poetic responses to existing

ones. And not only art but nature itself can beget in us detailed stories, articulating them in its geological strata and patterns of vegetation.[13]

After this more or less neutral transition, Part III of *Modern Painters II* (1846) returns to associationism, but now more in reaction against Alison than under Loudon's influence. Ruskin nevertheless builds on Alison's ideas, adding further to the moral and religious burden he had already begun to place upon them, and changing the names of the categories. Association proper becomes "Christian Theoria,"[14] individual or personal expression is "accidental association," and Alison's more general historical association—e.g., on the first prospect of Rome (see p. 11 above)—is now "rational association." Under Christian Theoria in turn are placed categories of the imagination, of which the highest is Imagination Associative, by which "images opposite or resemblant, or of whatever kind wanted, are called up quickly and in multitudes."[15] However, for Ruskin Alison's main shortcoming is not his terminology but the fact that his theory is amoral, "a mere operation of the senses."[16] With Ruskin the proper associational emotions are joy, admiration, and gratitude rather than tranquillity and melancholy.[17] The machine analogy is also abhorrent.[18] At any rate, Christian Theoria is not so much the perception of beauty as the redemption of the ugly. It "finds its food and the objects of its love everywhere, in what is harsh and fearful, as well as in what is kind, nay even in all that seems coarse and commonplace."[19]

It is, accordingly, in the conscience, rather than in the mind, that associations actually arise and that humble physical objects turn into poetic voices. A good conscience can turn all of nature "into one song of rejoicing, and all her lifeless creatures into a glad company, whereof the meanest shall be beautiful in her eyes." Conversely, the bad conscience can wither and quench nature's sympathy into "a fearful, withdrawn silence of condemnation, or into a crying out of her stones, and a shaking of her dust against us." In contrast to Alison's latent traces of a philosophy of ideal forms, with Christian Theoria the beautiful object can be anything so long as, through conscience, it is the center of an

[13] Ruskin is also associational in that he sees art as a language, i.e., as a way of expressing a subject matter divorced from the art itself (*ibid.*, 3:87–88); but he can also speak of works of art as *embodying*, rather than evoking, ideas, and this is of course un-Alisonian (*ibid.*, p. 92). Cf. also *Modern Painters II* (*ibid.*, 4:70–75) and, for this opinion of Lord Dudley's associationism, *ibid.*, 1:449–51.

[14] *Ibid.*, 4:50.

[15] *Ibid.*, p. 232.

[16] *Ibid.*, p. 35.

[17] *Ibid.*, p. 47.

[18] *Ibid.*, p. 67.

[19] *Ibid.*, p. 50.

II–2. Window for a man of feeling.
John Ruskin. 1837.
Ruskin, Poetry of Architecture.

II–3. Window for a man of imagination.
John Ruskin. 1837.
Ruskin, Poetry of Architecture.

[20] *Ibid.,* p. 73.
[21] *Ibid.,* p. 67.
[22] *Ibid.,* pp. 171–72.
[23] *Ibid.,* p. 50.

associational web—a web through which one "apprehends the great relations between the earth and its dead people."[20] Even more evident, perhaps, is that Ruskin seeks (not always successfully, as we shall see) to avoid the "sensualism" that Alison's ideas lead to, a sensualism which can so easily come from perceiving works of art emotionally. To call the beautiful the useful, he says, is to say admiration is hunger, love lust, and life sensation: "It is to assert that the human creature has no ideas and no feelings except those ultimately referable to its brutal appetites."[21] Yet Ruskin's concept of vital beauty, discussed in these very pages, does posit a living force that inhabits matter, a force that can be apprehended emotionally and that galvanizes objects with moral life, begetting reactions in the observer that can run from horror to love. So emotion per se is not objected to, only emotion that leads to "sensualism."

But after this lengthy preface—Alison *moralisé* as it were—Ruskin becomes pretty parsimonious with examples, especially architectural ones. He does, however, speak of landscape associations as they exhibit Nature's moral hierarchy: for instance, among plants Ruskin had not at first perceived any special beauty in the *Soldanella alpina* when he saw it "growing of magnificent size, on a sunny Alpine pasture." But, he adds, "some days after, I found it alone, among the rack of higher clouds, and the howling of the glacier winds, and . . . piercing through the edge of an avalanche. . . . The plant was poor and feeble, and seemingly exhausted with its efforts, but it was then that I . . . saw its noble function and order of glory among the constellations of the earth."[22] Ruskin also gives examples of heroic plants and beasts, even of heroic rocks. In general, even in humans the visual expression of a struggle against sin is more beautiful than any classic ideal.[23]

In his later book, *The Seven Lamps of Architecture* (1849), often connected with the advent of High Victorian Gothic, these Alisonian notes have a different timbre. In *Seven Lamps,* especially chapter 6, "The Lamp of Memory," Ruskin depicts architecture as a kind of storage monument for knowledge and admonition from the past. Buildings are eternal witnesses of passing human

affairs. Somewhat in the manner of Ledoux, they praise and condemn men's acts. But this happens only when they are very old, even ruinous:

it is in that golden stain of time, that we are to look for the real light, and colour, and preciousness of architecture; and it is not until a building has assumed this character, till it has been entrusted with the fame, and hallowed by the deeds of men, till its walls have been witnesses of suffering, and its pillars rise out of the shadows of death, that its existence, more lasting as it is than that of the natural objects of the world around it, can be gifted with even so much as these possess, of language and of life.[24]

Against this historical background details take on their specific meanings; even a line is beautiful in proportion to its richness of association, i.e., to the commonness of the natural objects it evokes.[25]

Ruskin also still speaks of architecture as having organic life, which occurs through variations like "the related proportions and provisions in the structure of organic form"; but this only means slight variations in the width of bays, etc., rather than genuine asymmetry.[26] As to color, meanwhile, he sees buildings as "organised creatures" in that color should never follow form.[27] Ruskin shows also how buildings can express emotions, e.g., mystery, pride, enthusiasm, and various kinds of admiration; there is even the expression of what he calls lusciousness.[28]

Associationism was further transformed in *Stones of Venice I* (1851) and *II* and *III* (1853). Ruskin's ideas on *architecture parlante* are maintained: the building is still admonitory, still a record of human activity, still a living creature. Thus he recommends "reading a building as we would read Milton or Dante, and getting the same kind of delight out of the stones as out of the stanzas."[29] Buildings in fact not only "talk" but "act," while churches, temples, and public edifices are "treated as books of history."[30] Some of these ideas still seem tenuously connected with Loudon, for example, the early chapters on foundations and walls. His treatment of dripstones, too, is similar to the discussion of chimneys in *The Poetry of Architecture*.

II–4. Window for a man of intellect.
John Ruskin. 1837.
Ruskin, Poetry of Architecture.

[24] *Ibid.,* 8:234.

[25] *Ibid.,* p. 139.

[26] *Ibid.,* p. 204. On p. 9 he says that symmetry in general is expressive of vulgarity and narrowness of mind. But see below, pp. 190ff.

[27] *Ibid.,* pp. 176–77.

[28] *Ibid.,* p. xxiii (from a diary of 1846–47).

[29] *Ibid.,* 10:206.

[30] *Ibid.,* 9:60.

II-5. *Moldings:* (left) *from the Fondaco de' Turchi;* (right) *from Vienne.* John Ruskin. 1851. *Ruskin,* Stones of Venice I, *1851.*

[31] See Cook and Wedderburn's introduction to *Stones of Venice II, ibid.,* 10:xlviii–xlix. The reviewer for the *Edinburgh Review* (94 [October 1851]:186–206) is characteristically conservative—i.e., more Loudonian, asserting that architecture can express only function.

[32] Ruskin, *Works,* 9:61.

[33] *Ibid.,* p. 44.

But such survivals are only minor notes in the great project that now occupies the center of Ruskin's intentions. This is nothing less than a sort of apotheosis of associationism: to "read" the architecture of a whole city as *the* record of its history of emotion, thought, and action, and through that to divine the principles of Gothic architecture as a whole. *The Stones of Venice* illustrates how in that city Byzantine and Gothic architecture were caused by, and expressed, a state of pure national faith and of domestic virtue, and how Renaissance architecture similarly was caused by, and expressed, national infidelity and domestic corruption.[31] Ruskin achieves his historiography, in other words, by contrasting passages of praise with passages of invective. The blackening of the Renaissance exalts the Gothic. The "stones" of the title are the stones that fall as Venetian civilization collapses, but they are also touchstones of the good and the bad in architecture, and in life.

In accordance with these principles, proper understanding comes only when the observer's mind has been implanted with Ruskin's lexicon of lost meanings:

It is not, therefore, possible to make expressional character any fair criterion of excellence in buildings, until we can fully place ourselves in the position of those to whom their expression was originally addressed, and until we are certain that we understand every symbol, and are capable of being touched by every association which its builders employed as letters of their language. I shall continually endeavour to put the reader into such sympathetic temper, when I ask for his judgment of a building; and in every work I may bring before him I shall point out, as far as I am able, whatever is peculiar in its expression.[32]

As the ecclesiologists had done in 1843 (see p. 44 below), Ruskin discerns special decadence in all forms of Late Gothic. Also, like the ecclesiologists, "this corruption of all architecture, especially ecclesiastical, corresponded with, and marked the state of religion over all Europe,—the peculiar degradation of the Romanist superstition, and of public morality in consequence, which brought about the Reformation."[33]

The best Gothic can be analyzed into Ruskin's well-known catalogue: savageness, changefulness, naturalism, grotesqueness, rigidity, and redundance. What has not perhaps been sufficiently noted is that these architectural characteristics are given as the inevitable manifestations of the builders' mentality (which, by the way, included qualities of mind not always thought desirable, e.g., rudeness, obstinacy, and "disturbed imagination").[34] Not only are these characteristics at times uncivilized, they are also divorced from beauty. Here Ruskin parts company with Alison and Loudon, maintaining that expression is not a part of beauty at all, that a building's "conversation" is quite distinct from its good looks.[35]

As might be expected, *The Stones of Venice* shows a number of specific ways in which details denote historical facts. For example, the moldings of the tomb of Marco Giustiniani in SS. Giovanni e Paolo show Christianity, with its naturalism, struggling with the classical formalism of the papacy ("the Papacy being entirely heathen in all its principles"). Ruskin goes on: "That officialism of the leaves and their ribs means Apostolic succession, and I don't know how much more, and is already preparing for the transition to the old Heathenism again, and the Renaissance." The bases in Fig. II–5 demonstrate the transition from temperance to luxury. One sees this in II–5 (*left*), where there is more of a balance between indentations and swellings and where the latter are crisper and less bloated than in II–5 (*right*). (This diagnosis again suggests that Ruskin saw the moldings as organs or fatty tissue.) In Fig. II–6 we move from formalism (*top*) to vitality, the latter being equated with Protestantism with a slight touch of Dissent, for it has falling leaves but nonetheless true life—"The forms all broken through, and sent Heaven knows where, but the root held fast." Also, there is continence in certain border lines, unity in the root, and simplicity in the great profile.[36] More generally, the grouped shafts of Christendom express the "distinct services of the individual soul," while the single shafts of ancient Egypt, for instance, stand for "the servitude of the multitudes."[37]

II–6. *Moldings:* (top) *"Fully Developed Venetian Gothic"; (bottom) "Perfect Lombard Gothic." John Ruskin. 1851.* Ruskin, Stones of Venice I.

[34] *Ibid.,* 10:184.

[35] *Ibid.,* 9:60–61, 256–57.

[36] *Ibid.,* pp. 369–72.

[37] *Ibid.,* p. 129.

But all these detailed expressions are only functions of a more essential expression, that of natural landscape:

The proudest architecture that man can build has no higher honour than to bear the image and recall the memory of that grass of the field which is, at once, the type and support of his existence; the goodly building is then most glorious when it is sculptured into the likeness of the leaves of Paradise; and the great Gothic spirit, as we showed it to be noble in its disquietude, is also noble in its hold of nature; it is, indeed, like the dove of Noah, in that she found no rest upon the face of the waters,—but like her in this also, "Lo in her mouth was an olive branch, plucked off."[38]

Such expression is very much more forceful, as it is more detailed and affective, than the more abstract sort linked to Gothic by earlier writers. In line with his organic beliefs, Ruskin even denies some of these earlier associations, for example, the idea that vertical forms express aspiration or refer to Heaven. Rather, he says, verticality expresses animal life, while southern Gothic with its horizontality equals languor and ease. The two styles also echo northern and southern trees: the fir, and "the broad table of the stone pine."[39]

In this way landscape constitutes an inner vision in any good building. Even the stones in a structure must be seen as being still on their original hillside: "To see what gifts Nature will give us, and with what imagery she will fill our thoughts, that the stones we have ranged in rude order may now be touched with life; nor lose forever, in their hewn nakedness, the voices they had of old, when the valley streamlet eddied round them in palpitating light, and the winds of the hill-side shook over them the shadows of the fern."[40] Similarly, good ornament is not the sculpture of man-made things but God's—not heraldry or orders but abstract lines, as from glaciers, or forms from earth (e.g., crystals), from water, fire, or air, and organic forms such as shells, fish, reptiles, insects, vegetation, birds, and mammals (the list being in ascending order of value).[41]

All of this leads Ruskin to claim that figure sculpture is the greatest form of architectural ornament. However, he also believes that a building can be

[38] *Ibid.*, 10:239.
[39] *Ibid.*, 9:186–87.
[40] *Ibid.*, p. 252.
[41] *Ibid.*, pp. 265–66.

organic in other ways. Since, as noted, it is an "organised creature," a wall "ought to have members in its make, and purposes in its existence . . . and to answer its ends in a living and energetic way." Ruskin even plays with the idea of a "living wall" like that in the Pyramus and Thisbe episode in *Midsummer Night's Dream*.[42] To achieve such living walls he several times suggests imitating the layers of geological formations, utilizing stones of different textures and colors. The "associations and analogies" connected with these can refer to "the growth or age of the wall, like the rings in the wood of a tree; then they are a farther symbol of the alternation of light and darkness, which was above noted as the source of the charm of many inferior mouldings: again, they are valuable as an expression of horizontal space to the imagination, space of which the conception is opposed, and gives more effect by its opposition, to the enclosing power of the wall itself."[43] Elsewhere wall stripes are "epochs in the wall's existence," like the rest periods in human life; or they can, with more Loudonian practicality, express the division into stories within, or else the building's internal structure.[44]

Not only stripes but spikes give the feel of life and action to a building. "Foreign builders," says Ruskin, had "a peculiar feeling in this, and gave animation to the whole roof by the fringe of its back, and the spike on its forehead, so that all goes together, like the dorsal fins and spines of a fish."[45] Indeed, as the building thus reveals its organized creatureliness, we can understand Ruskin's term "veil" as opposed to "body" for the upright part of a wall,[46] while the inner armature is seen as a skeleton or even an organic frame with exterior parts, e.g., finials. This frame, it is occasionally implied, may seem to move or act. The best of Venice's buildings have the fewest crockets and finials, "and her ecclesiastical architecture may be classed, with fearless accuracy, as better or worse in proportion to the diminution or expansion of the crocket."[47] The idea of a kinetic membrane is also implied when Ruskin remarks that Gothic has no formulas for composition: "It can shrink into a turret, expand into a hall, coil into a staircase, or spring into a spire, with undegraded grace and unexhausted energy . . . subtle

[42] *Ibid.*, p. 79.

[43] *Ibid.*, p. 347. In the Alps, says Ruskin, "string courses" of quartz and shale exist, so that Nature herself has architectural polychrome.

[44] *Ibid.*, p. 81.

[45] *Ibid.*, p. 403.

[46] *Ibid.*, p. 80.

[47] *Ibid.*, p. 404.

and flexible like a fiery serpent, but ever attentive to the voice of the charmer."[48] Thus for Ruskin the quality of changefulness (which he is discussing here) can mean the sense of growth and potential movement not only in the frame but throughout the fabric of the building, or through a series of buildings. Historical change is implicitly a kind of gesturing and growth.

Stones of Venice III (1853) is rather less associational. Or, to put it differently, as Ruskin follows Venice into its decay the varied expression he has earlier discerned is limited to the single meaning of ugliness and evil. This outcome will be discussed at the end of the present chapter; here it is enough to say that architectural associationism did not by any means disappear from Ruskin's pages. Thus in a manuscript fragment of the late fifties he asks of architecture: "Does it tell us what it is good for us to know, and make us feel what it is good for us to feel?"[49] As we shall see, High Victorian Gothic was not created specifically to fulfill such precepts. But Ruskin did provide its general associational climate.[50]

Other Writers: Wightwick, Lamb, White, Street

Four lesser writers exemplify other aspects of Victorian associationism. George Wightwick's *Palace of Architecture* (1840) is a history of architecture in the form of a prose romance.[51] A garden of buildings is described, containing examples of each architectural style. The parallels with Hadrian's villa or, better still, Gogol's *Architecture of Our Time* (1831) are obvious.[52] But with Wightwick the logic that knits the buildings together is associationism. Association can even supply beauty where form fails, says Wightwick, while various kinds of poetic feedback increase the artistic total:

We should . . . always be most willing to avail ourselves of scenic aid, and of those associations which history, legend, and song, may supply: but, if the comparatively unimposing and less beautiful in Architecture, may, by such means, be promoted in the rank of our affections (acquiring, from *accident*, an adventitious grandeur and inter-

[48] *Ibid.*, 10:212.

[49] *Ibid.*, 16:xxxii, n. 1.

[50] One other point that should be cleared up before leaving Ruskin's associationism is his concept of the pathetic fallacy. I have shown that Ruskin perceived "creatureliness" in buildings, yet this famous critical dictum says it is wrong to attribute feelings to inanimate things in such a way as to effect a wrong impression (*Works*, 5:204–20). But in citing this fallacy later authors have sometimes forgotten the essential modification: it is only the *wrong* kind of emotions that objects may not be said to feel. The pathetic fallacy actually reinforces Ruskin's organic-creaturely perceptions by emphasizing the need for consistency in an object's emotional content.

[51] *The Palace of Architecture: A Romance of Art and History.* For this architect see his autobiography, "The Life of an Architect," in *Bentley's Miscellany* 31 (1852):326–30 and in innumerable installments through vol. 43 (1858).

[52] Nikolai Gogol, *Sämtliche Werke*, ed. Otto Buck (Berlin: 1923), 2:315–39, esp. pp. 325–26.

est), how augmented is the charm, when the worth and quality of these advantages are matched in the perfection and majesty of the temple possessing them; when the pride of the Athenian Acropolis itself is rebuked by the superior stateliness of the temples which crown it; when the lingering blaze of departed genius and greatness gilds the aspiring vaults of a Westminster Abbey; or when the radiance of Scottish poetry lights up the arcades of a Melrose! . . . But, the buildings we have just alluded to, require no positive aid from landscape or legend, nor ennoblement from the King of day or the Queen of night; that is, they are dependent on no such accessories in the estimation of those, who, by education, are competent to appreciate their merely intrinsic beauty. A spectator of this happy class, when contemplating a noble piece of Architecture, becomes *his own poet*: unites himself with it in the bond of a perfect reciprocity; elevates it on the "vantage hill" of his own imagination; and there beholds it with all the rapture of an eager recipient. Stimulated by the abstract associations connecting it with the distinguished character of the age of which it remains to speak, he has already a sufficient theme for his fancy, which involuntarily acts the magician, till the very Genius of the temple rises before him.[53]

Wightwick prepares the reader for his garden tour with a triumphal gate (Fig. II–7) combining features from every important style and constituting a summary of all that lies within:

It symbolizes MUSEUM. It is a prologue, spoken by Retrospection. Like the brain of *Touchstone*, it is "crammed with observation, the which it vents in mangled forms." It is the "returned traveller," the "picked man of countries." Having studiously followed the windings of the templed walks to which it leads, you will return, competent to read the significant details of what, now, only *vaguely* addresses your understanding.[54]

Wightwick's book, couched as it is in the genre of the romance, is more ambitious than most books about architecture. Indeed, it rivals Ledoux in its poetic opulence. But beyond this the gate itself, as it compresses the history and beauty of all architecture, is a train of associations. With Wightwick in 1840, therefore, we make a crucial transition: up to now a building's associations had been literary, historical, or personal responses that completed an artistic transaction.

[53] *Palace of Architecture*, p. 13.

[54] *Ibid.*, p. 7. Wightwick of course means Jaques, not Touchstone.

II–7. Museum gate. George Wightwick. 1840.
Wightwick, Palace of Architecture, *1840.*

Now, with Wightwick, one work of architecture can constitute such a "reading" of another. A building can be an encyclopedia of other buildings. The "creatures" discourse not only with human observers but with each other; their messages are responded to by other messages. To put it in Alisonian terms, a new building can designate a series of older structures, hitherto unrelated, as its train of associations.

Though Wightwick quite readily admits that the gate's design "is only justified by the very peculiar circumstances of the case,"[55] these circumstances are similiar to those of High Victorian Gothic, for Wightwick's eclecticism is undertaken in the name of universality and can be understood only by an observer who has been trained to look at it. The gate even bears certain visual resemblances to the later style. It is, to be sure, unlike High Victorian Gothic in being symmetrical, while its prototype is ambiguous—it could be either a Late Antique city gate or an early medieval one. Still, the manner in which the juxtaposition takes place, the painful abruptness and absence of fluency, the "venting of observation in mangled forms," the use of primitive ornaments such as zigzags, bundled reeds, and the like, even the brutality of the engraving itself, and above all its presentation of the history of architecture from the cave fragment on the lower right across to the Mycenaean, Egyptian, Romanesque, and Gothic, and the simultaneous upward growth from this stratum, through a transitional attic, into three towers, one Oriental, one classical, and one medieval—these things all directly adumbrate High Victorian Gothic.

In 1850 Wightwick wrote an article that carried some of these ideas further, adding to them Ruskin's conception of the building as an "organised creature." However, in this case the creature is capable of verbal expression. "The connexion," says Wightwick, "of the constructive, with the exhibitory, features of a fine building is not less intimate than that, which exists between the mechanical perfection of the skeleton and the 'form divine,' of the complete man." Indeed, a building is a body or "carcase," lettered over "with beauty of diction, with poetic illustration, and with the charms of rhetoric. . . . —What the skin is to the body, the hair to the head, the eye-brows and lashes to the eyes, and the lips to the mouth,—such is the marble casing to the walls, the cornice to the facade, the pediment and architrave to the windows, and the porch to the door."[56]

Next we turn to E. B. Lamb. In 1843 he called on architects to reread Loudon's "Principles of Criticism in Architecture" in the *Encyclopaedia*. Three

[55] *Ibid.*

[56] Wightwick, "The Principles and Practice of Architectural Design" (Essay 7, 1850), in *Detached Essays of the Architectural Publication Society* (London 1853), esp. pp. 1–2.

years later he himself developed Loudon's favorite theme, which might be called the "automatic functional Picturesque":

The means at the command of the architect, when required to produce a picturesque edifice, are generally of such a nature that the mere convenient arrangement of plan will give him an outline in itself pleasing, without the least aid from ornamental accessories. [Domestic offices,] conveniently arranged, form powerful adjuncts in the picturesque, assisting, as they do, by their subordinate size and character, to connect the building with the adjoining scenery and surrounding landscape; by which the expression of habitableness, comfort, and security, is greatly enhanced. . . . By their size and importance, and the situation and decoration of the windows and doors, the principal rooms will sufficiently indicate their uses; and the greater elevation of a portion of the house is in itself a mark of its purpose, while the offices and other subordinate parts are kept low and with a less degree of ornament. . . . Again, the various heights of the roofs showing the different degrees of purpose, the combinations of chimney shafts, some in groups, some single, produce in the whole such a *necessary* variety of form, that with little assistance from the architect a picturesque composition is attained.[57]

The passage exhibits the movement of Loudon's ideas toward the High Victorian Gothic.

Like Lamb, William White was also a relatively workaday associationist. In October 1851 he published a paper, "Upon Some of the Causes and Points of Failure in Modern Design,"[58] which emphasized volumes and silhouettes as expressive features. Indeed White feels that roof planes should be the principal form of expression, and he is hostile to that cliché of Early Victorian domestic design, the tall, shaped chimney. Accordingly, room size and function should be proclaimed on the exterior not only with special windows (as with Loudon) but with separate roofs. This, with the elimination of the massive verticals provided by the earlier type of chimney, produces, in White's examples (Figs. II–8-II–9), elaborated polyhedral volumes that are thoroughly High Victorian Gothic. Indeed, the cottage in Fig. II–9 could be by G. E. Street. Hall, living room, hearth,

[57] *Studies in Ancient Domestic Architecture, Principally Selected from Original Drawings in the Collection of the Late Sir William Burrell, Bart*, pp. 12–13.

[58] *Ecclesiologist* 12 (1851):305–13. At this first reference to this publication, I should mention that it is a bibliographical nightmare. Nos. 1–36 were published from November 1841 through September 1844 and are differently bound in different libraries. It was continued in a new series, nos. 1–12 (January 1845–June 1846), and then again continued as nos. 49–189 (July 1846–December 1868). More confusing still, some early numbers appeared in second editions, with changed pagination. I have not attempted to collate the variations. For William White's other writings see Paul Thompson, "The Writings of William White," in Summerson, ed., *Concerning Architecture*, pp. 226–37.

major and minor bedrooms, and kitchen areas are for the most part clearly proclaimed, as in Early Victorian houses (e.g., Fig. I–9). But the chimneys are lower and thinner, and the fenestration is more irregular—i.e., more "expressive." At the same time the massing is more unified, there being much less segmented blockiness. The lower building in Fig. II–8 reveals even more volumetric differentiation for expressive purposes—i.e., more rooms are given separate roofs, but still the roof as a whole is continuous, as is not the case in Fig. I–9.

With White, indeed, functions invariably demand hierarchies of volume. In schoolhouses, for example, the master's dwelling must be sculpturally separate from the classroom, while the latter must receive a higher outline and more generous fenestration. White also warns against placing "a boys' and a girls' school-room of like form and equal size at right angles to each other with intersecting roofs," though he does not say why.[59] At any rate, it is the structure's outer topology that plays the main expressive role.

White's concern with volume differentiation led him to criticize the Houses of Parliament. Westminster Palace ought to have expressed the different bodies that meet there—Lords, Commons, and Convocation—in three differentiated volumes, while the committee rooms should have appeared as a fourth volume, equally distinct, in the form of a low (i.e., subservient) layer.[60]

White continued his theorizing in the later 1850s and in the 1860s. In 1856 he discussed windows as means of "prospect" and alternatively for the control of light, providing semiscientific analyses of different lighting conditions for different occupations and psychological states.[61] These comments occurred in a more or less Loudonian context, as did his discussion in the *Building News* in 1860, which makes it clear that White's theory was Common Sense both in the Scottish and the everyday meaning of that term.[62]

White's most interesting midcentury article appeared in 1861. It does much to explain some of the presuppositions about polychrome that members of the ecclesiological circle were capable of making. Particularly noteworthy is his repeated stress on the "unconscious influence" of color on the mind, an influence

II–8. Examples of architectural expression. William White. 1851. Ecclesiologist, 1851.

[59] "Causes of Failure," p. 311.

[60] *Ibid.*

[61] "On Windows," *Ecclesiologist* 17 (1856): 319–32.

[62] *Building News* 6 (1860):132–35.

that carries over from childhood and that is especially apparent, among adults, in the poor and criminal classes. White claims that our nerves are physiologically manipulated in predictable ways by color: for example, red excites while yellow draws the eye like light. Red is also the best color for "healthy action" in gloomy surroundings, while white is bad for the spirits and is to be discouraged in hospitals and jails. The desirable amounts of light are discussed: reposeful attention, for example, is best achieved in "moderate darkness."[63]

White's emphasis on functional expression through volumes rather than façade details is reflected in the architecture of other High Victorian Goths beside himself and in fact constitutes one of the main characteristics of the style. White extends or supplements Alison's machine parallel, but in a way that even approaches Le Corbusier's concept of a machine for living. From the references to color we can easily construct the typical High Victorian Gothic ecclesiastical interior. Even White's discussion of color's "unconscious influence" prefigures associational psychology after it had been taken over by Otto Selz and other forerunners of psychoanalysis.[64]

More important than Wightwick, Lamb, or White, both as writer and architect, was George Edmund Street.[65] In 1853 Street published a pamphlet, *An Urgent Plea for the Revival of True Principles of Architecture in the Public Buildings of the University of Oxford.* This is probably a bid on the author's part for the Science Museum commission, but beyond this (and despite the Puginian title) the booklet is an associational argument for a familiar end: the revival of Early and Middle Pointed in the university. For Street, these styles were more conducive to volumetric functional expression than Late Gothic with its regular, repetitive bays.[66] In this context the Ashmolean's classical regularities are even more objectionable: "I have but to turn to the Taylor Building to shew that in order to preserve uniformity in design, costly windows are built but to be blocked up, and a portico built never to be used; more than this, that from the exterior it is difficult if not impossible to obtain an idea of what the interior arrangement is, or what may be the object of the building."[67] Street also quotes

[63] "A Plea for Polychromy," *Building News* 7 (1861):50–55. White also had ideas on geometrical proportions in Gothic, which are explained with diagrams in "Some Principles of Design in Churches," *Transactions of the Exeter Diocesan Architectural Society* 4 (1850–53):176–80 (read May 8, 1851), and in "Modern Design—Neglect of the Science of Architecture," *Ecclesiologist* 14 (1853):313–30.

[64] See Mandler and Mandler, *Thinking: From Association to Gestalt,* for a review of this later associationism.

[65] For Street see *D.N.B.*, s.v.; A. E. Street, *Memoir of George Edmund Street, R. A., 1824–1881*; G. E. Street, *Unpublished Notes and Reprinted Papers*; H.-R. Hitchcock, "G. E. Street in the 1850s"; and Basil F. L. Clarke and John Piper, "Street's Yorkshire Churches and Contemporary Criticism," in Summerson, ed., *Concerning Architecture*, pp. 209–25.

[66] *An Urgent Plea for the Revival of True Principles of Architecture in the Public Buildings of the University of Oxford*, pp. 9–10.

[67] *Ibid.*, pp. 3–4.

Ruskin on architecture's duty to "tell us about nature," with the implication that the Museum should be a kind of statue of the banished countryside. (Indeed here and elsewhere Street is capable of a workmanlike imitation of Ruskin's prose.[68])

In 1855 Street's first major architectural treatise appeared, *Brick and Marble in the Middle Ages.* In this he repeats the sort of criticism he had made of the Ashmolean; for example, he comments unfavorably on the Church of Sant' Agata, Cremona, whose façade "tells its story so well, that at first we all mistook it for a theatre! So much for classic symbolism!"[69]

But Street's forte turned out to be more technological than aesthetic. His analyses stress constructional associations. For example, in the east end of the Broletto at Como, one of the *bifore* has two of its shafts knotted together (to illustrate which I borrow one of Ruskin's lithographs of 1851 [Fig. II–10]):

It takes much labour and skill to cut several shafts out of one block of marble, but all this labour and skill is unthought of, if they are entirely separated, or held together by a band which might perchance be made of some other material; this knot therefore is devised as the only means of explaining to us that the shafts so carved have really been accomplished with a very great expenditure of time and patience and skill.[70]

Again, speaking of what he calls "constructional" (i.e., Venice) vs. "incrusting" (Bergamo, Cremona, Como) schools of polychrome in northern Italy, Street says: "It might almost be said that one mode was devised with a view to concealment, and the other with a view to the explanation, of the real mode of construction."[71]

Color can contribute substantially to the lessons embodied in structure. In the past, the different hues of mixed minerals and glass "should have enabled the educated eye to revel in bright tints of Nature's own formation, whilst to the uneducated eye they would have afforded the best of all possible lessons, and by familiarizing it with, would have enabled it to appreciate, the proper combination of colour and form."[72] Here is another use of Ruskin's notion of the

II–9. A further example of architectural expression. William White. 1851. Ecclesiologist, 1851.

[68] For instance, *ibid.,* p. 17.

[69] *Brick and Marble in the Middle Ages: Notes of a Tour in the North of Italy,* pp. 200–201.

[70] *Ibid.,* pp. 233–34. Ruskin in *Stones of Venice I* (*Works,* 9: pl. 5, opp. p. 174) had illustrated this window as the perfect type of uncusped Gothic arch.

[71] *Brick and Marble,* p. 279.

[72] *Ibid.,* pp. 284–85.

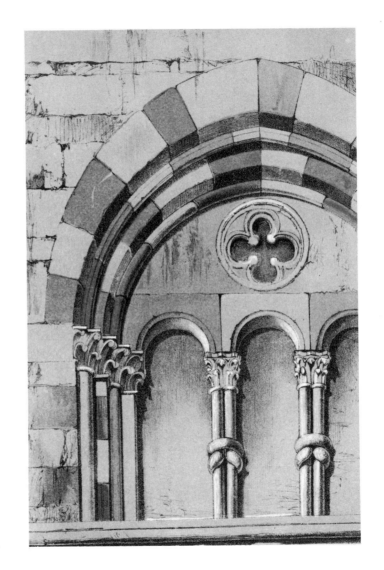

II–10. Window from the Broletto, Como.
John Ruskin. 1851. Ruskin, Stones of Venice I.

urban building as a statue of rural Nature. Street continued to express these ideas throughout his life, and they reappear in his Royal Academy lectures of 1881: "The construction of the exterior," he says, "should, as far as possible, show the arrangement of the interior, and you ought at once to know something about the positions of the floors, the shape of the roofs, and the sizes and uses of the principal rooms, merely by examining the exterior of the building."[73] In these ways did Street remain both truly a High Victorian Goth and truly an heir of Loudon.

Biological Progress

Street's theories will serve to introduce Gothic in what for our purposes is its main role, as the basis for a new universal style. The idea was of course parallel to, or perhaps partly derived from, historical associationism; and it had much to do with the creaturely perceptions I have discussed. But it was also a local English version of the European notion of organic art, a notion that not merely an individual work of art, but the whole of art history as well, was like an organism. And if art history was creature-like, its past evolution could be known and its future not only foretold but manipulated.[74]

Generally speaking, the architecture that most recommended itself to the Victorians for this purpose was Gothic. Gothic was anonymous and had taken root differently in different countries. It seemed an inevitable expression of a people's art instinct, to use Carl Schnaase's term, and of faith. Thus for Schimmelpenninck Gothic, as opposed to Grecian, was *the* organic style. It was progressive, vertical, arched, filled with light, possessed of multiplying parts, adapted to use, and based on "a principle of vitality within."[75]

The ecclesiologists not only believed that Gothic was organic but anticipated Ruskin in saying that in its growth it had expressed the rise and fall of the societies that had produced it. In the introduction to their translation of book 1 of Durandus's *Rationale divinorum officiorum* (1843), the Norman style is seen to

[73] Quoted in A. E. Street, *Memoir*, pp. 337–38. However by this time Street was enough of a classicist to quote Alberti and Wotton (*ibid.*, pp. 338, 340). His best-known work, moreover, *Some Account of Gothic Architecture in Spain* (London, 1865), contains very little associationism, though it is notable for the high standards of its archaeology.

[74] The idea was not new, and had existed in the writings of Goethe, Sulpiz Boisserée, and the Schlegels. In the introduction to his *Geschichte der bildende Künst* (1:ix–x) Carl Schnaase says that works of art are created by the "interpenetration" of the art sense with the other elements of society. He makes "art sense" a kind of biological instinct working in an environment. The suggestion is that these things can be controlled, and even that, in the future, new styles will be bred. For ideas on organic progress outside the arts see J. B. Bury, *The Idea of Progress: An Inquiry into Its Origin and Growth*; for recent views on the phenomenon in architecture, see L. Grote, ed., *Historismus und bildende Kunst*. Peter Collins discusses the same thing more briefly in *Changing Ideals in Modern Architecture*, pp. 29–41, 149–58. These German ideas would have been brought into England in such translations as Georg Moller's *Essay on the Origin and Progress of Gothic Architecture* and Franz Kugler's *Handbook of Art History*, which was abstracted, e.g., in the *British Quarterly* in the late 1840s. See also Paul Frankl, *The Gothic:*

Literary Sources and Interpretations through Eight Centuries, pp. 541–42.

75 *Principles of Beauty*, pp. 386–98. Street also felt that Gothic, notably English Gothic, had this inner growth logic (*Notes and Papers*, pp. 318–19). Indeed, even classicists like James Fergusson seemed to feel that this was true and that, conversely, with the Renaissance the basically dead "copying or imitative styles" began (*A History of Architecture in All Countries, from the Earliest Times to the Present Day*, 1:ix–x). With more brio Ruskin writes in *Stones of Venice II*: "the following year [1421], on the 27th of March, the first hammer was lifted up against the old palace of Ziani. That hammer stroke was the first act of the period called the 'Renaissance.' It was the knell of the architecture of Venice,—and of Venice herself" (*Works*, 10:352).

76 Gulielmus Durandus of Mende, *The Symbolism of Churches and Church Ornaments*, intro. and trans. John Mason Neale and Benjamin Webb, pp. cxix–cxx.

77 *Ibid.*, p. cxiii.

78 *Ibid.*, p. cxxiv.

79 *Ibid.*, p. cxxv. See also Ruskin's vision of architecture transforming its style in poetic reaction to the changes of history in *Stones of Venice II* (*Works*, 10:238).

be simple and factual, like Norman religion. It is based on the fundamental tenets of the Christian faith, it expresses the victory of the English Church over paganism, and, in fact, "excepting the doctrine of the Holy Trinity . . . we shall find [in Norman] almost exclusive reference to history." It is called "the style of facts" as opposed to later styles of the imagination.[76] Decorated, or Middle Pointed, as the ecclesiologists called it, while more allegorical, is still an expression of events. Its first appearance was caused by the Church's victory over Erastianism in the martyrdom of Thomas à Becket and by the abrogation of the Constitutions of Clarendon. But Decorated ultimately began to show the first signs of that illness, the Renaissance, which would pour forth from Italy. In a way that anticipates *Stones of Venice* Neale and Webb wrote: "We cannot but consider, that [about 1300] or a few years later, it took a wrong turn, and being hurried in a short space through the hectick of a flush of rare beauty, declined thenceforward slowly but surely." The reason for this was the Statute of Mortmain–i.e., the decay of Middle Pointed into Perpendicular was a symptom of increasing interference with the Church by the state:[77] "Now could there be a more fitting expression of this than the Perpendicular style? Does not its stiffness, its failure in harmony, its want of power and adaptation, its continual introduction of heraldry, its monotony, its breaking up by hard continued lines, its shallowness, its meretriciousness, its display" show this?[78] The same thing is true in France. The state sustained the Church but "made its observances meaningless, while sustaining their splendour . . . gave it outside show, while eating out its heart. Does not Flamboyant express this? A vast collection of elegant forms, meaninglessly strung together."[79]

In the same vein, in 1851, the Reverend Thomas James reported to the Architectural Society of the Archdeaconry of Northampton that "nothing so distinctly expresses the character and genius of a nation [as its architecture]. Stern or frivolous, true or hollow-hearted, devoted to religion or to commerce, the ruling passion of a people is stamped on its Architecture; and buildings will often give the true portrait of an age (unconsciously, indeed, and therefore

more faithfully), when historians flatter, and monuments lie, and records fail."[80]

To show how widespread this notion was—especially the sense of architecture as a sort of creaturely message—I will cite an American example from a novel of this same year, 1851. In *The House of the Seven Gables* Hawthorne thus describes the building of the title:

As for the old structure of our story, its white-oak frame, and its boards, shingles, and crumbling plaster, and even the huge clustered chimney in the midst, seemed to constitute only the meanest part of its reality. So much of mankind's varied experience had passed there,—so much had been suffered, and something, too, enjoyed,—that the very timbers were oozy, as with the moisture of a heart. It was itself like a great human heart, with a life of its own, and full of rich and sombre reminiscences.[81]

Similar ideas never actually died out in the Victorian period; as late as the 1880s Street was calling architecture, when "read" by the connoisseur, "the most permanent and intelligible" of the visible records of the past.[82]

With such interpretations all architectural styles can mean something, since they all express truths about the societies that brought them about. This, with the increased eclecticism the Victorians were now permitting themselves, led to the concept of a universal architectural language built around a Gothic core. In 1852 John P. Seddon published *Progress in Art and Architecture with Precedents for Ornament*, which limited itself to Gothic, for the most part, but made that style the expression of an ancient tendency toward artistic progress. In this Seddon was followed by Owen Jones, who four years later published his more famous, more lavish *Grammar of Ornament*, a similar attempt to find, as the author remarks in the Preface, coherent "general laws" of ornament.[83] However, Jones did not place his "languages" all under the heading of Gothic, nor did he talk about artistic progress (though his chapter on primitive ornament contains notions similar to those that, years later, Adolf Loos would express in his famous article on ornament and crime). But Jones's universality is more truly universal than the selective eclecticism of the ecclesiologists; for Jones there was a parlia-

[80] *Ecclesiologist* 12 (1851):407–8.

[81] (London, 1925), p. 23.

[82] Quoted by A. E. Street, *Memoir*, p. 320 (Royal Academy Lectures, 1881). See also George Gilbert Scott, *Remarks on Secular and Domestic Architecture, Present and Future.*

[83] *The Grammar of Ornament*, p. 1.

ment of styles, while for the ecclesiologists Gothic was more of a divine right monarch.

To return to Street, he, like Seddon, wanted a "Modern Gothic" which would expand eclectically out of the revived old Gothic, but he preferred Italian to English as the model. The reason was that Italian Gothic had addressed itself to an artistic situation similar to that of Victorian England. Italian Gothic was *already* eclectic; that is, it was an unbeautiful but neutral matrix onto which a great variety of detail from alien styles had been grafted.[84] On the basis of this model the "true principles" of other Gothic architectures were quietly to be incorporated; eventually even classicism could be brought in:

As classic and pointed architecture had proceeded on two entirely different principles, neither of them in any way identical, but each in some respect true, so we were well entitled, if we chose, to gather from each that which was best in principle, and in our work to combine them,—not in the production of a hybrid and mixed style of architecture, but only in the development of our application of those true principles of construction, of which the architects of the pointed style were the first to acknowledge the necessity, and the first to introduce. . . . It is in this respect that Italian pointed architecture is of so much value, as showing—sometimes, it is true, in too decided a manner—how this combination of much of the distinctive character of classic and Gothic architecture may be united and harmonised.[85]

Elsewhere Street suggests that the medieval Italians' union of classicism with Gothicism may have been unconscious. But whatever the case, they had succeeded in bringing together the structural virtuosity, the "progressiveness" of Gothic, with its efficient pointed arch and ribbed construction, and the serene conservatism of the Roman.[86]

Polychrome, already given as an example of associations with nature, at the same time constituted a second universalizing factor, after eclecticism. It was Italian, but was related to the polychrome of Germany and even England—for instance, that executed "by our own forefathers in the coursing of flintwork with stone, or in the counter-charging of red and white stones which we see in some of the Northamptonshire churches."[87]

[84] A. E. Street, *Memoir*, p. 387; G. E. Street, *Brick and Marble*, p. 256. There was already plenty of published information on Italian medieval architecture, e.g., the accounts of Cadell, Castellan, Willis, and Thomas Hope, listed in my Bibliography. In the 1840s the *Builder* published illustrations of Italian details, for example the Sicilian ones in vol. 4 (1846): 462, 606, 618. Even Pugin, though it is not generally remarked, praised Italian architecture by implication, since he included the Sistine Chapel screen in his *Treatise on Chancel Screens* of 1851. According to Robert Kerr, he had also admired northern European Gothic in 1847 ("On the Life of Welby Pugin," *Builder* 20 [1862]:366). Lord Lindsay, in his *Sketches of the History of Christian Art*, 2: 1–40, describes Italian Romanesque and Gothic very favorably, but without illustrations, and G. G. Scott knew Venetian Gothic in 1851 (*Personal and Professional Recollections*, pp. 157–59).

[85] G. E. Street, *Brick and Marble*, pp. 267–68.

[86] *Ibid.*, p. 263. In *ibid.*, p. 254, Street suggests that the "completeness" of English Gothic, as opposed to Italian, may be traced to the lack of an older competing mode in England, whereas in Italy there were magnificent Roman remains.

[87] *Ibid.*, p. 283.

Street mentions, as another technological improvement among the Italians, that type of Florentine arch whose intrados is semicircular but which has a pointed, equilateral-arched extrados. This not only *appears* to be strong but actually *is* "the strongest possible form of arch."[88] One might suggest too that its juxtaposition of the two main motifs of classical and Gothic made it a talisman of the new universalism. In any case it was precisely polychrome, plus this type of arch, that became the principal clichés of High Victorian Gothic (Fig. II–10).

Street was extreme in his eclecticism,[89] but not as extreme as A. J. B. Beresford-Hope, president of the Ecclesiological Society. When are we to stop eclecting, the latter asked in 1858: "I answer, I will stop where common sense tells me to stop. When I can no longer assimilate I will cease to absorb: I will absorb nothing which common sense forbids, but I will go on till common sense interposes a check. . . . I would even rifle the treasure houses of Classic art, and carry off the spoil of Renaissant." In the same pamphlet he even suggests that Byzantine and Saracenic can be brought under control.[90] Subsequently Hope made this process of continual assimilation an imperative—"progression by eclecticism."[91] This would create in Modern Gothic a superstyle for the Empire and the world. Many later writers, such as Hugh Stannus, also looked forward to a time when "all the buildings of a civilized country would be constructed in the same [eclectic] style as the law of progress had altered it,"[92] and in 1858 the *Building News* referred to purism pejoratively as "architectural unitarianism."[93]

Nonetheless, this universal eclectic style was still Gothic, or at least medieval. For many, Gothic was really a habit of interpretation, i.e., an assemblage of associations quite divorced from particular forms. In 1862 William Burges had urged his friends to visit the Japanese court at the Exhibition, where the real Middle Ages, he said, was to be found.[94] And at the end of our period, in 1889, William Morris gave a lecture called "Gothic Architecture" which included the Palace of Diocletian at Split, the early phase of Byzantine, and Norman, all as variations of Gothic.[95] Fifty years after Wightwick, the eclectic gate, conceived as expressing the union of different styles, could very nearly be taken to repre-

[88] *Ibid.*, p. 276.

[89] A. E. Street, *Memoir*, pp. 263, 384–85. Other authors who called for a new eclectic architecture were Thomas L. Donaldson (*A Preliminary Discourse on Architecture*, p. 29) and G. G. Scott (*Remarks*, p. 269). Ruskin, on the other hand, in later life was against eclecticism of whatever sort, though in *Poetry of Architecture* (*Works*, 1:117–18) he had implied that geographically differentiated eclecticism was necessary in Britain.

[90] *The Common Sense of Art*, pp. 21–22 and n. 11. For Hope see *D.N.B.*, s.v.; Henry William Law and Irene Law, *The Book of the Beresford-Hopes*, esp. pp. 126–241; and A. G. Lough, *The Influence of John Mason Neale*, pp. 12–13.

[91] *The English Cathedral of the Nineteenth Century*, p. 31. The idea may also have had something to do with Lord Lindsay's "progress by antagonism," outlined in his *Sketches of Christian Art*. In *English Cathedral*, p. 65, Hope quotes his father, Thomas Hope, as having suggested that all the beauties of architectural history might be combined into a new style that would be "our own."

[92] Hugh H. Stannus, "Queen Anne and the Gothic Revival," *Builder* 33 (1875):363–64. T. H. Lewis and G. E. Street, in their article "Architecture" in the ninth edition of the *Encyclopaedia Britannica*, s.v., stress that styles are no longer distributed topographically, so that nations can no longer be identified by them.

sent a single idiom. Where with Loudon the requirements of expression had merely dissolved the boundaries between styles, now the same requirements, pushed farther, had reconstituted them into a sort of onrushing empire called "Gothic."[96]

This assimilative tendency was more than merely tinged with imperialism. "Gothic" possesses itself of the styles, now denatured into partial vocabularies or dialects, of other cultures. By incorporating the best in them, and by removing their indigenous structures, it exploited them and dominated them. Indeed, this procedure was conceived as the key to architectural progress. Thus Ruskin saw the Oxford Museum in 1859 as an appliance designed to conflate Britain's approaching domination of the earth with the laws of the universe. "The University," he said, "has become complete in her function as a teacher of the youth of the nation to which every hour gives wider authority over distant lands; and from which every rood of extended dominion demands new, various, and variously applicable knowledge of the laws which govern the constitution of the globe, and must finally regulate the industry, no less than discipline the intellect of the human race."[97] The youth of Oxford would become worldwide administrators and judges under the laws inculcated in the Museum's lectures and laboratories and embodied, even embedded, in its architecture.

Sexuality in Victorian Architecture

This desire to "breed" a new architecture obviously relied on the sexual metaphor present in earlier architectural writing. The Victorians continually referred to the "manly" qualities or, conversely, the "feminine grace" of architecture. To Hope Gothic was particularly masculine, the architecture of "germination and continuity," as opposed to the female classical, which was the architecture of "superposition and horizontality."[98] To him, in fact, "the Early Gothic of England, particularly in the days before it had quite emancipated itself from the Roman-

[93] *Building News* 3 (1857):2.

[94] Quoted by Elizabeth Aslin, "E. W. Godwin, William Burges and the Japanese Taste," p. 781.

[95] *Gothic Architecture: A Lecture for the Arts and Crafts Exhibition Society*, pp. 24–29.

[96] Eastlake was also a subscriber to this theory of organic development (*A History of the Gothic Revival*, p. 253).

[97] John Ruskin and Henry W. Acland, *The Oxford Museum*, pp. 64–65.

[98] *Common Sense of Art*, p. 15.

esque, and . . . even more so the Early French Gothic, are pre-eminently masculine. . . . I little envy the soul of the man who does not feel himself moved when he stands beneath the stern male choir of Shoreham or of Canterbury."[99]

Ruskin also, at least in his youth, could see buildings thus. With him, in fact, even a site, before it was built on, could be sensual: thus for what he calls "picturesque blue country," one "distinctive attribute is sensuality. . . . every line is voluptuous, floating, and wavy in its form; deep, rich, and exquisitely soft in its colour; drowsy in its effect; like slow, wild music. . . . the cultivation . . . here seems to leap into the spontaneous luxuriance of life, which is fitted to minister to [man's] pleasures."[100] In sculpture, to take another example, Ruskin saw "masculine handling" in the placing of special ridges and hollows to give it power, even though the result appeared rough and unfinished on close view.[101] At larger scale, the apse at Beauvais is the "great type of simple and masculine buttress structure."[102] St. Mark's, Venice, on the other hand, is female: a gorgeous "image of the Bride, all glorious within, her clothing of wrought gold."[103] In *Stones of Venice II* (1853) Ruskin claims that good Gothic has the look of having been built by strong men—a certain roughness and nonchalance mixed in places with exquisite tenderness which is a sign of broad vision and the "massy power of man."[104] In a different way, the *Building News* attributed to Ruskin the notion that eclecticism, which of course Ruskin abhorred, was a sort of architectural adultery and fornication.[105] Street also noted the existence of architectural sexuality. He referred to Amiens as "perhaps the noblest and most masculine piece of architecture in the world"[106] and to the "nervous manliness" of French Gothic in general.[107]

More important for our purposes, it was also common to imply that architecture constituted a male-female combination. Hope sensed female qualities in the ogee, for example, as used at Bury St. Edmund's, and felt that such forms were as necessary as male ones for true organic evolution. Later the ogee was "toyed and dallied with" by the Goths, until it became "a symbol of weakness and lux-

[99] *Ibid.*, p. 19.

[100] *Ibid.*, pp. 148–50. Such landscapes had "a Greek feeling, in which sensation was made almost equal with thought, and deified by its nobility of association; at once voluptuous, refined, dreamily mysterious, infinitely beautiful."

[101] *Ibid.*, 8:215–16.

[102] *Ibid.*, 9:206.

[103] *Ibid.*, 10:140–41.

[104] *Ibid.*, 4:63n, 142n; 10:268. The first two references are to notes of 1883, wherein Ruskin, regretting these youthful impetuosities, claims that really "the sexual instinct is entirely excluded from consideration throughout the argument of this essay" and that he takes no notice of "the feelings of the beautiful, which we share with flies and spiders." In the second of the notes he adds that "the pleasure of the eye is never confused with the blind and temporary instincts of the blood; and that, briefly, and always, a girl is praised because she is like a rose,—not a rose because it is like a girl."

[105] *Building News* 3 (1857):2.

[106] G. E. Street, *Brick and Marble*, p. 4.

[107] *Notes and Papers*, p. 317.

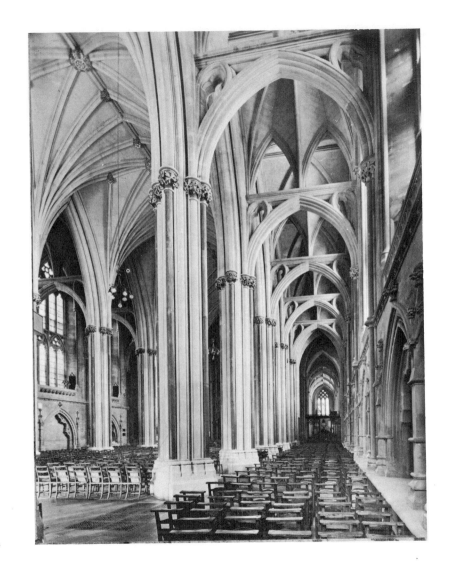

II–11. Nave, Bristol cathedral.
G. E. Street. 1868. Photo Mansell.

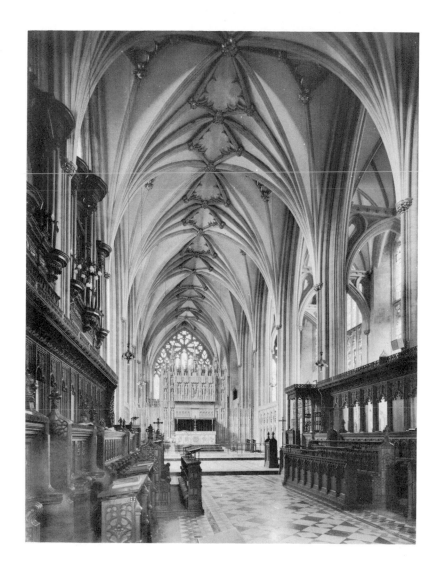

*II–12. Choir, Bristol cathedral.
Designed ca. 1298. Photo Mansell.*

ury." But this only means that female forms must be redeemed to take their honorable place in Modern Gothic: they were like the fallen women of literature and painting. This sexual differentiation, says Beresford-Hope, is no mere matter of ornament. It is basic, and has its own purposes. In a way reminiscent of the French eighteenth century, female architecture is continuous in form, Middle Pointed being a good example, with its "flimsy mullions." Male architecture, as in Early French, is, in contrast, discontinuous, with deep cutting and thick reveals.[108]

A similar thought was expressed more lengthily by a writer to a Bristol newspaper, ca. 1867, apropos of Street's remodeling of the Cathedral:

The construction of the nave [Fig. II–11] may be regarded as the providing of a husband to the widowed, or perhaps virgin, choir [Fig. II–12]. A comparison of the details of the choir with that [sic] of the new work of the nave will show this. The choir is essentially female in its character and expression. Dean Eliot is wont to say to his friends: "I have always regarded the arcading of this choir with its graceful lancet arches, rising in unbroken sweep from floor to apex, as the most perfect realisation of female grace and virgin purity yet achieved in architecture"; and the Dean is right, and Street is right too. He was restricted to the style of architecture of the choir; he has complied with the restriction, and has saved his reputation as a poet by simply changing his sex. Out of the rib he took from the female he has made a male; every member of the one is to be found in the other, and yet no member is precisely alike in both.[109]

A comparison of Street's nave (1868ff; Fig. II–11) with the choir designed 570 years earlier (Fig. II–12) does indeed reveal what might be called a sexual differentiation. In the choir the attenuated ribs emphasize the full continuities of the surfaces they contain, breaking at the vault crests into a sort of rococo orifice. In the side aisles the spandrel mouchettes are "organic" in a Ruskinian sense—bending and pliant. In Street's nave, on the other hand, changes of direction are marked by more gristly joints, and the aisle mouchettes bend with power

[108] *Common Sense of Art*, pp. 19–21.

[109] Quoted in A. E. Street, *Memoir*, p. 178. Street began work on the nave in 1868, and the towers were only completed in 1888. The chancel dates from the first third of the fourteenth century.

rather than pliancy. One notes especially the stiff detailing of the south aisle wall, reminiscent in its sturdiness of the Law Courts (Fig. IV–38), then just about to be erected. To paraphrase Hope, the "female" architecture at Bristol is one of flowing surfaces and planes, with flimsy ossatures; the male is abrupt, jointed, and with a deep thick frame. The one is cavelike, the other skeletal. Such sexual distinctions will play a great part in the churches built under the auspices of Hope's organization, the Ecclesiological Society.

One final aspect of all this has to do with the building as an exhorter and punisher—an aspect that deserves the lurid term "sadomasochistic." By this I mean a pleasure in painful perceptions, a pleasure that has reached artistic or social expression without entirely losing its physical overtones.[110] For architectural sadomasochism, as for architectural sexuality in general, we have been prepared by the eighteenth century. Burke had called terror the basis of the Sublime, designating that quality, on several grounds, as "approaching nearly to the nature of what causes pain." One reason was that sublime objects are very large, emitting a great number of rays which crowd into the eye together, producing an unpleasant but also awesome tension in its membrane.[111] On a different tack Uvedale Price had suggested that ornament was essentially abrasive: rough, sharp objects on a smooth, soft ground (the rough sharp parts being Picturesque and the smooth parts beautiful).[112] Like other writers on the beauty of ruins, he seems to have been fascinated by their associations of humiliation and pain.[113] The whole cult of ruins is in this sense a sadomasochistic pleasure in vandalism, dismemberment, and ugliness: *durch Leiden Freude.*[114] For Price, indeed, the Ugly almost seems at times an independent aesthetic category along with the Beautiful, the Sublime, and the Picturesque.[115] Payne Knight and others dwelt on the same theme, while as a complementary study Knight investigated the aesthetic values, in literature, of distress, terror, cruelty, and deformity.[116]

These ideas, and their relation to a sensual aesthetic in general, were more systematically discussed by Lord Jeffrey in his 1811 review of Alison's *Essays*.

[110] On this issue see Wilhelm Stekel, *Sadism and Masochism: The Psychology of Hatred and Cruelty*, 1:57–136, which recognizes the identity of the two perversions. For their social, and artistic, and religious forms see Theodor Reik, *Masochism in Sex and Society*, pp. 277–433. As for sadomasochism in the arts, there is Mario Praz, *The Romantic Agony*, though this is more of a florilegium than an analysis. More recently there have been, for architecture, Günter Metken, "Jean-Jacques Lequeu ou l'architecture rêvée," *Gazette des Beaux-Arts*, 6th ser., 65 (April 1965):213–30; Jacques Guillerme, "Lequeu et l'invention du mauvais goût," *ibid.*, 66 (September 1965): 153–66; and André Chastel, "The Moralizing Architecture of Jean-Jacques Lequeu," *Art News Annual* 32 (1966):71–83.

[111] *A Philosophical Enquiry into the Origin of Our Ideas of the Sublime and the Beautiful*, 4:9. See also Monk, *The Sublime*, 84–100.

[112] *Essays on the Picturesque*, 1:49–51.

[113] *Ibid.*, p. 53. The pre-Victorian ruin cult is beautifully discussed by Rose Macaulay, *Pleasure of Ruins*.

[114] A quotation from an 1819 letter by Beethoven to the Countess Marie Erdödy, quoted by Reik (*Masochism*, p. 329), which provides the title of the German edition of Reik's book. Curiously, Reik misquoted the phrase, which appears in the following sentence: "wir endliche mit dem unendlichen Geist sind nur zu Leiden und Freuden gebohren, und beinah

Jeffrey argues not only that beauty is entirely a matter of bodily sensations, and that "the love of sensation . . . seems to be the ruling appetite of human nature" but that

many sensations, in which the painful seems greatly to preponderate, are . . . sought for with avidity, and recollected with interest, even in our own persons. In the persons of others, emotions still more painful are contemplated with eagerness and delight; and therefore we must not be surprised to find, that many of the pleasing sensations of beauty or sublimity, resolve themselves ultimately into recollections of feelings that may appear to have a very opposite character.

Jeffrey then develops Burke's sadomasochistic explanation of the Sublime: the "dreary, gloomy, dismal, awful, or terrible" exites ideas of danger and alternately humiliates and exalts the spirit, i.e., both punishing and rewarding it.[117]

These ideas are also bound up with the suffering central to Christianity. Schimmelpenninck's book, which was republished in 1859 and which included "A Classification of Deformities," posits an architectural lexicon of Christian suffering. Cable moldings stand for the cords that bound the victims; sawtooth moldings stand for "the instruments with which they were sawn asunder"; hatched moldings stand for the axes they were chopped up with; indented moldings symbolize the spikes that tore them; the chevron, the chains and racks that tortured them; the beak head and the tiger's head, the birds and beasts that devoured them; and the billet, the faggots piled to feed the flames of martyrdom. "The Early Christian Missionaries left these," she concludes, "not as mere ornaments, but as records on their churches, and not only as records of what had been done, but as incitements to endure."[118] Gothic architecture is not simply a message about past torment. With its garnish of torture equipment it offers to the observer the prospect of his own suffering for Christ. But such ideas are only bizarre additions to the more commonplace sort of Christian sadomasochism, of which there are so many Victorian instances, e.g., this hymn by John Mason Neale, one of the founders of the Ecclesiological Society:

könnte man sagen, die ausgezeichnetsten erhalten durch Leiden Freude" (A. C. Kalischer, ed., *Beethovens sämtliche Briefe*, 2 vols., [Berlin, 1907], 2: no. 466).

[115] Price, *Essays*, 1:49.

[116] Knight, *Inquiry*, pp. 315–29.

[117] *Edinburgh Review* 18 (May/August 1811): 7–9. See also William Gilpin, *Remarks on Forest Scenery, and Other Woodland Views*. T. D. Lauder's introduction to this book seems almost word for word the same as Jeffrey's review.

[118] *Principles of Beauty*, pp. 392–93.

My sin is great,—my pain is sore,—
My strength is gone,—my spirit fails;—
For me the Cross Thy great Love bore,
For me the Scourge, for me the Nails;
For me the Crown around the Temples set,
For me the Agony and Bloody Sweat.[119]

Here is an exact verbal equivalent of Schimmelpenninck's chevron and sawtooth "incitements." Neale's sermons and hymns are full of such notions. A different but consonant tradition was the conflict in the professional press about the restoration of medieval buildings. Both factions, "scrape" and "antiscrape," accused each other of demolishing buildings for pleasure. On the one hand rebuilding was a form of demolition; on the other, a laissez-faire attitude led to a slower but equally sure form of ruin. Thus the images of suffering in prayer, sermon, and hymn were buttressed by an air of *ruinenlust* in the very fabric in which the worship was conducted—at least in those buildings which were medieval. The ecclesiologists also emphasized the worshiper's physical as well as mental discomfort. Butterfield, for example, declared in an article that "overmuch effort, as it seems to me, has been made to produce a too easy and lounging seat for church use." He advocated doing away with upholstery, cushions, and hassocks, and de-emphasized the seat in favor of the kneeling board.[120]

Ruskin, as we might expect, had a more complicated view. When he advocates stylized ornament, for example, which he calls "right conventionalism," it is because this represents "a wise acceptance of, and compliance with, conditions of restraint or inferiority."[121] At other times his eloquence leads him to express ideas of pain with a relish that proclaims considerable enjoyment. He speaks of a genre of battle painting that has "brutal ferocity and butchered agony, of which the lowest and least palliated examples are those battles of Salvator Rosa which none but a man base-born, and thief-bred, could have conceived without sickening."[122]

But these are mere phrases. In a much more deliberate and systematic vein

[119] *Hymns for the Sick*, p. 2. Sometimes these notions were not merely metaphorical for the Gothic Revivalists. Scott is said to have habitually lacerated his arms when he prostrated himself in prayer for his dead son (*Recollections*, p. xx).

[120] For example, see J. J. Stevenson, "Architectural Restoration: Its Principles and Practice," *Builder* 36 (1877):552–53; for William Butterfield, see his "Church Seats," *Church Builder*, n.s. 6 (1885):77–82.

[121] Ruskin and Acland, *Oxford Museum*, p. 85.

[122] Ruskin, *Works*, 4:201.

Ruskin suggested that in art the sculptured forms of inorganic matter really stand for the decay of that matter from its living state. Such forms therefore signify feebleness, sickness, and death. They are a corpse-quality in architectural creatureliness. The effect of them is that "the ocular sense of impurity connected with corruption is enhanced by the offending of other senses and by the grief and horror of it in its own nature, as the special punishment and evidence of sin." Even from this corruption, morally viewed, good, and therefore beauty, can come.[123]

The theme of joy, or at least benefit through punishment, is one that Ruskin sounds throughout his works. It is clear, in *Seven Lamps*, that he dislikes machine ornament and substitute materials because they make it easy to get effects that had formerly been achieved with difficulty and sacrifice. This goes against man's duty on earth, which should tend to deny pleasure to the self: "he who would form the creations of his own mind by any other instrument than his own hand, would also, if he might, give grinding organs to Heaven's angels, to make their music easier. There is dreaming enough, and earthiness enough, and sensuality enough in human existence, without our turning the few glowing moments of it into mechanism."[124] Thus does associationism become a way of transmitting admonitions of reinforcement for the conscience. We have noted how Christian Theoria redeems the ugly; and we have seen that a face worn by sin can be more truly beautiful than an ideal one. However, association's real task is as often punishment as redemption. "But for this external and all-powerful witness," says Ruskin, "the voice of the inward guide might be lost . . . and the strength of the protection [of conscience] pass away in the lightness of the lash. Therefore it has received the power of enlisting external and unmeaning things in its aid, and transmitting to all that is indifferent its own authority to reprove or reward."[125]

Ruskin did not, however, as Schimmelpenninck did, see Gothic buildings as monuments of torture. For him they were love objects and suffering creatures. But he makes their suffering religious or moral. A building is more beautiful in decay than in its ideal state because it has been victimized by evil forces. He

[123] *Ibid.*, p. 129.
[124] *Ibid.*, 8:219–20.
[125] *Ibid.*, 4:73.

celebrates in words the "beauties of . . . advanced dilapidation" in San Michele, Lucca, just as his well-known watercolor of this church celebrates the warpings and violations that time and vandalism have inflicted.[126] Like most of Ruskin's architectural illustrations, this is a fragment torn from its context rather than a proper detail, evoking Wightwick's phrase, "crammed . . . observation vent[ed] in mangled forms."[127]

Other examples of this attitude abound in Ruskin. In *Stones of Venice I*, he contrasts on the same plate (Fig. II–13) a detail from Arthur's Chocolate House, St. James's Street, London, as remodeled in 1811 by Thomas Hopper, with one from the thirteenth-century façade of San Pietro, Pistoia. The contrast brings out Ruskin's dislike of linear regularity—here presented as sharply geometrical—in the ashlar masonry, parsimonious moldings, and arbitrary voussoirs of the classical building. By contrast his fragment of Pisan Gothic allows each stone to expand to a shape seemingly determined from within its core. The stones have that same resiliency we saw in the chimneys of Fig. II–1. Yet this very effect occurs through wear and spalling—it is a liberation caused by damage and decline. The plate therefore exemplifies two types of pleasure through pain: the condemnation (à la Pugin) of classical rigor through visual satire and an equal delight in praising that which is partly destroyed.

Often Ruskin affirms that defacement, stripping, corruption, discoloration, and ruin improve works of art, even in a purely formalist sense:

Again, upon all forms of sculptural ornament the effect of time is such, that if the design is poor, it will enrich it; if overcharged, simplify it; if harsh and violent, soften it; if smooth and obscure, exhibit it; whatever faults it may have are rapidly disguised, whatever virtue it has still shines and steals out in the mellow light; and this to such an extent, that the artist is always liable to be tempted to the drawing of details in old buildings as of extreme beauty, which look cold and hard in their architectural lines. . . . On the front of the Church of San Michele at Lucca, the mosaics have fallen out of half the columns, and lie in weedy ruin beneath; in many, the front has torn large masses of the entire coating away, leaving a scarred unsightly surface. Two of the

[126] *Ibid.*, 3:207.

[127] Ruskin also could identify truth with savagery, as in the preface to the 1880 edition of *Seven Lamps* (*Works*, 8:15), where he speaks of the "savage carelessness" with which his original etchings were bitten and elsewhere adds, "Their truth is carried to an extent never before attempted in architectural drawing" (*ibid.*, p. xlv).

shafts of the upper star window are eaten entirely away by the sea-wind, the rest have lost their proportions; the edges of the arches are hacked into deep hollows, and cast indented shadows on the weed-grown wall. The process has gone too far, and yet I doubt not but that this building is seen to far greater advantage now than when first built."[128]

In Venice Ruskin found even more fascinating wrecks: the Fondaco de' Turchi

is a ghastly ruin. . . . the covering stones have been torn away from it like a shroud from a corpse; and its walls, rent into a thousand chasms, are filled and refilled with fresh brickwork, and the seams and hollows are choked with clay and whitewash, oozing and trickling over the marble,—itself blanched into dusty decay by the frosts of centuries. Soft grass and wandering leafage have rooted themselves in the rents, but they are not suffered to grow in their own wild and gentle way, for the place is in a sort inhabited; rotten partitions are nailed across its corridors, and miserable rooms contrived in its western wing; and here and there the weeds are indolently torn down, leaving their haggard fibres to struggle again into unwholesome growth· when the spring next stirs them: and thus, in contest between death and life, the unsightly heap is festering to its fall.[129]

Such ruins are the more ruinous, such departed glories the more humiliated at present, in the present inhabitants' despoiling disregard. Even in the case of St. Mark's, "the beauty which it possesses is unfelt, the language it uses is forgotten; and in the midst of the city to whose service it has so long been consecrated . . . it stands, in reality, more desolate than the ruins through which the sheep-walk passes unbroken in our English valleys."[130] The Venetians, in *Stones of Venice*, are as much barbarians as the savages among whom the ecclesiological missionaries went. Ruskin in Venice was like Catherwood in Mexico. Even his picture of the crowds around St. Mark's is like a Victorian's view of a New Guinea tribe: "unregarded children,—every heavy glance of their young eyes full of desperation and stony depravity, and their throats hoarse with cursing,—gamble and fight, and snarl, and sleep, hour after hour, clashing their bruised

[128] *Ibid.*, 3:204–6.
[129] *Ibid.*, 10:145.
[130] *Ibid.*, pp. 91–92.

II–13. (left) *Detail from Arthur's Chocolate House, as remodeled 1811 by Thomas Hopper;* (right) *detail from San Pietro, Pistoia, thirteenth century. Ruskin,* Stones of Venice I.

centesimi upon the marble ledges of the church porch. And the images of Christ and His angels look down upon it continually."[131]

Even in *Seven Lamps* Ruskin had claimed that these teeming ruins, like the vacant medieval shells of the English countryside, are the result of a decline in truth, a decline which can equally be traced "along the bleak promontories on which the Pharos lights came once from houses of prayer,"[132] or, more completely and with more rigor and detail, in the later book, by following the dread advance of Renaissance architecture as it ate through Venice's medieval fabric. For Ruskin, Renaissance architecture was more than the absence of life; its deadness was malignant, it was an anti-architecture, a disease. However, though he says at the beginning of *Stones of Venice III* that he "cannot pollute this volume by any illustrations of its worst forms,"[133] he in fact dwells on it for hundreds of

131 *Ibid.,* pp. 84–85.

132 *Ibid.,* 8:98–99.

133 *Ibid.,* 11:150.

pages. Venetian Renaissance architecture is indeed "among the worst and basest ever built by the hands of men, being especially distinguished by a spirit of brutal mockery and insolent jest, which, exhausting itself in deformed and monstrous sculpture, can sometimes be hardly otherwise defined than as the perpetuation in stone of the ribaldries of drunkenness."[134] For Ruskin a Gothic building, especially, is a beloved victim, tortured not only by time but also by its rival and successor mode. But he watches and records this torture with pleasure—as he warns off restorers with bitter vehemence. Associationally, indeed, the beauty of his own vision redeems the ruins he describes. As the architectural stones of Venice founder and fall away, literature takes wing and we have *The Stones of Venice.*

Associations between buildings, creatures, and informational appliances continued to be present in Victorian associationism, while at the same time the latter became extraordinarily assimilative. It stretched out into the landscape and through ranges of building types into the regions of conscience, history, and empire. Its most exalted form was Christian Theoria, which included even ugliness as a possible form of beauty, i.e., as a symbol of sin and redemption. Wightwick furthered association's range by suggesting that new buildings could constitute treatises or poems about old ones. White increased the types of possible functional symbols by including volumes and silhouettes. Street, engrossed by the technological associations of materials, advocated Italian Gothic as the core tradition best adapted to the breeding of a modern Gothic, since it was best suited to the grafting on of alien motifs. The Victorians continued to sexualize buildings. Male and female characteristics were seen in different styles, and some buildings represented the mating between two genders of form. This habit was given a sadomasochistic cast in writings about associations with martyrs and the beauty of decay, wherein the building was seen either as a monument and promise of suffering or as a tortured love object. All these features will reappear when that bizarre science, ecclesiology, supervises the birth of High Victorian Gothic.

[134] *Ibid.*, p. 135. He has a similar attitude toward painting. In *Stones of Venice II* (*ibid.*, 10:436–37) he praises the unrestored works one finds in odd corners of churches: "They are . . . almost universally neglected, white-washed by custodes, shot at by soldiers, suffered to drop from walls piecemeal in powder and rags." But nonetheless "what is left of them, however fragmentary, however ruinous, however obscured and defiled, is almost always *the real thing.*" Even more oddly, in *Modern Painters II* (*ibid.*, 4:317–18), Leonardo's Christ in the *Last Supper* is the best Christ ever painted, but perhaps the beauty of the mural "is as much dependent on the very untraceableness resulting from injury as on its original perfection."

III·THE ECCLESIOLOGICAL SOCIETY

Pugin Classiciste

Ruskin and the other writers mentioned in the last chapter did much to develop the associational principles of High Victorian Gothic. But as everyone now knows, it was the Ecclesiological Society that actually invented the style and first embodied it in their model church, All Saints, Margaret Street, London. I have therefore saved their version of associationism for this separate chapter. In fact, while their doctrines are being elaborated, we shall also see them practically applied in buildings and projects. The present chapter thus constitutes the main transition of this book—from associational theory to High Victorian Gothic practice.

 Previous writings on the Ecclesiological Society have quite properly stressed

[1] The standard account is in Henry-Russell Hitchcock, *Early Victorian Architecture in Britain*, 1:97–161. See also the more recent studies by James F. White, *The Cambridge Movement, the Ecclesiologists and the Gothic Revival*, esp. pp. 9–14; Collins, *Changing Ideals in Modern Architecture*, pp. 100–110; Phoebe B. Stanton, *The Gothic Revival and American Church Architecture: An Episode in Taste, 1840–1856*, pp. 3–29, 60–90, which has the earlier bibliography.

[2] For instance, any of the plans in Pugin's *The Present State of Ecclesiastical Architecture in England*, especially those of the church at Cheadle, St. George's, Southwark, St. Wilfred's, Manchester, etc.

[3] For Cheadle see the *Illustrated London News* 10 (1847):28–29; Denis R. Gwynn, *Lord Shrewsbury, Pugin, and the Catholic Revival*, pp. 49–52; and Hitchcock, *Early Victorian*, 1:81–83.

[4] For St. George's see the *Illustrated London News* 1 (1842):515–16; *The British Almanac and Companion* (1849), p. 231; Michael Trappes-Lomax, *Pugin, a Medieval Victorian*, pp. 206–14. Ruskin's famous attack on this building appears in *Stones of Venice I* (*Works*, 9:436–40).

its debt to Pugin.[1] Not only did the ecclesiologists begin by advocating the Gothic Revival manner he pioneered; they even, as with Beresford-Hope, narrowed his range of possibilities and chose fourteenth-century English Decorated as the point of departure for future development. Nevertheless, the fact remains that they were associationists and Pugin was not. As a result, for all their early praise of him, his approach quickly came to seem inconsistent, most obviously so in their overseas mission program.

Pugin's own attitude toward English Gothic had been anti-eclectic, even Neoclassical in spirit. Like Ruskin, he had looked upon Gothic art as an absolute —the way Thomas Hope, for example, had looked on Greek. Even Pugin's plans are Neoclassical, in the sense that they are axial, symmetrical, and unrelated to the idiosyncratic space groupings, "expressive of fitness for the end in view," of Loudon and of High Victorian Gothic.[2] It is the same with his elevations. The dainty spire of Cheadle (Fig. III–1), though alive with pretty and correct details, is part of a fully symmetrical volume composition, the church's west front (the south porch is later; see Fig. III–2).[3] Similarly, St. George's, Southwark, Pugin's most ambitiously scaled building, with its three rickety gables and narrow central tower, has a regularity that is in no essential way a departure from Georgian practice.[4]

Admittedly, St. George's is not what Pugin had wanted it to be. But Cheadle may be taken as one of his most uninhibited statements, and even Cheadle is not merely latently Neoclassical but is lacking in any but the most cut-and-dried symbolism. The program is entirely heraldic and iconographical rather than associational—all "style" and no "expression." The doors, of English oak (Fig. III–3), are painted bright red to symbolize the blood of martyrdom, and engrailed with gilded lions rampant. The exterior niches are filled with standard figures—Saints Peter and Paul and the Latin Doctors. Set into the western tower buttress is the kneeling donor, the Earl of Shrewsbury, offering a model of the building to St. Giles, while the Earl's patron, John the Baptist, stands by. The decorative scheme with its mottoes and statues, its interior painted diapers,

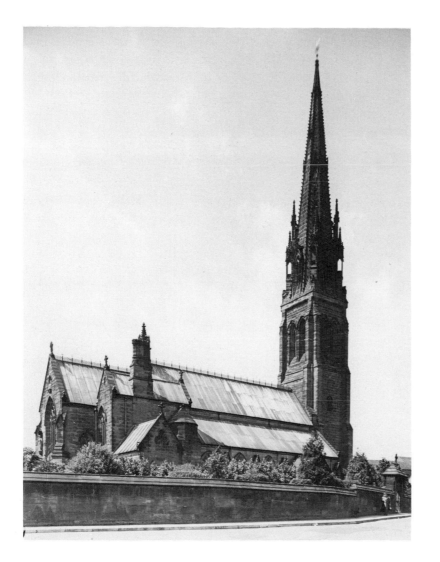

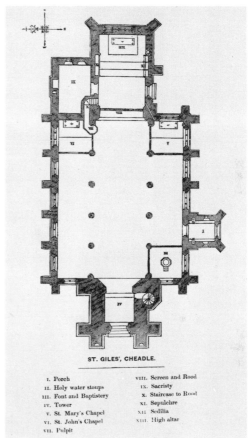

ST. GILES', CHEADLE.

I. Porch	VIII. Screen and Rood
II. Holy water stoups	IX. Sacristy
III. Font and Baptistery	X. Staircase to Rood
IV. Tower	XI. Sepulchre
V. St. Mary's Chapel	XII. Sedilia
VI. St. John's Chapel	XIII. High altar
VII. Pulpit	

III–2. Plan, St. Giles.
A. W. Pugin. Pugin, Present State, 1843.

III–1. Exterior, St. Giles, Cheadle.
A. W. Pugin. 1841–46. Photo NMR.

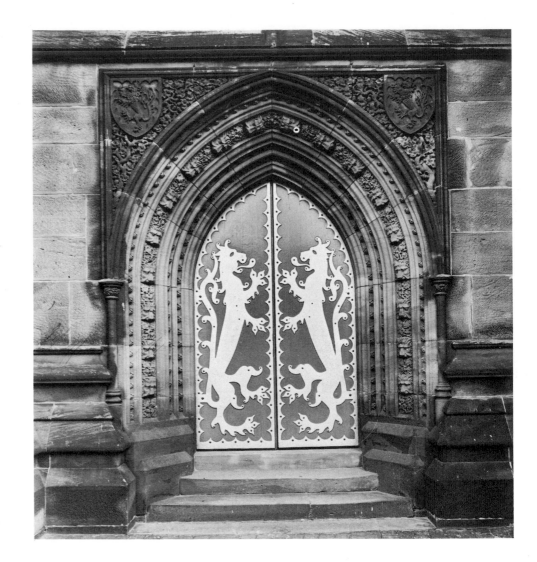

III–3. *Main doors, St. Giles.*
A. W. Pugin. Photo NMR.

III–4. (opposite page) *Interior, St. Giles.*
A. W. Pugin. Photo NMR.

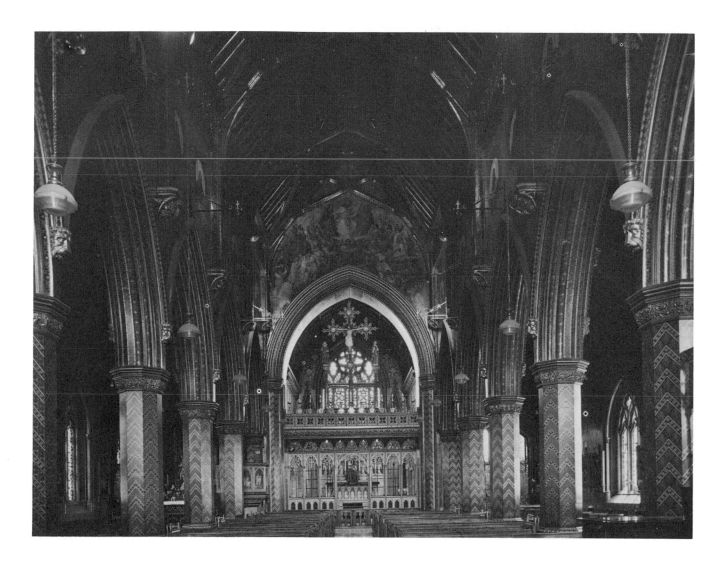

checkers, and zigzags, is not expressive of the site, the congregation and its background, or the period. While certainly not excluding such symbolism, ecclesiology required a complementary associationism. Thus, in innumerable ways St. Giles represents an Early Victorian sensibility. It has the quality, in its thick walls and reveals, its deep buttresses, its nonchalant roofs, in the weighted grace of the spire as it moves from the tower into its crown of pinnacled dormers, and in its dim golden interior (Fig. III–4), of a vision from Britton or Turner.[5]

The usual Pugin-type church as built by his followers (including, for a time, the ecclesiologists) was an equally archaeological-pastoral structure, with Hope's "feminine characteristics" prevailing. Such buildings worked well in villages or the countryside but not in towns. For example, a typical Puginesque church in London, St. Barnabas, Pimlico, by Thomas Cundy II (Figs. IV–1-IV–2) is almost grotesquely rural, a gawky jumble of village shapes quite unlike the skyscraperish, bundled shafts of volume and void we will find in Butterfield's All Saints, Margaret Street (Fig. IV–7). Another Puginian church that was inappropriately rural in its setting was Dawkes and Hamilton's St. Andrew's, Wells Street, Marylebone (1844–46), which was only allowed to let its west front peek out from a row of terraces,[6] and yet another such is St. Stephen's, Rochester Row, Westminster (1845; Fig. IV–6), by Benjamin Ferrey. Salvin did the same thing in St. Stephen's, Uxbridge Road, Hammersmith, of 1849–50. But the list is really endless.[7] It all shows how Pugin's church style failed to assimilate urban topography. There was no expression of slums, immigrants, coal gas, terrace housing, tall buildings and narrow approaches—nothing of the hardness, decay, and grimy color of urban life. Yet all of these are qualities that the ecclesiologists felt it their duty to express in their slum missions. It is therefore not surprising that High Victorian Gothic should make its appearance as an antidote to this sort of Puginism: aggressively urban in form, and contemptuous of the Early Victorianism of buildings like St. Giles.

There is, however, one respect in which Pugin did look firmly toward High Victorian Gothic. This is in what was called his "plain style," used not for

[5] Note Hitchcock's beautiful description cited in n. 3 above. The pastoral, early nineteenth-century character in Pugin's architecture is echoed in his writings. Despite his clamorous and witty prose he often breaks into setpieces that remind one of Leigh Hunt, Hazlitt, or even Chateaubriand—for example, the description of the day-long movement of sunlight in a church in *Present State*, p. 14. It would be interesting to investigate the French side of Pugin's intellectual heritage in the same way that Phoebe Stanton has investigated his English background ("The Sources of Pugin's *Contrasts*," in Summerson, ed., *Concerning Architecture*, pp. 120–39)—though here Quatremère de Quincy is in fact discussed.

[6] The church does have High Victorian Gothic furniture, however. It is now in Kingsbury (Nikolaus Pevsner, *The Buildings of England: Middlesex* [Harmondsworth, 1955], p. 121).

[7] See Hitchcock, *Early Victorian*, 1:97–161. On the other hand, it should be remembered that in the early 1840s there was still considerable feeling for the old Commissioners' Style. See, for example, the rivalry between Pugin and Scoles as reviewed in *Builder* 1 (1842):98–100. Other architects, like Arthur Ashpitel, worked in a style that was neither Puginian nor Commissioners' (*Builder* 4 [1845]:278). Eventually even Pugin hinted that a special urban style might be necessary (*Treatise on Chancel Screens*, p. 119).

churches but for houses. In the bishop's palace at Birmingham (now destroyed), the contrast between its plainness and the rich cathedral, also by Pugin, was clear (Figs. III–5-III–6). The same contrast appeared within the palace, for its chapel possessed a full treasury of Puginian riches—traceried window, tapestries, an altarpiece in high relief, riddel curtains of precious stuff, a tiled floor. In contrast, the hall (as published in Pugin's *Present State*) boasted only heavy cubical forms, square beams, and flat boards with emphatic joints (Fig. III–7).[8] Similarly, the hall in Pugin's own house at Ramsgate (Fig. III–8) was very plain, with uncompromising, carpenter-like rectangles in the dado, jumbo arched ribs flanking the fireplace, and a big, prickly wallpaper pattern.[9] The dour humility of these clerical interiors makes an expressive contrast to the soft seemliness of Pugin's houses of God and is a real foretaste of things to come. Not surprisingly, High Victorian Goths like Robert Kerr had considerable praise for Pugin's plain style.[10]

Ecclesiology Becomes Independent

The ecclesiologists did not differ from Pugin merely in their belief in Alison and Loudon;[11] they were also unalterably opposed to Picturesque composition for its own sake—this was mere "effect."[12] Every form had to have a meaning, and that meaning lay in a tradition of expression; as they put it, "an arrangement, without precedent, is also without meaning."[13] And they did not simply equate Gothic with Christianity, like Schimmelpenninck and Pugin, but matched certain kinds of Gothic with certain kinds of Christianity, e.g., with their own Anglo-Catholicism.[14]

In the pages of the *Ecclesiologist* and elsewhere these ideas were developed into a rich debate on architecture as an associational language. In the *Transactions of the Oxford Architectural Society* (a sister of the Ecclesiological Society, of which Ruskin was a member), a learned speaker from St. John's College distinguished three modes of architectural discourse. There was Symbolism, as set

[8] Pugin, *Present State*, pp. 97–103.

[9] Even Pugin's first house, St. Marie's Grange in Alderbury, near Salisbury (1835), has a High Victorian Gothic look, as John Piper notes ("St. Marie's Grange, the First Home of A. W. N. Pugin").

[10] "On the Life of Welby Pugin," *Builder* 20 (1862):345.

[11] See, for example, *The Christian Observer* 1 (October 1850):684–98 (a review of *Seven Lamps*), which contrasts Ruskin's book with the work of the ecclesiologists. The reviewer claims that the latter were successful precisely because "association is a very powerful feeling, and probably no where does it shew its influence more decidedly than in Architecture." The reviewer then thanks Ruskin for devoting this force to a more Protestant cause. For this aspect of ecclesiology see n. 1 above and Lough, *John Mason Neale*, pp. 6–38.

[12] E.g., their review of J. L. Petit's *Remarks on Church Architecture* (*Ecclesiologist* 1 [1841–42]:87–101).

[13] *Ibid.*, 12 (1851):26.

[14] *Ibid.*, 1 (1841–42):87–101; "Romanesque and Catholick Architecture," *ibid.*, 2 (1842–43): 5–16.

forth in Neale and Webb's introduction to the Durandus translation, Typicality, and Esotericity—the latter two being the author's own discoveries. This speaker, Robinson Thornton, further distinguished between what he called proto-Symbolism, i.e., intentional representation, and Deutero-Symbolism, "the modification of the structure resulting from the metaphysical modification of the architect's mind by Catholic doctrine and contemplation."[15] Thornton's lecture is interesting because it is actually a linguistic analysis of architecture, positing an unconscious element in the architectural "speech" it discusses.

One possible experience of the ecclesiologists that might have caused them to favor associationism more than Pugin did was the fact that they worshiped in Anglican churches, while Pugin worshiped in Roman Catholic ones. The older Anglican churches were anchored in long traditions embracing the Renaissance as well as the Middle Ages. They constituted physical trains of associations, rich environments of tombs, cenotaphs, memorials, and the like. Even though they disliked the form many of these furnishings took, the ecclesiologists could hardly have been unaffected by their profuse associations. Pugin, both in his antiquarian purism and in his Catholicism, with its brand-new buildings for brand-new congregations, had abandoned all this.[16]

But even a newly built ecclesiological church was called upon to "express" more than a Pugin church. Not only was it to possess traditional symbolic sculpture; it was to tell of its place in the hierarchy of chapel, parish church, and cathedral.[17] The functions of its different parts were also to be made plain, with the porch symbolizing humble entry, the nave the broad gathering of the congregation, the chancel proud offering, and so on. Even the sacristy was called upon to "explain itself," usually with a chimney, and the altar with a gable.[18]

Yet even more fundamental was the fact that for the ecclesiologists the church building was a penitential appliance, an architectural paraphrase of the suffering body of Christ. We have glimpsed this already in J. M. Neale, and here is Neale again, quoting Lancelot Andrewes: "For, indeed, *solutum est Templum hoc*, this Temple of His Body; the Spirit from the Flesh, the Flesh from the

[15] *Transactions of the Oxford Architectural Society* (January 1848–July 1849):68–70.

[16] Moreover, the assimilative energy of Anglo-Catholicism matched that of associationism. High Churchmen were often more independent of authority than Low, especially in their innovations in ritual. Here was another divergence from Pugin, who naturally believed in a centralized, authoritarian church. And even Pugin, in his lack of sympathy with the Roman Church's post-medieval path, was considered heterodox by some of his fellow churchmen (e.g., *Dublin Review*, n.s. 22 [January 1874]: 215).

[17] *Ecclesiologist* 1 (1841–42):181–83; *ibid.*, 12 (1851):403–4.

[18] *Ibid.*, 12 (1851):28, 192.

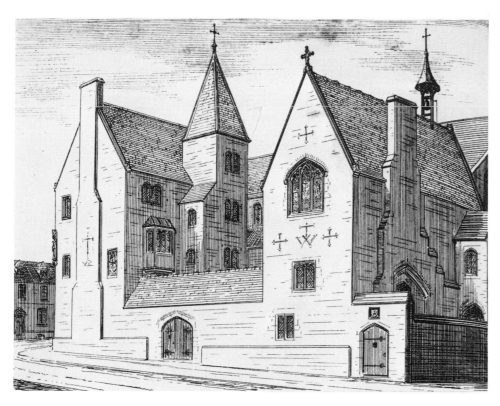

III–5. Exterior, bishop's palace, Birmingham. A. W. Pugin. 1839–41. Pugin, Present State.

III–6. Plan, bishop's palace.
A. W. Pugin. Pugin, Present State.

III–7. Hall, bishop's palace. A. W. Pugin. Pugin, Present State.

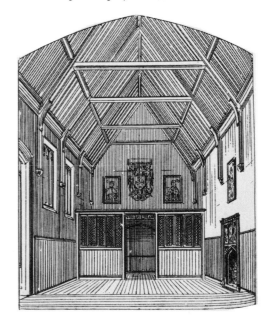

III–8. The Grange, Ramsgate. A. W. Pugin. 1841–43. Photo NMR.

[19] "A Catena Symbolica from Writers of the Western Church," *Ecclesiologist* 12 (1851):3–11; see also Durandus, *Symbolism*, pp. cxxxiv–cxxxv, 24–25.

Blood was loosed quite. The roof of it, His Head, loosed with thorns: the foundations, His feet, with Nails; the side aisles, as it were, His Hands both, likewise."[19] The church building is the agent by which the worshiper gains joy and freedom through metaphorical crucifixion. Neale and Webb added a number of medieval texts to their Durandus edition, in which such ideas are elaborated. In the *Fardle of Facions* not only is the crucified body—presumably Christ's—seen in the church building, but we are told that the chancel should be round so as

to resemble his head, with bell turrets for ears. Durandus himself says the same, adding that the sacrifice of the altar denotes the body's heart. Following Richard of St. Victor he claims that the increasing size of the sanctuary, chancel, and nave group, respectively, stands for the progressively greater numbers of absolute virgins, the (relatively) continent, and the married. The increase in size marks a decrease in holiness. But the Ecclesiological Society equated sexual deprivation with holiness even in seating arrangements: at any rate, they used the word "promiscuous" to describe the mingling of men and women in the same pew.[20]

Deprivation led easily to actual discomfort. Thus there was the Society's campaign to replace cushioned box pews with un-upholstered "benches," i.e., the open wooden seats most churches now have, often with attached kneelers. (We have already noted Butterfield's sentiments on this head.) Kneelers were advocated on the grounds of their beneficial discomfort. Even heating could be banned; in any case, we are told, incense, generously burned, would heat a church sufficiently, as would the body heat from the larger numbers now to be brought to the buildings as a result of the elimination of box pews and the revival of "rubrickal" services. Even gaslight was banned, being a form of coddling.[21]

Along with the advocacy of discomfort went the ecclesiologists' well-known relish for verbal censure, amusingly recorded by Kenneth Clark.[22] In 1843 there was an "Architects Condemned" section in the *Ecclesiologist*'s index and, in some years, a "Church Desecrations" column (not unlike "Outrage" in the *Architectural Review* these days). "Church Desecrations" dwelt with censorious glee on instances of rubbish in chancels, dilapidations in sacristies, and other church-wardenly crimes. As to the criticism of new buildings, this too could be extraordinarily hostile. In 1843 the *Ecclesiologist* found Blore's Christ Church, Hoxton, "truly contemptible . . . one of this gentleman's architectural enormities." In 1845 Ferrey was described as possessing the power of doing "much mischief by carelessness, singularity, or unartistic compliance," while a church at Spitalgate,

[20] *Ecclesiologist* 5 (1846):41–45.

[21] See the pamphlets listed in my Bibliography under "Cambridge Camden Society," and also J. W. Bowden, *A Few Remarks on Pews*.

[22] Clark, *Gothic Revival*, pp. 226–39.

Grantham, was said to be of the worst class, most poverty-stricken and unsatisfactory. Holy Trinity, Harborne, Staffs, was "an odious structure rendered at once offensive by pretence, and ridiculous by failure." As to the architect of a church in Oldbury, Worcestershire, he belonged in the stocks, and a church in Surrey, at Kingswood, Walton-on-the-Hill, was "as bad as anything can be."[23] There is much more of the same, especially in the 1840s. Such language is in striking contrast to that contained in the bland pages of the *Builder* and other organs of the professional press.

All this narrow hostility helps us understand the oft-repeated statement that the ecclesiologists approved of one style and one style only—Middle Pointed.[24] It is true that this was said in the *Ecclesiologist* and elsewhere, and that it was acted upon. Indeed, not merely the style, but actual ancient models were to be copied line for line. This duty always took the form of willed servility, going beyond even the intermediate "fettered effort" of "inventive imitation" to what was called "mechanical imitation." It was a punishment but was also the only road to potential freedom for architects who had allowed the life-giving principle of Christian art to die out. However, when the architect had purged himself of the sins of such as James Wyatt, he could be reborn. The pain of mechanical imitation would lead to the joy of Modern Gothic.

The associational, non-Puginian spirit of the ecclesiologists can be glimpsed in the very earliest practical criticism they published in their journal. Their first project, though not illustrated, is well enough described for us to draw such a conclusion. It is a small church by Edmund Sharpe,[25] with aisled nave, central western tower, and unaisled chancel—a project that remained unbuilt. Sharpe had been scholarly and correct, according to the reviewer, but his design was far from faultless: the nave was vaulted, which was thought "presumptuous" in a small church. The central western tower made the building look too much like a meetinghouse. There were western triplets, which was a violation of chapel "expression," and there were no porches, which are necessary in chapels to signify humility. The walls were too high and the roof too shallow, another piece

[23] *Ecclesiologist* 3 (1843):99; *ibid.*, 4 (1845): 89, 186–87, 283–84. Price, in "The Picturesque Moment," interestingly links Butterfield's "glorying in ugliness," as Summerson puts it, to the earlier Picturesque.

[24] *Ecclesiologist* 3 (1843–44):134; Eastlake, *Gothic Revival*, p. 359; Clark, *Gothic Revival*, p. 233. Ruskin was also taxed with wishing to "make the profession work in chains," as reported in the *Ecclesiologist* 10 (1849):119. And indeed Ruskin did say in *Seven Lamps* that as we teach children to copy literally when they learn to write languages, so it must be for architecture: "under this absolute, irrefragable authority, we are to begin to work; admitting not so much as an alteration in the depth of a cavetto, or the breadth of a fillet" (*Works*, 8:257).

[25] *Ecclesiologist* 1 (1841–42):21. For Sharpe see Eastlake, *Gothic Revival*, pp. 235–36, and Hitchcock, *Early Victorian*, 1:154–55.

of arrogance. Thus in the very first building designed for the Society we see critical standards being applied that Pugin himself would not necessarily have observed, for he had had no objection to central towers, and the only reason he abjured vaulted roofs, for chapels or anything else, was lack of funds. Chapels with western triplets are also commonly found in his oeuvre, while his admiration for Perpendicular caused him many a time to build chapels with high walls and flat roofs.[26] Moreover, the reasons urged for these non-Puginian criteria are emotional, dramatic, and social: the building expresses presumption, and it doesn't know its place.

Another 1841 project, this time executed, shows the same standards at work. This was for a small proprietary chapel at Arley Park, Cheshire, by Anthony Salvin.[27] Salvin's building was Middle Pointed, and consisted of an unaisled chancel and nave attached to the house by a short cloister. The description in the *Ecclesiologist* is more favorable to this design, though here again the walls were said to be too high and the roof too low–i.e., again, insufficient humility.

But it was in the overseas mission field that the departures from Pugin, and the concern with humility vs. arrogance, were dramatic. From the beginning this area was of immense concern to the *Ecclesiologist*. As noted, there had early been a demand that the Society supply designs not only for churches but for schools and hospitals in the colonies. By the mid-1840s they were regularly sending out plans and models. They even dispatched an architect to North America.[28] In the first issue of the *Ecclesiologist* we read that drawings and models are being sent to New Zealand for a group of Norman mission structures.[29] Next came a series of articles on colonial architecture, and once it was even suggested that a special ecclesiological mission journal be established.[30] Although this was not done, in 1848 a New World outpost was founded, the New-York Ecclesiological Society, whose official architects were Richard Upjohn, John Notman, and Frank Wills.[31] The *Ecclesiologist* once observed that the most promising part of the whole movement was this overseas program.[32]

Many overseas buildings were ordinary Puginian churches or cathedrals, like

[26] Many of Pugin's churches were Perpendicular, for example, St. Marie's, Bridegate, Derby (1838–39); St. Anne's, Keighley, Yorks. (1840), was a chapel-form structure with western triplets.

[27] *Ecclesiologist* 1 (1841–42):141–42. Arley Park, Northwich, was the residence of R. E. E. Warburton, a member of the Society.

[28] *Ibid.*, 11 (1850):211. They sent Frank Wills to Fredericton, New Brunswick, to build for the new diocese there (Stanton, *Gothic Revival*, pp. 127–58).

[29] *Ecclesiologist* 1 (1841–42):4–5. In *ibid.*, 8 (1847):141–42, a new cathedral in Adelaide is described, part of a college quadrangle, of brick, and with a low, embattled crossing tower and crude tracery. In the same volume a stone church for Prossers Plains, Tasmania, is described (p. 87). For Street's church in Hobart Town, Tasmania, see *ibid.*, 12 (1851):150–52. Another article in this volume, by W. H. Walsh, describes the state of ecclesiology in New South Wales (p. 223). In Australia the two Blackets, father and son, and William Wardell remained more Puginian than High Victorian Gothic. The earliest Australian work in the latter style seems to come not earlier than the seventies or even eighties.

[30] *Ibid.*, 11 (1850):211–12.

[31] Other architects associated with the Society were J. W. Priest of Brooklyn, Edward S. White of Charleston, S.C., and Arthur D. Gilman of Boston. Not exactly a Puginian (except for Priest), let alone a Butterfieldian group! For

that by Frank Wills and Butterfield at Fredericton, New Brunswick (1845–53). Similarly, St. James the Less, Philadelphia (1846), a chapel-like parish church, is a "mechanical imitation" of a specific medieval prototype, St. Michael's, Long Stanton, Cambridgeshire.[33] But such Puginian-mechanical structures were not possible in more primitive surroundings, where materials were often limited to the local vernacular and the lack of skilled workers made execution of all but the simplest details impossible. The same limitations also forced the examination of non-English prototypes. As Beresford-Hope put it, ecclesiology was to become as familiar with San Clemente, Hagia Sophia, and the Church of the Holy Sepulchre as with Heckington and York. "We should think upon workhouse chapels, hospital chapels, and barrack chapels, and missionary churches in the midst of Leeds and Manchester. We should remember that Great Britain reigns over the torrid and the hyperborean zone, that she will soon have to rear temples of the True Faith in Benares and Labrador, Newfoundland and Cathay."[34] The dictates of organic progress and the expression of culture and landscape demanded that ecclesiology cast its stylistic net very wide. And it was also to develop, adds Hope, "in accordance with the achievements of modern science [as well as with] our increased acquaintance with the products of all lands, their marbles, their woods, their ornamental work; do not our increased means of commerce all point to fresh stores of artistical wealth, which may hereafter be devoted to the service of the sanctuary?"[35]

These were the convictions and experiences that really pushed the ecclesiologists into their anti-Pugin position. Their first attack appeared in the *Eccelesiologist* in 1846. The onetime friend and master was now described as a joyous child, a veritable Horace Skimpole of the Revival, who made charming sketches "while all about him [were] in breathless progress."[36] In 1847 Hope made what was essentially an even more anti-Puginian declaration. Beautiful though the English medieval ideal had been, he said, it would now have to be given up, even for buildings in England. Even Decorated was, after all, "but one accidental variety of the numerous buildings which in various ages, various lands, and for

the story of the New-York Ecclesiological Society see Stanton, *Gothic Revival*, pp. 159–211.

[32] *Ecclesiologist* 8 (1847):378.

[33] *Ecclesiologist* 6 (1846):195; Stanton, *Gothic Revival*, pp. 106–15.

[34] *Ecclesiologist* 7 (1847):89–90. Benjamin Webb wrote that the Society had been called on for help in the Canadas, Bombay, Ceylon, Sierra Leone, Mauritius, the Himalayas, Tasmania, Guiana, Australia, New Zealand, Newfoundland, Egypt, and Hong Kong ("On the Adaptation of Pointed Architecture to Tropical Climates," *Transactions of the Cambridge Camden Society* [Cambridge, 1845], p. 218).

[35] *Ecclesiologist* 5 (1846):52.

[36] *Ibid.*, p. 11. Thus did the ecclesiologists again anticipate Ruskin, whose attack came only in 1851 (see n. 4 above). In both cases the attackers were ungenerous, and the *Edinburgh Review* (94 [October 1851]:189 [American ed.]) berated Ruskin for his criticism. See also Unrau, "A Note on Ruskin's Reading of Pugin."

various diversities of purpose, the Catholic Church had reared up to the honour of the LORD." Hope questioned its suitability to the needs of the nineteenth century. The modern Church, he said, must be a "living and energizing body, not merely a curious object of antiquarian investigation." One must sift and probe, he added; one must test the "methods which she has adopted in various times, and under various circumstances, to meet her ever-changing wants." He also suggested that ecclesiology profit by the "vast wholesale methods" that now replaced "the more tedious processes of manual labour" and that after due experiment with new building techniques, "where useful and legitimate [they be] pressed into the service of the Church."[37]

Speluncar and Hyperborean Gothic

As early as 1846 articles in the *Ecclesiologist* were suggesting two basic colonial styles, one for the north and the other for the south. The northern style would be based partly on the native vernacular of whatever country the building was designed for.[38] In southern climes a variant of Lombard was suggested, since Lombard was associated with warm climates and was also the mother style of medieval architecture. The two styles also had programmatic implications. The Hyperborean, as I will call it, using Hope's word, was more or less limited to small buildings or interiors. The Speluncar, or southern style, could be executed in polychrome masonry and was capable of monumentality. Both were largely a paper architecture, as it turned out. The styles were in a sense as fantastic as their names, but this very quality, and the freedom it bestowed, made them effective foils for the commonplace reality of "mechanical imitation" and Puginism at home.

Speluncar churches, as a separate type, were first written about in 1845, though the name was not given to them until 1851.[39] From the first the precedents of Italian Gothic were mentioned in connection with Speluncar; the

[37] Hope, "The Present State of Ecclesiological Science in England," *Ecclesiologist* 7 (1847): 89–94.

[38] *Ibid.*, pp. 89–90. And the erection of Scott's St. Nicholas, Hamburg, became "a living mandate to us to do our missionary duty to the human race" (*Ecclesiologist* 12 [1851]: 378). George L. Duyckinck, at a meeting of the New-York Ecclesiological Society (reported in *ibid.*, pp. 229–30), asked for an "American Gothic," while the *Ecclesiologist* itself (10 [1849]:203) had advocated Swedish wooden architecture for Maine and Michigan and northern Italian (i.e., Speluncar) for Georgia, Florida, and Texas.

[39] See Webb, "On the Adaptation of Pointed Architecture to Tropical Climates," pp. 199–218; John Mason Neale, "On the Ecclesiology of Madeira," *Transactions of the Cambridge Camden Society* (Cambridge, 1845), pp. 219–35; Anon., "Colonial Church Architecture—Ceylon," *Eccesiologist* 7 (1847):168–71; William Scott, "Some Notes on the Cathedral of Las Palmas, with a Few Thoughts on Tropical Architecture," *ibid.*, 12 (1851):29–45; and J. F Bourne, "On Tropical Architecture," *ibid.*, pp. 169–72.

churches were to be massive, usually round-arched, low-roofed, often glassless, and carved with tropical flowers and fruits such as the Victoria Regia, the cactus, the banyan, and the pawpaw. Not only Romanesque but even Anglo-Saxon detail was recommended. Heavy planes, stubby piers, open screens, and, in particular, brilliant polychrome, either structural or applied, were in abundance. There were to be few moldings, and the entire effect was to depend on outline and mass rather than on variety and contrast of surface. One author even suggested "a complete Pointed style, which is almost without windows."[40]

These ideas involve something discussed earlier: that in going back to the origins of "Catholick" architecture in order to rekindle its living spirit, one might have to go back before Gothic, or even before Christianity. William Scott wrote:

The philosophical way to study tropical requisites is to pursue tropical architecture from what we can discover of its original or more complete *nisus*—say in India, through its various developments—Chinese, Siamese, Mexican, Egyptian, Persian, Babylonian, with its actual influence on Christian art in the ecclesiology of Chaldea, Ethiopia, and the Eastern Empire. Until the subject is investigated thus analytically from some distinct tropical centre through its various waves, till its last ripple breaks on the banks of the Rhine or the Loire, all that can be attempted is to suggest disjointed hints.[41]

Scott's idea somewhat recalls the hypothesis of J. C. Murphy in his 1795 book on Batalha, that Gothic began in ancient Egypt.[42]

Speluncar may also have had a more immediate root—or perhaps only a fortuitous parallel—in Pugin. In sketches from his days as a scene designer at Covent Garden (Fig. V–4) we find massive, round-arched images quite unlike the small-featured *Rundbogenstil* generally used by Schinkel, Durand, or J. W. Wild. Instead, with their monumental vaults, these designs at once recall Boullée and anticipate Richardson. More important for us, however, they also seem to anticipate what can be divined from verbal descriptions of the tropical designs of the ecclesiologists of the 1840s and 1850s.

[40] Scott, "Tropical Architecture," p. 40.

[41] *Ibid.*, p. 43.

[42] In the introduction to *Plans, Elevations, Sections, and Views of the Church at Batalha.*

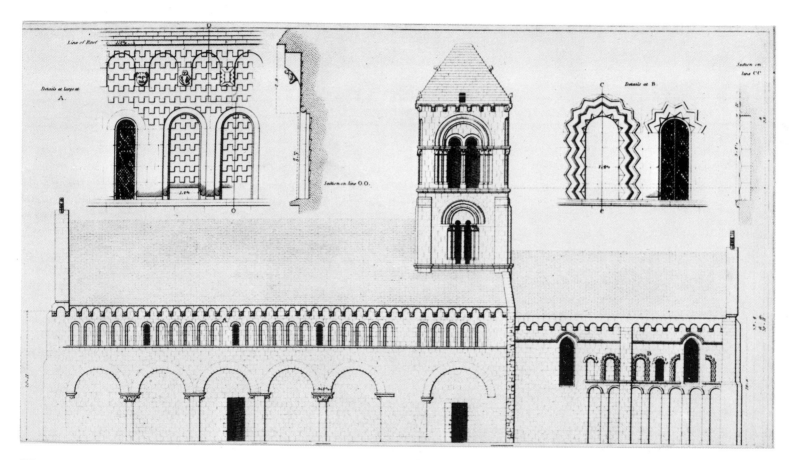

III–9. Than church, near Caen. Engraved by A. W. Pugin. 1827. A. C. Pugin and Le Keux, Specimens of the Architecture of Normandy, *1827.*

[43] *Ecclesiologist* 1 (1841–42):4–5, 47, 51. We are told that lithographic views on a "large and splendid scale" will be published, but I have not been able to track down any. The importance of cathedralesque (if not cathedral) churches in the mission field was as great as at home, as the *Ecclesiologist* made clear throughout the 1840s. See also A. J. B. Beresford-Hope, "Cathedrals in Their Missionary Aspect."

[44] The ecclesiologists' enthusiasm for Norman in the early 1840s was only part of a wider enthusiasm for this style, e.g., Wild's Christ Church, Streatham, of 1842 or Salvin's Holy Trinity, Sewstern, Leicestershire, of the same year. In a similar vein, probably, was Salvin's original design for St. Mark's, Alexandria (Egypt), an Anglican church which was to be a full-fledged monument, unlike the usual embassy chapels in other tropical towns. However, the *Builder* (5 [1846]:421) thought that the Egyptian workmen would be unable to execute Salvin's details. More Continental was Wild's design for Christ Church, also in Alexandria (built in 1842–48), but these designs were less related to the ecclesiologists' Speluncar than to the work of Persius and Gärtner on the Continent.

[45] *Ecclesiologist* 5 (1846):191–92; *ibid.*, 7 (1847):168–71. See also Hitchcock, *Early Victorian*, 1:150. The present structure is by other hands and dates from 1852–54 (Basil F. L. Clarke, *Anglican Cathedrals Outside the British Isles*, p. 16).

[46] *Ecclesiologist* 7 (1847):170.

The earliest reference to Speluncar designs I have come across is found in the group of drawings sent to New Zealand in 1840,[43] mentioned earlier. These were to consist of a cathedral and several identical parish churches; the group was not built. It is significant that the Norman prototype chosen was French rather than English, at least for the parish churches, which were to be based on one at Than, near Caen (Fig. III–9). Another point is that although in the next year, 1841, the ecclesiologists at home were just beginning their battle to distinguish cathedrals from parish churches, the New Zealand missions were to be given aisled chancels, transepts, and central towers—all of which were forbidden in parochial structures as "presumptuous." In the Empire, apparently, pride could replace humility.[44]

In 1846 wider license was granted. Carpenter designed a brick and plaster cathedral surrounded by open verandas and arcades for Colombo, Ceylon.[45] Definitive drawings made in 1846 (Figs. III–10-III–11) were said to combine the native vernacular with features from local Buddhist temples. In plan Carpenter's project called for a short three-bay nave with double aisles, transepts, crossing, and a chancel with double-aisled chevet that was actually longer than the nave. The entire building was to be rib-vaulted. The outer aisle was an open veranda, the windows being filled with metal screens rather than glass. A lower forechurch was built on the west front, "for purposes of discipline," said the *Ecclesiologist*:[46] this idea was borrowed from the local Buddhist temples. The use of additional open screens between the outer and inner aisles was to produce something of the aspect of the Certosa at Pavia. The plaster which was to cover the brick was a native product called *chunam*, a shell stucco which could be polished to shiny whiteness. The effect of these exotic elements, the brilliant surfaces, the screens, and the exceedingly French plan would have been softened only by the English tracery. The result, had it been built, would have been an associational amalgam of native, Continental, and English features.

The Bishop of Colombo mentions another church, in the town of Numara

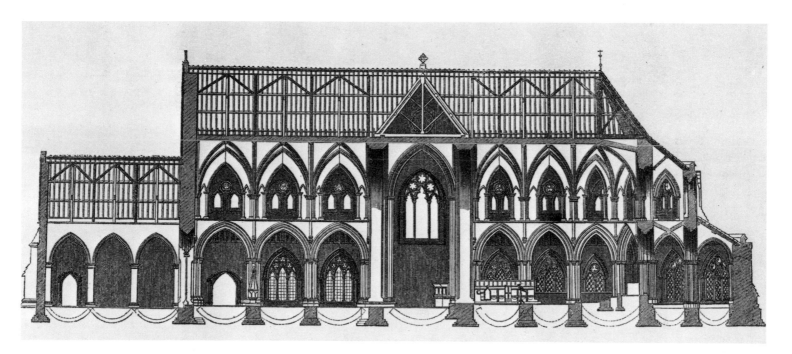

*III–10. Longitudinal section, proposed cathedral for Colombo, Ceylon.
R. C. Carpenter. 1846.* Ecclesiologist, *1861.*

III–11. Plan, Colombo cathedral. R. C. Carpenter. Ecclesiologist, *1861.*

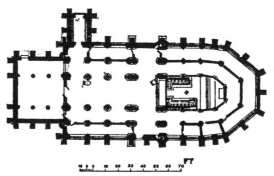

Eliya, ruggedly built of "unhewn granite and teak."[47] This was in a high, cool part of the country, so wood was possible (the Colombo project had called for a metal roof). Then in 1851 Carpenter presented plans for a church in Point-de-Galle, Ceylon, which adapted the Colombo design and Speluncar principles.[48] It too was to be covered with *chunam*. The nave was a ribbed barrel vault; the chancel, also vaulted, was to have a painted roof. Carving, however, was abolished: details "are being kept purposely very simple, and consist merely of single and double splays." There was a saddleback tower and a cloister, and the roof, of teak, was to be triple-gabled, like that of the Austin Friars, London. The lucerne windows in the clerestory were designed in galvanized metal. In 1852 William White designed a college for a place called Woodlands, South Africa, in which the walls were to be of mud and plaster, with cast native ornament and thatched roofs.[49]

The choice of Early Gothic or Romanesque in these churches was often justified on the grounds of the local culture, the law of progress, and the need for primitive associations. "As the work will be chiefly done by native artists," explained the *Ecclesiologist*, speaking of the planned New Zealand buildings, "it seems natural to teach them first that style which first prevailed in our own country." French Romanesque had been introduced into England as a foreign style brought by foreigners; among the Maori it would be appropriate for this reason and also because "its rudeness and massiveness, and the grotesque character of its sculpture, will probably render it easier to be understood and appreciated by them."[50] As to their cathedral composition, the parish churches themselves were more or less cathedral in function, being centers for communal activities and education, sometimes even providing living quarters for converts. They often boasted choirs and several clergymen, and since they were remote they possessed extraordinary administrative freedom.

This Speluncar tradition, or at any rate intention, of 1841 and the years following forms an essential context for the High Victorian Gothic which began in

[47] *Ibid.*, 8 (1847–48):88–92.

[48] *Ibid.*, 12 (1851):22–23; *ibid.*, 23 (1862): 32–33.

[49] *Ibid.*, 13 (1852): 301.

[50] *Ibid.*, 1 (1841–42):4–5.

III–12. Proposed cathedral for Honolulu.
William Slater. 1862. Ecclesiologist, 1862.

England in 1849. In this Speluncar setting the Italianism, planarity, color, and primitivism of All Saints (Fig. IV–7) do not shock as they did in Early Victorian London. For example, in 1862 Slater published a project for a cathedral in Honolulu (Fig. III–12)[51] which consisted of a four-bay nave, transepts with crossing tower and broach spire, and an apsidal two-bay choir with chevet: it thus had basically the same system as Carpenter's Colombo cathedral of 1846. There was an engaged tower at the southeast corner and a chapter house adjacent to the northeast angle of the apse. Here again an exterior veranda was designed to give the effect of cloisters, but rather than using a native vernacular material Slater called for painted Lombard polychrome. The harsh interior, with its "simple splays" and air of didactic primitivism belongs naturally to the Speluncar, yet it is at the same time fully High Victorian Gothic (cf. esp. Fig. IV–9).[52]

We can close our discussion of Speluncar with a note on a material considered appropriate not only for that style but for Hyperborean and High Victorian Gothic too: brick. In November 1852 W. A. McVickar, an American clergyman who may earlier have contributed to the creation of Hyperborean Gothic, published an article in the *New-York Ecclesiologist* on "Brick, a Material for Churches." The article was undoubtedly influenced by Butterfield's ideas on the subject, but it is significant at this early date because it has a transatlantic, if not colonial, source. McVickar writes:

We will suppose a church of simple form, nave, chancel, and tower, to be built of brick, letting red brick be the groundwork. Our base course will be red, sufficiently varied by two courses of blue limestone which are used to bind and strengthen it. Above the water-table we begin to panel; but in the present case we will allow the panels to develop into a blank arcade, every third space being pierced with a window; the pilasters and arch will still be red; but for the blank wall between we will employ straw-coloured brick—and this may be ornamented in a variety of ways: it may be banded with lines of black—it may be diapered with black—it may have geometric figures powdered over it—or, again, a medallion of terra-cotta may be made the center

[51] *Ibid.*, 23 (1862):158–59. Slater's design was abandoned for an "Early French" one by Slater and E. C. Carpenter, built in 1867–1902 (Clarke, *Anglican Cathedrals*, pp. 210–12).

[52] Other quite possibly related schemes were R. C. Carpenter's planned church for St. Helena (*Ecclesiologist* 12 [1851]:216); Slater's scheme for a cathedral at St. Kitts, B.W.I., which was consecrated in 1859 (Hope, *English Cathedral*, p. 88); Carpenter's cathedral for Jamaica, B.W.I. (*Ecclesiologist* 16 [1855]:140), not erected; and the projects by Street, Burges, and others for the memorial church at Constantinople (Hope, *English Cathedral*, pp. 89–94).

of some geometric figure, formed by variously coloured brick upon the yellow ground. It will at once be seen that there is no end to the richness with which spaces of this kind may be ornamented.

McVickar goes on to mention zigzag brick string courses, brilliant colors on the terra-cotta discs, sculptures in the manner of Luca della Robbia, and "encaustic tiles, slabs of various marbles, and the different coloured bricks"; he also advocates brick interiors and brick vaults. He closes with the implication that Lombardy will provide suitable precedents for most of this.[53] McVickar's ideas are significant, since he is actually describing a typical High Victorian Gothic wall treatment four years before All Saints emerged from its mass of scaffolding.

Hyperborean Gothic proper, however, was more apt to be of wood than brick, and there was a special appropriateness, aside from the need for topographical expression, in wooden Gothic for countries like Canada and the United States. Many scholars held that medieval architecture was a stone development from wooden prototypes. Anyone wishing to establish Modern Gothic in the north, therefore, might well begin with this wooden stage.[54] Moreover, the zigzags, notchings, punctures, and chamfers of northern medieval woodwork were properly "expressive" of the talents and tools of the house carpenters who built these wilderness chapels.[55] Accordingly, the *Ecclesiologist* published a number of articles on the subject.[56]

One such early wooden chapel was designed by White, not for a hyperborean zone but for a hypermeridian one, the Diocese of Cape Town. The date is 1849 and, unlike his 1852 church for the same country, this one was to be of wood (Fig. III–13). It is a thin rectangle about 70 feet by 20, with a gabled roof and a sparse timber frame braced with raked shores in the manner of buttresses. The chancel is provided with returned stalls in the manner then specially approved, with the lectern in the center, beyond the screen. On the exterior a skeletal bell cote marks the beginning of the chancel; the south porch, more than any other part of the church, resembles the medieval timberwork that had pro-

[53] *New-York Ecclesiologist* 5 (November 1852):173–74.

[54] See James Hall, *Essay on the Origin, History, and Principles of Gothic Architecture*; Johann C. C. Dahl, *Denkmäle einer sehr ausgebildeten Holzbaukunst aus dem frühesten Jahrhunderten in den innern Landschaften Norwegens.* John Weale did the honor of pirating his plates for his "Primitive Churches of Norway," *Quarterly Papers on Architecture,* 1 (London, 1844). Ruskin mentions Dahl's idea too, in *Stones of Venice I* (*Works,* 9:434).

[55] In the spirit in which J. F. Bourne recommended Anglo-Saxon detail for Speluncar (*Ecclesiologist* 8 [1847]:144–45). For the link between this kind of primitivism and progress, see Collins, *Changing Ideals in Modern Architecture,* pp. 67–69. Schimmelpenninck held that simple crude ornament was similarly necessary to reach the Early British illiterates (*Principles of Beauty,* pp. 383–98).

[56] *Ecclesiologist* 7 (1846):190–93 (a letter on Swedish ecclesiology by G. J. A. Gordon); *ibid.,* 8 (1847):63; *ibid.,* 9 (1848):16, on Norwegian churches by W. S. Scott; in *ibid.,* 12 (1851):400 we are told that drawings of Swedish churches by a Mr. Mandelgren of Stockholm are to be engraved in later numbers. This does not happen. America, being a wood-building country, was the scene of equal interest: *Ecclesiologist* 13 (1852): 18–21. See also Charles Congdon, "Wooden Churches," *New-York Ecclesiologist* 3 (1851):182–85, illus. opp. p. 131 (Hitterdal church), and 4 (1852):26–29. In this volume, pp. 91–93, is a

letter from a Danish ecclesiological society, the Selskabet for Danmarks Kirke-Historie. Meanwhile, the famous log church at Greensted, Essex, had been illustrated in *Builder* 7 (1849):115, as restored by T. H. Wyatt.

57 B. Weinreb, *The Gothic of Gothick* (book catalogue) (London, n.d.), no. 288. The *Builder* (2 [1844]:470–71) had illustrated a rather different temporary wooden church, of lighter build, designed by Peter Thompson and erected in Kentish Town in that year. It had a deep chancel, which was, of course, properly ecclesiological, but the interior was covered with oak-grained wallpaper. More "progressive" was William McVickar's Chapel of St. Cornelius, Governors Island, New York (*New-York Ecclesiologist* 2 [1849]:76). This may be linked to the rise in America at this time of two other wood-building traditions, one real and the other legendary: the Stick Style and the Log Cabin Myth. In 1850 William Hay, clerk of the works for Scott's St. John's Cathedral, St. John, Newfoundland, designed wooden churches for that region (*Builder* 8 [1850]:462–63), while another was planned for St. Francis' Harbor, Labrador (*Ecclesiologist* 11 [1850]:200; *ibid.*, 12[1851]:240).

58 *Ecclesiologist* 11 (1850):262–63.

59 *Ibid.*, 12 (1851):59. The design was first published as part 4 of *Instrumenta ecclesiastica* in 1851, then again in the 1856 complete edition. The building was intended for Tristan da Cunha.

60 William Frederick Vroom, *Christ Church*,

vided the inspiration for the whole. The very open frame suggests substantial walling, which conceivably could have been mud (in which case the church might have to be classed as Speluncar rather than Hyperborean).[57]

The next example of Hyperborean Gothic, a wooden church Carpenter designed about 1850,[58] is unequivocal. This was published in 1851 and again in 1856, though never erected, so far as I know (Figs. III–14-III–17).[59] It consists of an aisled three-bay nave with continuous unaisled chancel and south porch. There is no tower, which helps the assertively sloping roof to provide an air of humility, but, as if to counteract this effect, the wall framing is pronounced and stocky, consisting of heavy beams, posts, plates, and lintels slotted for panels. Again, the basic scheme evolved from wooden porches of the Weald of Kent and Essex, as in White's chapel. One thinks also of medieval barns such as the one at Harmondsworth, Middlesex (Fig. III–20), and even of Scandinavian prototypes. For all its simplicity Carpenter's project has a richly eclectic train of associations.

The ease with which Carpenter's conception translates into standard High Victorian Gothic is shown by Christ Church, St. Stephen, New Brunswick (Figs. III–18-III–19). This was designed by Edward S. Medley, its rector, in 1863. Medley had spent four years, from 1853 to 1856, in Butterfield's office.[60] Originally Christ Church had a salient southwest tower with saddleback spire; unfortunately, the tower was destroyed soon after it was completed. Medley also departed from Carpenter's conception by raising the mighty clerestory, increasing the slope of the nave roof, and emphasizing the contrast between posts and studs. The curved braces over the door in Carpenter's design now contain a pointed panel with a cinquefoiled rose inscribed within it, and the bargeboards are correspondingly enriched.

The interior is even more Butterfieldian. The complementary possibilities of walnut, cherry, and pine are exploited in a stalwart eight-bay frame rising to a height of fifty-five feet. The system consists of powerful wooden arches on short chamfered posts. There is a crossing space just before the towering chancel—another High Victorian Gothic device—and the east wall of the latter is flat, with

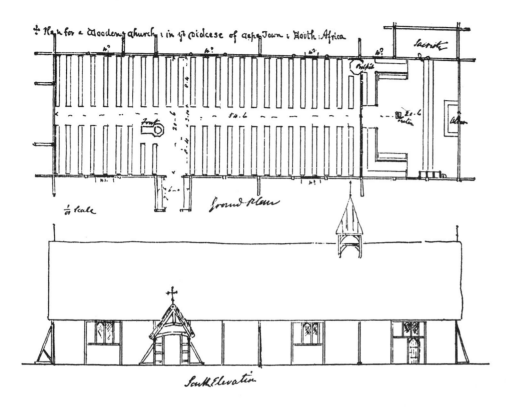

Plan for a Wooden church: in ye Diocese of Cape Town: South Africa

Ground Plan

South Elevation

III–13. Wooden church for the Diocese of Capetown. William White. 1849. Weinreb, The Gothic of Gothick, n.d.

a window in it by Butterfield himself. Moldings of all kinds are suppressed, while the foiling and paneling (the latter is not original) are of the simplest.

This sort of building has an obvious parallel in the dense geometrical surfaces of some of Loudon's designs and of Pugin's plain style (Figs. I–22, III–7, III–18-III–19). There is the same sense of lamination and joiner-like simplicity, and there are other parallels as well—with the American Stick Style, for example. However, as Scully's findings have made clear, the latter boasted a hyperbolically bony membrane with a taut dry skin of weatherboarding or shingles, quite differ-

St. Stephen, N. .B., p. 19. Medley built five smaller churches of extraordinary character in the same province; Douglas Richardson will shortly publish them. On Vroom's evidence Medley can be added to the very short list of pupils given for Butterfield by Summerson (*Heavenly Mansions*, p. 162).

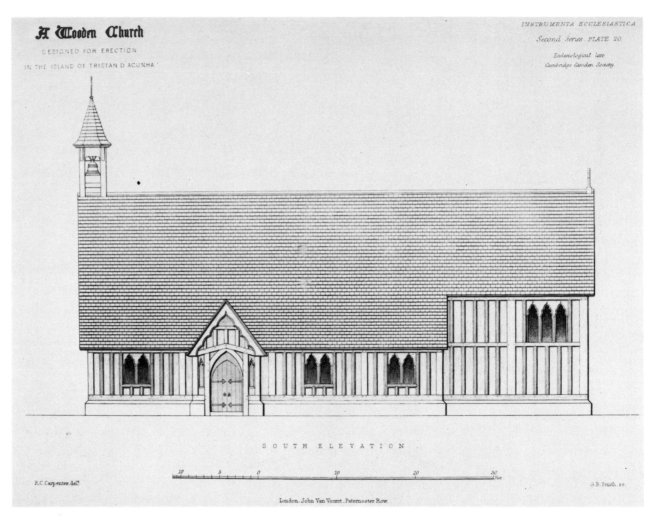

SOUTH ELEVATION

R.C.Carpenter. delt.

G.B. Smith. sc.

London. John Van Voorst, Paternoster Row.

III–14. Side elevation, wooden church for Tristan da Cunha. R. C. Carpenter. 1850. Instrumenta ecclesiastia, *1856.*

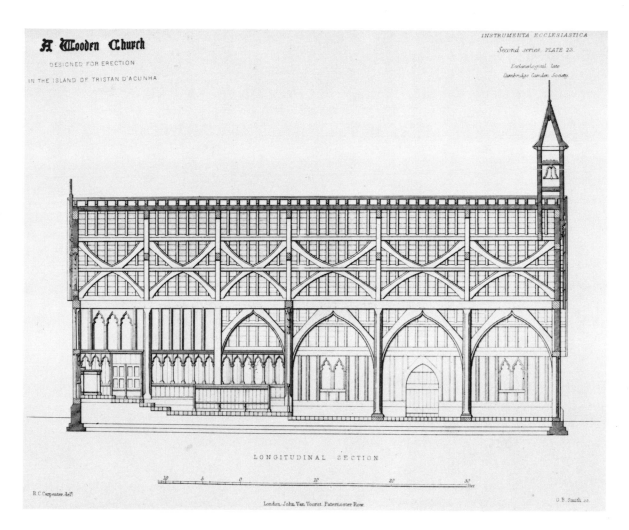

A Wooden Church

DESIGNED FOR ERECTION

IN THE ISLAND OF TRISTAN D'ACUNHA

INSTRUMENTA ECCLESIASTICA

Second series, PLATE 23.

Ecclesiological late
Cambridge Camden Society

LONGITUDINAL SECTION

R.C.Carpenter. del.

London. John Van Voorst. Paternoster Row.

G.B. Smith sc.

III–15. *Longitudinal section, Tristan da Cunha church. R. C. Carpenter.* Instrumenta ecclesiastica.

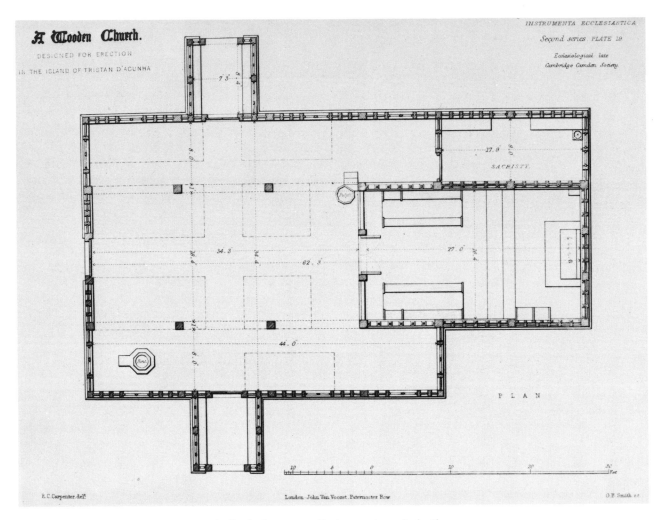

London. John Van Voorst. Paternoster Row

III–16. Plan, Tristan da Cunha church. R. C. Carpenter. Instrumenta ecclesiastica.

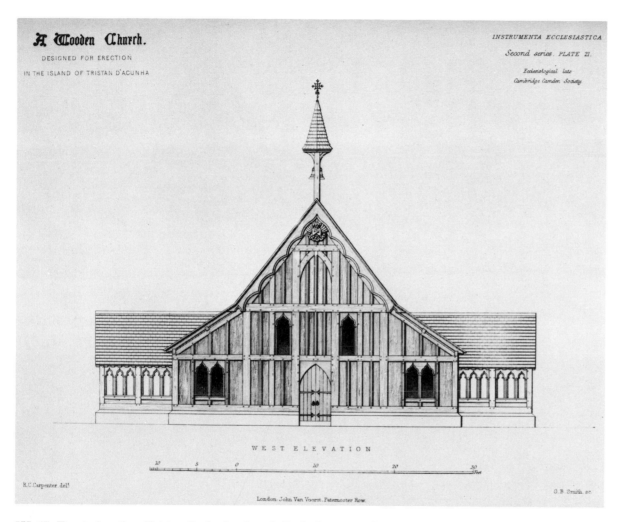

A Wooden Church.

DESIGNED FOR ERECTION

IN THE ISLAND OF TRISTAN D'ACUNHA

INSTRUMENTA ECCLESIASTICA

Second series. PLATE 21.

Ecclesiological late
Cambridge Camden Society.

WEST ELEVATION

R.C.Carpenter del!

G.B.Smith sc.

London. John Van Voorst. Paternoster Row.

III–17. Front elevation, Tristan da Cunha church. R. C. Carpenter. Instrumenta ecclesiastica.

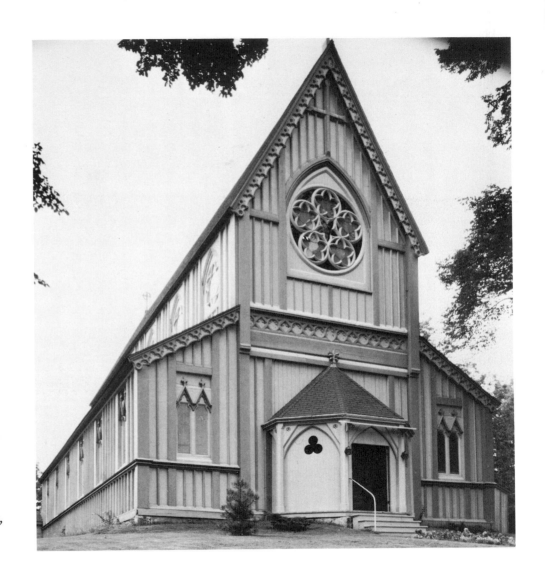

III–18. Exterior, Christ Church, St. Stephen, New Brunswick. E. S. Medley. 1863–64. Photo author.

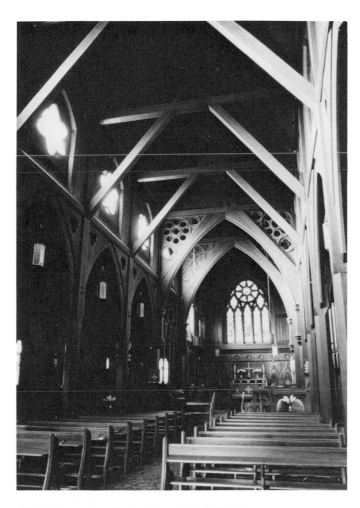

III–19. Interior, Christ Church. E. S. Medley
Photo Douglas Richardson.

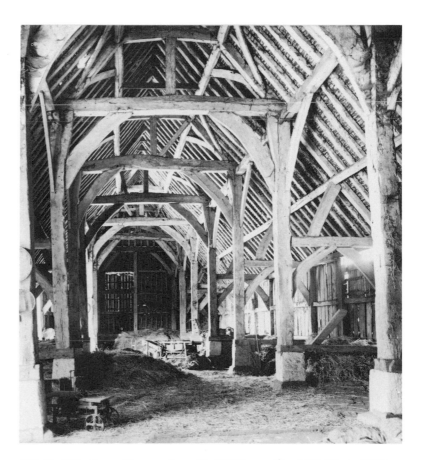

III–20. Tithe barn. Harmondsworth, Middlesex. Ca. 1400. Photo NMR.

ent in effect from Medley's interlocked and jutting frameworks.[61] More important for present purposes, the Medley building is functionally like Slater's 1862 project for the Honolulu cathedral: it is, first, High Victorian Gothic; second, a logical development of a mission style; and third, an exuberant release from the "mechanical imitation" of ecclesiology's earlier phase. Like Speluncar, therefore, Hyperborean created an essential, though somewhat mythical, dialectic with Puginism—a semi-imaginary architecture full of imagination and freedom.

The theoretical and formal developments outlined in this chapter push forward the implications of the associational theory described earlier: there is the construction of a superstyle from fragmented substyles, the assimilative worldwide spread, and the desire to express topography, materials, and means of production. There is also the attempt to create biomorphic, implicitly sexualized imagery and to "breed" a Modern Gothic. These principles made long-continued use of Pugin's approach impossible for the ecclesiologists: for them Puginism was simply a preliminary purgation. Even their earliest criticism separated them from him, as it struck an emotive and dramatic note and paved the way for the bolder contrasts of Speluncar and Hyperborean. Indeed, the two mission styles, the one cavernous, heavy, and curved, the other angular and skeletal, produced buildings completely free of Revival orthodoxy. They belong to the world of High Victorian Gothic.

[61] Vincent J. Scully, Jr., "Romantic Rationalism and the Expression of Structure in Wood: Downing, Wheeler, Gardner, and the 'Stick Style,' 1840–1876." The same may be said of Eastlake's manner, as set forth in his *Hints on Household Taste* (London, 1868), taken up by Americans, and either classicized or Gothicized.

IV · THE STYLE APPEARS

The Urban Minster

It is time to turn fully from theory to practice. In the following pages I shall try to inject into my reaction to High Victorian Gothic buildings some of the emotion and meaning they had for their earliest viewers. I shall refer to their creaturely and machine natures, and to their harshness, in accordance with the theory I have been expounding. Having saturated myself in Victorian criticism, I assume that the buildings act upon me as they were intended to, but as a safety measure I will wherever possible check my own reactions against the words of contemporary critics. The latter, in fact, have supplied bountiful proofs that their responses to the debut of High Victorian Gothic were of this nature.

To set the scene briefly, the great *Bedeutungsträger* of High Victorian Gothic was the urban minster. This was intended to accomplish in the slums at home what Speluncar and Hyperborean were to do abroad. However, where the

overseas missions were varied and centrifugal, fanning out from ecclesiology's center and taking their character from their different environments abroad, the urban minster was uniform and centripetal, pulling this outer variety back into a consolidated metropolitan style.

The chief origins of the urban minster are to be found in the work of W. F. Hook, Vicar of Leeds, in the late 1830s.[1] Hook's plan was that slum missions should present grandiose pageant-like services to impress the poor. As a further form of impressiveness his church had transepts and a large choir whose roof was higher than that of the nave. The result was that the urban minster, like the overseas mission, was an exception to the rule that parish churches ought not to look like cathedrals, or, as Hope put it, in missions "the choral system must be allied to the cathedral system [and] planted among gigantic mills and crowded alleys."[2] The "natives" of Leeds, Manchester, and London were to be proselytized through the same techniques later applied to those of Ceylon and New Zealand.

Hook's own church, St. Peter's, was a large, undistinguished Perpendicular edifice "situated," said its vicar, "in the very worst part of town, the very sink of iniquity, the abode of Irish papists."[3] It had been remodeled in 1839 by R. D. Chantrell. Architecturally it attracted Hope and the ecclesiologists mainly because of the enormous choir area or *chorus cantorum* that filled the building to its waist and was open to the nave. This made for a wide, squat basilica well adapted for processions.[4] (Once again this is non-Puginian, for Pugin's plans were relatively long and narrow, and with the choir screened from the nave.)

In his book *The English Cathedral of the Nineteenth Century*, Hope tells how he himself developed Hook's ideas in the 1840s: the "minster" was to rise amid a cluster of subsidiary buildings, including a school, perhaps a mechanics' institute, a clergy house, and so on. It was to look huge and prepotent. "The railway station," says Hope,

with its fluctuating thousands, has replaced the sulky booking-office, Gloucester Coffee-House, or Elephant and Castle. The long train stands in the place of the compact

[1] See *Ecclesiologist* 8 (1847–48):129–34; Hope, *English Cathedral*, p. 130; G. G. Pace, "Pusey and Leeds"; and W. R. W. Stephens, *The Life and Letters of Walter Farquhar Hook*, 2:190–204.

[2] *English Cathedral*, p. 130.

[3] Stephens, *Hook*, 1:403.

[4] *Ecclesiologist* 8 (1847–48):133.

stage-coach; great central hotels, with their machinery of lifts and their array of coffee-rooms, are gradually encroaching on the tavern and the lodging-house. Can then the influence of this same spirit—this increased appreciation of vastness—this greater aptitude for living and moving in a crowd—not make itself felt in man's religious transactions?[5]

Other writers had already sounded these themes, even specifying the actual forms through which the desired impressiveness was to be achieved. In 1850 G. E. Street wrote an article "On the Proper Characteristics of a Town Church."[6] It was to have high, smooth walls and flattish roofs—just the reverse of country churches. There were to be colored bands of stone, setbacks, and panels. Projections generally were to be thin. Some of these ideas had earlier been suggested for Speluncar; however, Street also advised large windows and high clerestories to suit the cities' dark climate. Towers were to be set back from the street, with clearly defined bases and caps. Like Hope, Street wanted full cathedral massing for the town church—with transepts, apse, and chevet, numerous side chapels, and perhaps double aisles.

The motive underlying this desire for a proud, splendid architecture, with perhaps the cruel force of a great factory, was twofold. On the one hand, it expressed, as the *Ecclesiologist* implied, the Church as a citadel-fortress; in the words of its New World offshoot, it suggested that "the church now finds herself surrounded by infidelity, cold faith, and unsanctified learning, and every new temple which she erects should be like Noah's ark—a protest and a warning."[7] Once again we hear praise for uncomfortable seating: Street, in fact, not only urged the abolition of box pews but seemed to prefer no fixed seating at all, not even "benches"; at least he praised the large Continental crowds of worshipers "standing and sitting [on movable chairs], leaving no passage-way and no waste room, anxious only that they may, by pressing near, hear every word of warning and of advice!"[8]

The second aspect of this taste was that, after all, the poor themselves desired it. Thus Henry Phillpotts, Bishop of Exeter, explained:

[5] Pp. 128–29.

[6] *Ecclesiologist* 11 (1850):227–33.

[7] *New-York Ecclesiologist* 4 (1852):185.

[8] G. E. Street, *Brick and Marble*, p. 84.

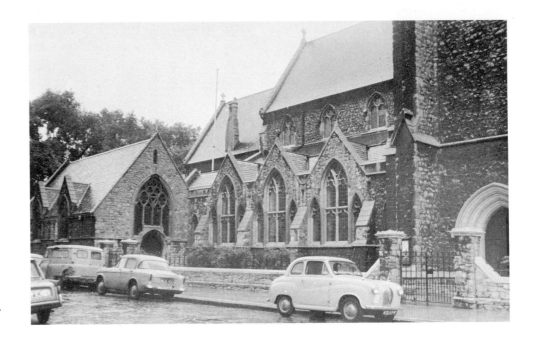

IV–1. Exterior, St. Barnabas, Pimlico. Thomas Cundy II (and William Butterfield?). 1846–49. Photo author.

IV–2. (opposite page) Interior, St. Barnabas. Thomas Cundy II. Photo NMR.

[9] *Ecclesiologist* 12 (1851):219.

Where the congregation consists mainly of the poorest orders, there we commonly observe a great love of a majestic and even elaborate service. The ornaments of their church—the storied glass—the painted, and, it may be, gilded walls—the table of the LORD elevated above the rest, and decked with sober yet costly furniture—the pealing organ—the chanted psalms—the surpliced choristers—the solemnity of the whole ritual—gladdens while it elevates their minds; they recognize in it their own high privilege as Christians, and rejoice to find themselves equal participants with their richest neighbours in the homage thus paid to the common LORD and FATHER of all.[9]

Phillpotts adds that the church's magnificence, far from raising these people in

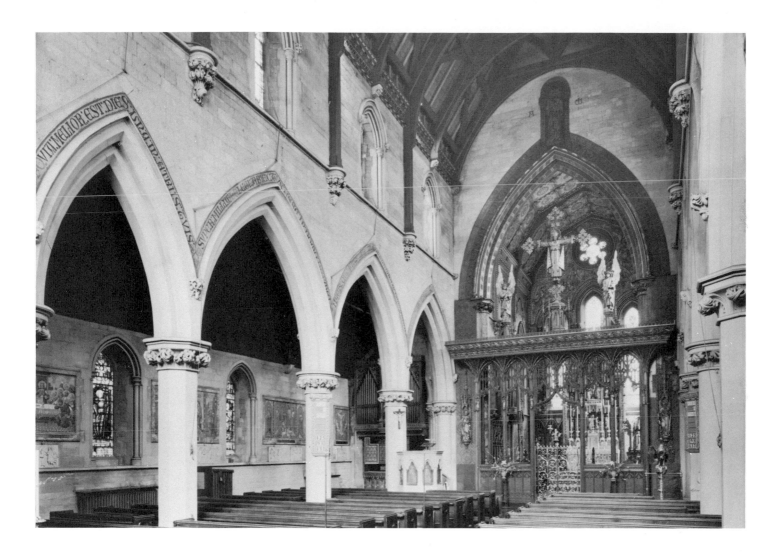

their level of life, was intended to impress upon them the inevitability of their squalor and to "solace [them for] that poverty to which the providence of God had consigned them."[10]

We have already glanced at an early, relatively unsuccessful urban minster, Cundy's ecclesiastical group in Pimlico (Figs. IV–1-IV–2).[11] While this is no mere remodeling like St. Peter's, it nonetheless breaks most of Street's rules. It is low-walled and roofy; it lacks color and contrasting bands; the walls are rough instead of smooth, and not paneled; and the projections are bold. The clerestory errs in being low, while the tower rises directly from the sidewalk. Nevertheless, Cundy's church possessed important new properties: all its seats were free, and attached to it were a monastic-looking school and clergy houses. The interior, moreover (Fig. IV–2), displays a lavish color that would have been familiar to few working-class residents of Pimlico in any surroundings, least of all in a church.[12] Against this plain background of an Early English nave and a one-celled chancel is a tall, ornate screen with heavy rood beam, the upper part of it an arcade of thin, traceried arches. The chancel floor and dado are rich with Hardman's encaustic tiles, the walls and cradle-ceiled roof enlivened with paint. Though the basic means are still Puginian, the effect is cruder and brighter and more rigidly zoned—e.g., as between rich chancel and plain nave—than in St. Giles (Fig. III–4). Next to the southwest porch a small green courtyard opens unexpectedly between the church and the other buildings. This is another sharp juxtaposition; the use of such sudden openings became an important part of the formulas for urban minsters.

The next urban minster, St. Mary Magdalene's, Munster Square, was begun in 1849 (Figs. IV–3-IV–4).[13] Here the architect, Carpenter, was Puginian or even a little pre-Pugin in the bald interior, now much gilded, but he did provide the more cathedral-like chancel needed for mission ecclesiology's greater pomp. In St. Mary's, indeed, an unequivocal divergence from Pugin at last appears in a major London ecclesiological church. In contrast to St. Giles, Cheadle (Figs. III–1-III–2, III–4), with its typically centralized plan and its elevations equally

[10] *Ibid*. G. E. Street claims that rich color has a greater appeal to the religious mind no matter what social class it belongs to (*Brick and Marble*, p. 128).

[11] For St. Barnabas see *Builder* 7 (1849):162; *Ecclesiologist* 11 (1850):110–14; *Illustrated London News* 16 (1850):428; *Punch* 19 (1850):229; Eastlake, *Gothic Revival*, pp. 248–49; Hitchcock, *Early Victorian*, 1:153–54.

[12] The chief begetters of All Saints, Margaret Street, were also involved with St. Barnabas. Hope was a patron (*Ecclesiologist* 20 [1859]: 188–89), and Hitchcock asserts that Butterfield assisted in designing the schools and clergy house (*Early Victorian*, 1:238).

[13] For St. Mary's see *Ecclesiologist* 10 (1849): 353–54; *Builder* 13 (1855):354–55; Eastlake, *Gothic Revival*, p. 250; and Nikolaus Pevsner, *The Buildings of England: London. II. London except the Cities of London and Westminster* (London, 1952), pp. 361–62.

tending toward symmetry, this building, as designed, was to have had slightly but visibly differing aisle widths and lengths.[14] An even more irregular feature would have been the tower, which was not built. Pugin's tower is centered on the west front and is the feature that gives his church its overriding axiality. Carpenter's tower was to be placed one bay in from the southwest corner, forming a small entrance courtyard. Such tower placement was not unusual in country churches by this time, but here it would have provided a novel, even radical, asymmetry and would, at the same time, have formed a sharp, clear slot of vertical space before it—a tall banner, as it were, proclaiming the entrance. Such a conception is quite opposed in spirit and form to the humble porches of Pugin and of orthodox domestic ecclesiology. Also, the detailing on Carpenter's exterior is sparing. Ornament appears only at the angles and edges, whereas Pugin's ornament sprouts continuously, forming a rich blanket. Above all, in contrast to Pugin's church (and also to Cundy's), St. Mary's meets the lot line more definitively. Cheadle and, to a lesser extent, St. Barnabas are walled off from the street and ringed with protective subsidiaries. St. Mary forms firm, continuous solids with the sidewalk and areaways. In keeping with this effect the walls are high and smooth, the projections thin, the windows larger in scale, and the planned tower not only set back but far more clearly articulated than those of the earlier two churches. Thus, far more than they, more than any earlier building I know of, St. Mary's anticipates Street's precepts for the urban church.

One final point concerns materials. All these churches are of stone, but we have noted McVickar's advocacy of polychrome brick—at least for the wilderness culture of the United States. And even for civilized purposes Street had frequently cited brick, or brick and stone together, as being both suitable for eclectic grafting and progressive.[15] In 1851 the *Ecclesiologist* had praised brick as the preeminently urban material and told how Butterfield could put together the "bricks of a manufacturing city . . . with a judgment and delicacy [that can impart] an Italian hue and refinement to the coarse and disheartening vicinity of coal-smoke and mill-chimneys."[16] In urging the use of "fresh stores of artistical

[14] This north aisle was not built until 1885, by Carpenter's son, R. H. Carpenter, but the 1855 publication of the project (*Builder* 13 [1855]:354–55) shows that the varying proportions were part of the original conception.

[15] *Brick and Marble*, p. xiv. See also the letter from Butterfield on brick for city churches mentioned in the *Annual Report of the New-York Ecclesiological Society No. 3*. By 1861 a writer for the *Ecclesiologist* was claiming that brick was necessary in London because it was "naturally a brick town" (*Ecclesiologist* 22 [1861]:317).

[16] *Ecclesiologist* 12 (1851):69.

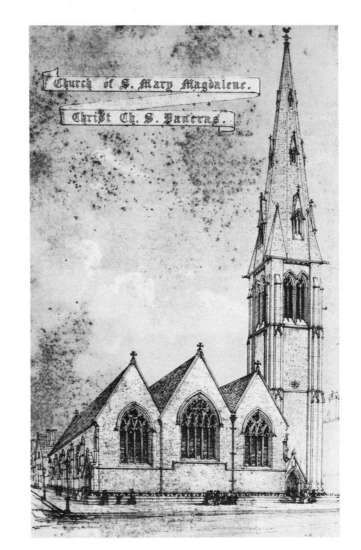

IV–3. Proposed design for St. Mary
Magdalene's, Munster Square, London.
R. C. Carpenter. 1849. Ecclesiologist, 1849.

IV–4. (opposite page) Interior, St. Mary
Magdalene's. R. C. Carpenter. Photo NMR.

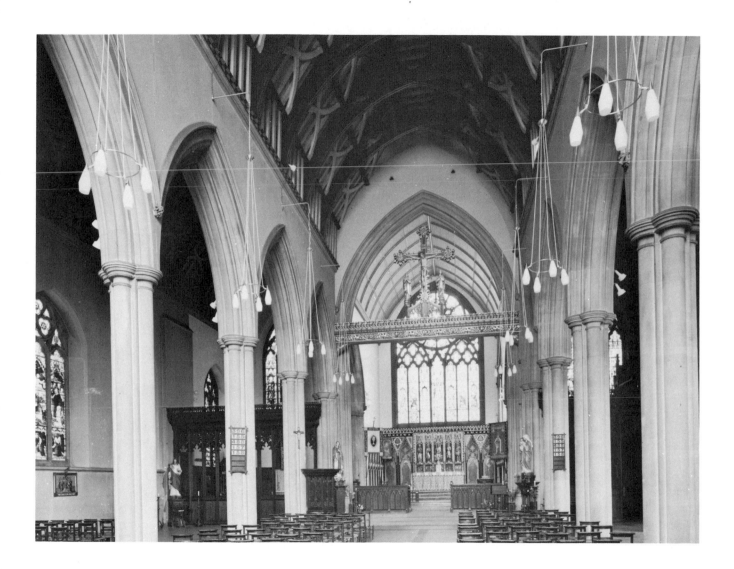

wealth," the *Ecclesiologist* had turned more and more to Italy.[17] Italy even helped provide useful milestones with which to mark out future evolution: the contrast between present and future architecture was to be measured by that between Torcello and Cologne. In 1848 Webb, one of the co-founders of the Cambridge Camden Society, gave wholehearted approval to the brick churches of Venice with their mosaics and apses;[18] in 1851 the importation of such new forms and materials was held by the *Ecclesiologist* to be not merely desirable but "indispensable" for architectural development.[19]

In 1848–49, when, presumably, All Saints was being designed, and during the ensuing years when it was being built, even the *Builder* ran material that anticipated Butterfield's new manner. In 1849 there was an orotund article by W. Cave Thomas on color in "internal ecclesiastical decoration," and throughout the early 1850s numerous illustrations of Venetian, Pisan, and Sienese domestic architecture appeared—much of it, by the way, dating from Ruskin's hated cinquecento.[20] The first hint of original High Victorian Gothic architecture in the *Builder* comes in 1854. It is an illustration of Scott's new chancel for the old Camden Church, Camberwell,[21] though this is round-arched and in other ways has more of a relationship to anti-High Victorian Gothic (cf. Chapter V below) than to Butterfield. A more truly High Victorian Gothic building is St. Mark's Schools, Liverpool, by T. D. Barry, illustrated later that year. Publication of this design, with its gray brick, red sandstone dressings, and spiky silhouette, was an important herald of the new style.[22]

But there had long been curiously proto-High Victorian Gothic effects to be seen in illustrations of native English medieval work. Street's instances of English structural polychrome have been noted; even more, one thinks of the lavish plates of the Society of Antiquaries' *Vetusta monumenta* series, published from the end of the eighteenth century through the early decades of the nineteenth. Some of these engravings, with their firm, solid architectural surfaces worked over with machinesque ornament (restoring original paintwork), anticipate with remarkable accuracy the work of Butterfield and Street (Fig. IV–5). Even straight-

[17] *Ibid.*, 5 (1846):52.

[18] *Sketches of Continental Ecclesiology, or Church Notes in Belgium, Germany, and Italy,* p. 118.

[19] *Ecclesiologist* 12 (1851):180–81.

[20] *Builder* 9 (1851):171, 10 (1852):120, 12 (1854), *passim.*

[21] *Ibid.*, 12 (1854):362–63.

[22] *Ibid.*, pp. 534–35.

IV–5. (left) *Magdalen Chapel, near Winchester. Late thirteenth century. Society of Antiquaries,* Vetusta monumenta, *1796.*

IV–6. (right) *St. Stephen's, Westminster. Benjamin Ferrey. 1845–47.* Builder, *1850.*

forward Puginian interiors could be thus transformed in the process of engraving. I have already mentioned Ferrey's St. Stephen's, Westminster. This is Puginism of the most unquestionable sort, yet the engraving of its nave and chancel that appeared in the *Builder* in 1850 (Fig. IV–6) gives it almost the steel of Butterfield. In contrast to the photograph of St. Mary Magdalene's interior (Fig. IV–4), Ferrey's looks harsh. Yet in reality, nowadays at least, the effect is, if anything, the reverse.

[23] *Ecclesiologist* 12 (1851):90–91.

[24] Early on—e.g., *ibid.*, 4 (1845):56–57—apses were not really condoned, though they were held to take away from the flatness that a short, square eastern limb might have. Later, Hope (*English Cathedral*, p. 188) tentatively approved of them for basilicas, by which term he meant wooden-roofed parish churches of "minster-like" proportions. He had in mind an apocalypse-like arrangement of clergy seats in a wide semicircle, as at Torcello. The scheme actually became widespread in Dissenting circles, and in America such buildings as Richardson's Trinity Church, Boston, are in this sense "parish basilicas." See also Hope, *English Cathedral*, pp. 224–25.

[25] *Notes and Papers*, p. 160.

[26] *Builder* 11 (1853):56–57; *ibid.*, 17 (1859): 328, 364–65, 376 (a laudatory letter from Street), 377, 392, 437, 472–73; *Building News* 5 (1859): 486–88, 586, 778, 1085; *Ecclesiologist* 20 (1859):184–89; *The British Almanac and Companion* (1854), pp. 238–40; *ibid.* (1860), pp. 229–31; *Gentleman's Magazine* 206 (1859):633–34; Eastlake, *Gothic Revival*, pp. 251–55; William A. Whitworth, *Quam Dilecta: A Description of All Saints' Church, Margaret Street, with Historical Notes of Margaret Chapel*; Law and Law, *The Book of the Beresford-Hopes*, pp. 161–68, 175–77; John Summerson, *Heavenly Mansions and Other Essays on Architecture*, pp. 159–76; A. B. de T. Andrews, *A Guide to All Saints'*; Hitchcock, *Early Victorian*, 1:584–94; Paul Thomp-

The glassy glitter of High Victorian Gothic, with its hard surfaces and aniline colors, is also reflected in the ecclesiologists' attitude toward stained glass. They not only liked it but wanted to preserve the moment at evening when the church is saturated with light both within and without—when daylight illuminates the glass while candles are burning inside. The effect could be achieved naturally only at certain times of day, but by rimming the exteriors of the windows with gaslight, a permanent appliance for nighttime services could be created. Speaking of the House of Lords, which had such an installation, the *Ecclesiologist* praised its "singular, almost unearthly effect."[23] All surfaces were to be saturated with the special brilliant colors that, for White and his fellows, exerted such "unconscious influence" over the minds and hearts of believers.

Nevertheless, despite its transepts, height, and general ambitiousness the urban minster was not truly a cathedral. At the same time so colorful and so Italianate, it was really more of an exotic "basilica." And this "basilican" aspect was expressed by the use of open timber roofs.[24] Such roofs were also preferable, according to Street, because they make possible a "change and variety" in plan that is less easily achieved in a vaulted structure with its regular bays.[25]

Putting all this together, we should not be surprised to find the first true High Victorian Gothic building an urban minster, magnificent in squalid surroundings, developing the new features of St. Mary Magdalene's, built with Italianate virtuosity of stock brick, hard and shiny in color, with Speluncar walls and Hyperborean roof, and expressing, in forms and materials, the "Catholick" topographical extent of the Anglican Communion.

All Saints and Other Butterfield Churches

All Saints, Margaret Street, Westminster, was designed in 1849 and consecrated ten years later, on the twentieth anniversary of the founding of the Cambridge Camden Society (Figs. IV–7-IV–10, IV–12-IV–14).[26] The church was built, according to the *Building News*, in the middle of a bohemian slum—which pro-

vided additional motives for the "foreign character" Hope thought slum minsters should have.[27] William Butterfield was a logical choice for the commission because for almost a decade he had been the Ecclesiological Society's mission specialist, a dutiful practitioner of mechanical imitation, designing plate and furniture and providing working drawings of medieval models for overseas use. The climax of this period of his work was 1845–48, when he rebuilt St. Augustine's Abbey, Canterbury, as a college for mission clergy.[28]

Up to this point, apparently, Butterfield in his British work had been a docile Puginian. It is therefore worth noting that Hope, that prime mover both of overseas and of High Victorian Gothic, made a major contribution to All Saints (as well as to St. Augustine's). In the former case he acted as a sort of unofficial patron and, indeed, claimed partial credit for the design.[29] Whether or not this claim was justified, it is undeniable that the style of All Saints is not fully anticipated in Butterfield's earlier work, and perhaps Hope does deserve some credit for the way the church was able to "domineer by its elevation over the haughty and Protestantized shopocracy."[30]

The English qualities of the complex should be discussed first. They are chiefly its square-chancel plan and basic articulation (Figs. IV–7-IV–9, IV–12-IV–14). Occupying a rectangular site approximately 100 feet square, in the middle of the block, All Saints forms a tall, narrow U opening to the street. Along the sidewalk runs a low brick wall which at one time was topped by an arcaded iron fence. There is no foliage or grass of any sort; on the left are the schools, the master's room, and the library, and on the right the equally high but wider clergy residence, both of which are entered from the court. There is a common basement. Behind, in the southwest corner, is the entrance porch for the church proper. The south aisle and clerestory of the church form the rear of the court, and the tower rises from the western bay of this aisle, behind the schools.[31]

Thus functions are condensed: aisle becomes court wall, tower rises from house, chancel slides into nave, baptistery is encased in south aisle. These volumes all declare themselves vertically by stopping short in their rise at points suggest-

son, "All Saints Church, Margaret Street, Reconsidered." It should be mentioned, as an oddity, that neither Neale nor Webb seem to have attended the consecration (*Guardian*, June 1, 1859).

[27] *Building News* 5 (1859):486–88.

[28] For Butterfield's mission work see *Ecclesiologist* 2 (1842–43):117, 126; 3 (1843–44):134; 5 (1846):98–100, 111–12, 141. The article signed "P. W." in the Supplement to the *D.N.B.*, s.v., attributes churches in Poona, Bombay, Cape Town, Port Elizabeth (South Africa), and Madagascar to Butterfield. He designed cathedrals for Melbourne and Adelaide (South Australia). For Butterfield himself, aside from the bibliography given in n. 26 above, see *Men and Women of the Time* (London, 1899), p. 162; *Journal of the Royal Institute of British Architects* 7 (1900):241; *The Times*, February 26, 1900, p. 8; Thieme-Becker, *Allgemeines Lexikon der Bildenen Künstler*, s.v. (by James Weale); Hitchcock, *Early Victorian*, 1:572–613; Paul Thompson, "William Butterfield," in Ferriday, ed., *Victorian Architecture*, pp. 167–74; and Mark Girouard, "Milton Ernest Hall, Bedfordshire." Butterfield himself wrote a pamphlet, *Church Seats and Kneeling Boards*, and an article, "Church Seats," in *Church Builder*, n.s. 6 (1885):77–82.

[29] Law and Law, *The Book of the Beresford-Hopes*, pp. 161–68.

[30] *English Cathedral*, p. 235. Hope had planned

a model church which sounds not unlike All Saints as early as November 1845, when writing to Benjamin Webb: "We must really make our Church a model Church: it should have, like St. Saviour's, Leeds, the spiritual advantage of being planted on a site which very much wants one, combined with greater aesthetical perfection." It was to be tall and apsidal, with "a boundless area of nave to hold as many as possible of the adjacent all but heathen population. The windows should be lofty and space be afforded for mural painting, window tracery and painted glass being also developed to perfection" (quoted in Law and Law, *The Book of the Beresford-Hopes*, p. 161). In 1853 Hope claimed that "the artistic invention of the design [of All Saints] is fully as much due to me as it is to him [Butterfield]. The following points were entirely my suggestion: the use of granite and alabaster and of brick externally, the frescoing of the east end, the German plan of a choir raised above the nave, and the vaulting of the choir, and the fixed super-altar" (quoted in *ibid.*, pp. 176–77). Street says that someone other than Butterfield, and against Butterfield's advice, had ordered the groining to be painted and the vault ribs gilded, and that that person was also responsible for the character of the glass (*Builder* 17 [1859]:376). This person, not named, was probably Hope, who was ultimately to write: "The architectural responsibility of All Saints, Margaret-Street, rested in my hands; and, in concert with my accomplished friend Mr. Butterfield, it was my object

ing their relative importance, rather like the vertical bars on a graph (Fig. IV–7). Thus we read (following the original published design): humble gate, humbler fence; clergy house on the right, gentler, more domestic (more chimneys, more windows, more gables) schools on the left; dependent porch, ascending hierarchy of aisle and clerestory, and triumphing tower with what was at the time the tallest spire in London, variously reported to be 222 or 227 feet.[32] The fenestration elaborates the functional differentiation of the parts, with the domestic windows in white sash and the ecclesiastical ones traceried; within these categories there are further functional distinctions—e.g., the staircase, living quarters, and communal room in the school are expressed, as are the aisle and clerestory of the church. So too the brickwork, laid in richer patterns in the church than in other parts, makes a due distinction, as do the roofs. The basic ecclesiastical associations are all in order, while the mission purpose is clearly indicated through the assertiveness and scale of the group.

The underlying composition confirms its Englishness in that it seems borrowed from a Pugin plain-style source already mentioned, the bishop's palace at Birmingham (1839–41; Figs. III–5-III–6).[33] This too had been set tightly around a small court separated from the street by a wall and arched gate. The Birmingham palace also had high gabled wings at right angles to the hall and a tower in the left-hand inner corner of the court. Here, as at All Saints, a nave-like space ran across the back, though this housed a library, not a church. Both buildings were of red brick with irregular stone dressings and with additional patterns of vitrified headers.

But Butterfield's adaptation of this prototype is the measure of the difference between Early and High Victorian Gothic. Pugin's building occupied its site with a certain nonchalance. But All Saints, especially with its "expressive" fenestration, is a strange sight among the demure rectangles of Margaret Street. This is particularly true of the windows as they relate to the normal coordinates of the street façades. On the right-hand wing is a bay of segmentally arched openings just off center, and to the right of these an unrelated bay of very thin windows.

To the right, now, there is another vertical row of windows centered under its gable, just to reinforce the point. On the left of the main row of windows—missing it by inches—is a doorway (not shown in Fig. IV–7). Similar effects appear everywhere, warping the surrounding geometry.

Butterfield has also tautened the planes that seem in Pugin's building (as illustrated) somewhat slack. The ecclesiological designer's ornament suggests abrasion and extrusion. At gable level the black brick lines and zigzags in All Saints lace through the red brick ground like thongs—an effect greatly exaggerated, however, by the engraver of Fig. IV–7. Similarly, where Pugin's roofs are handled as volumes, Butterfield's are handled as pronged parapets forced sharply beyond the roof planes.

Some of these things are simply further developments along the path taken by St. Barnabas and St. Mary Magdalene's. Thus similar pronged parapets and roofs had appeared in the former, while All Saints continues to animate space and volume into tall or long slots, continues to abrade and segregate ornament, to internalize patterns in the manner of St. Mary's. But now there is also exotic detail. The building is tinctured with mission trophies; the black brick cross on the gate tympanum reminds one of a "primitive" woven design, and some of the window arches look Islamic (Fig. IV–7). These resemblances, however, are general, and even more general are the zigzags, diapers, and stripes common to so many ages and countries.[34] They are, in fact, just such universalizing, "Catholick" details as Street and others were calling for. The masonry, meanwhile, expresses the tools and machines that shaped it.

The use Butterfield makes of all this is peculiarly dissonant. His technique evokes Wightwick's "mangled forms." The diapering, for example, is commonplace in Perpendicular and Tudor, but Butterfield's stripes move up the side of the building in irregular jumps and, as built, are joined at times by white checkers, in disregard of floor levels and openings, until at the gables of the street façades they become borders for zigzags. This arrangement lasts for two rows, and then the narrowing triangles that contain them are dressed with tall unbanded diapers

to work out a higher and more minster-like type of parish church than previously existed in modern British architecture" (*English Cathedral*, p. 235).

[31] Law and Law, *The Book of the Beresford-Hopes*, pp. 161–68.

[32] *Builder* 11 (1853):56–57; Hitchcock, *Early Victorian*, 1:581. Such increasing upper elaboration, a form of structural and even theological expression, is elucidated by John Betjeman: "A general Victorian principle was that Gothic is more elaborate the nearer it reaches Heaven. This Butterfield followed. But he also emphasized construction. Where there is a heavy downward pressure at the base the lines are few and horizontal and strongly marked. When the wall is a screen wall only, as above the East window [of Keble College chapel], he uses chequer pattern. Roof thrusts are indicated by criss-cross pattern" (*First and Last Loves*, p. 157).

[33] Pugin, *Present State*, pp. 102–8. Douglas Richardson reminds me that the model of St. Augustine's, Ramsgate, depicted in the south transept window of that church is elongated in such a way as also to resemble All Saints.

[34] Hitchcock (*Early Victorian*, 1:574–79) claims that the effect is generally German and Lombard, which could have been partly the result of the trip Weale says Butterfield took to northern Germany, Scandinavia, France, and northern Italy (Thieme-Becker, *Allgemeines Lexikon der Bildenen Künstler*, s.v.).

(not shown in Fig. IV–7). The difference between such visual dissonance and the serene uniformity of typical Italian stripes (Fig. IV–11) is striking. In such earlier usages the stripes might not have corresponded to floor levels or matched openings, but they were regular. Under Street's rules the stripes might have been irregular but would have unequivocally expressed inner divisions of the building. With Butterfield the stripes do neither the one nor the other. The coordinates generated by the windows are quite different from those of the stripes—and which of the latter, if any, tell us about floor levels is not sufficiently clear. This random-looking heterogeneity is increased by the voussoirs in the street façades. These interrupt, and indeed shatter, the horizontals in a way quite different from the Monza façade, where voussoirs smoothly become stripes and vice versa.

The interior of All Saints is more brightly colored than the exterior and is dominated, in terms of structural expression, by the alabaster framing of its arches. "Beyond question," said the *British Almanac*, "it is the most gorgeous church interior in the kingdom." *The Guardian* saw All Saints as a composite of southern and northern architecture—though without using the terms Hyperborean and Speluncar—and as an essentially male, even violent structure. They were pleased that there was "nothing effeminate or luxurious" in the capitals and contrasted All Saints's virility with the "weak patternings" of Pugin and Owen Jones. The *Gentleman's Magazine* similarly saw the church as a composite of southern and northern Gothic but as superior to Italian in that it avoided the latter's faults. The northern elements, especially the wooden roof, made up for the "failures" characteristic of Italian.[35]

The plan of All Saints is normal for an urban minster, only three bays long (Figs. IV–8-IV–9); the side aisles are low, emphasizing the central space's "minster-like" aspect. The baptistery, as noted, is located in the southwest corner between the tower piers (Fig. IV–10). The aisles end in chapels flanking the sanctuary, the latter being screened with large-scale stone traceries.

But within this normal English arrangement Butterfield once again reveals his eclecticism. Here is the coalescence of south and north, of cave-like and

[35] *British Almanac* (1860), p. 229; *Guardian*, Supplement, May 25, 1859; *Gentleman's Magazine* 206 (1859):633–34.

IV–8. Plan, All Saints.
William Butterfield. Builder, 1853.

IV–7. Exterior, All Saints,
Margaret Street, Westminster.
William Butterfield. 1849–59. Builder, 1853.

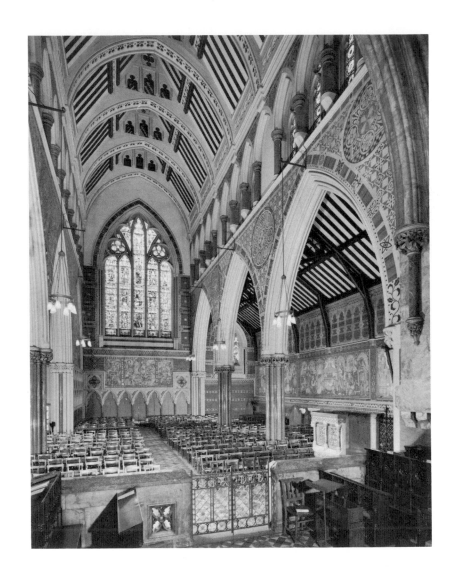

IV–9. Interior, All Saints.
William Butterfield. Photo NMR, 1965.

IV–10. Original design for font and baptistery, All Saints.
William Butterfield. Builder, 1853.

IV–11. Monza cathedral. Knight,
Ecclesiastical Architecture of Italy, *1843.*

IV–12. Exterior, All Saints.
William Butterfield. Photo NMR, 1943.

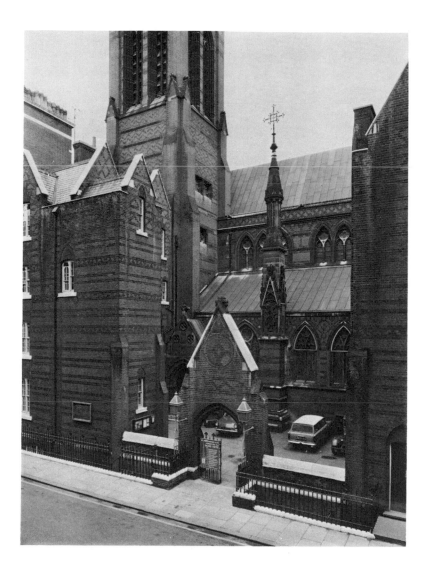

IV–13. Exterior, All Saints.
William Butterfield. Drawing of ca. 1953.
Andrews, A Guide to All Saints, 1953.

IV–14. Forecourt and entrance, All Saints.
William Butterfield. Photo NMR, 1965.

forest-like. Here, "the woods and marbles of the world" make their obeisance to Modern Gothic. Devon alabaster, marbles from Languedoc and Siena, and a stone called "Irish Green" marble are interwoven. Almost as bright are the local tiles which pave the floor in red, black, white, and yellow. The interior walling is red brick with black tile string courses and Caen stone dressings. The interior is thus an expressive reflex of the exterior but is enriched both literally and figuratively with insets and incised with designs of brown, white, green, and red mastic. These, again, invariably form primitive, universal patterns of stripes, zigzags, checkers, circles, triangles, and the like.

In the interior as on the exterior there is also that now familiar sense of willful deformation. The obeisance of the world's woods and marbles is a painful one, as seen in the height of the nave arches, made more dramatic by the telescoped plan,[36] and by the relative shortness, by Victorian standards, of the clustered colonnettes supporting them. We see it in the profiles of the wooden trusses above, with their metallic perforations, and (to the Victorian, Wilkie-accustomed eye anyway) in the warped, stiffened creatures of Dyce's reredos.[37]

Here, therefore, I must introduce the much-discussed question of Butterfield's sadomasochism. I have already evoked this quality in my associational "reading." As soon as the building was finished, in 1859, the *Ecclesiologist* sensed in it the same quality, calling it "Pre-Raphaelite" in its stern truthfulness and adding: "Curiously enough there is here to be observed the germ of that same dread of beauty, not to say the same deliberate preference of ugliness, which so characterizes in fuller developement the later paintings of Mr. Millais and his followers."[38] The writer found the effect as a whole, however, manly and austere, in fact, almost sublime. This quality was consonant with such things as the "violent," "coarse" capitals and string courses.

The reaction in the professional press was blander. The *Building News*, in a long article, mentioned only the gloom of the exterior and the surprising dazzle of the interior, though, also in 1859, a *Builder* correspondent found All Saints "a magnificent protest."[39] But in 1872 Eastlake described the church as having

[36] The habit of placing choir stalls for laymen beyond the chancel screen or rails, as here, was at first condemned by the *Ecclesiologist*, though it later became standard practice. Butterfield may have been an early adherent of the plan, if he is the "W. B., Architect" who wrote to the *Ecclesiologist* (1 [1841–42]:55) advocating this arrangement.

[37] Ruskin may actually have influenced the selection of Dyce for this job because he made the suggestion in 1852, early in the construction of the church (*Stones of Venice III, Works*, 11:36n). It is curious that he adds that Rossetti and Millais might turn out to be gifted fresco painters and that they ought to be given commissions at All Saints. The present reredos is a 1909 copy by Ninian Comper of Dyce's original, which is preserved behind the Comper copy.

[38] *Ecclesiologist* 20 (1859):185.

[39] *Building News* 5 (1859):486–88; *Builder* 17 (1859):364.

"scandalized" architects with the proportions of its tower and spire, which indeed "sent professional critics to their wit's end with amazement." Eastlake also emphasized the point that it was a "bold and magnificent endeavour to shake off the trammels of antiquarian precedent, which had long fettered the progress of the Revival."[40] In the same year J. T. Emmett, a critical scourge who went beyond even the *Ecclesiologist* in his denunciations, claimed that the "speckled and spotted coloured brick patterns" of the church "are precise reminiscences of a favourite nursery toy"—a form of ecclesiastical infantilism that he felt it his duty to reprehend.[41] Thus in a number of contemporary reactions to Butterfield's building there is clearly a sense of its being masculine, and also purposely ugly, bizarre, revolutionary, abrasive, violent, coarse, and shocking. Eastlake, in fact, even anticipates Summerson's famous image of the church as "a saint in fetters," i.e., the image of a creature freeing itself, or about to do so. This of course also echoes the ecclesiologists' original scenario for a period of servile copying and "fettered invention," followed by freedom.

Summerson did not revive this idea of Eastlake's until 1945, but the critical writings about All Saints of the preceding two decades were already tinged with these sadomasochistic perceptions. Thus in 1928 Kenneth Clark had spoken of Butterfield's "sadistic hatred of beauty," a comment he reaffirmed in a 1950 footnote in *The Gothic Revival*: he added that there was "a Dickensian need of cruelty in Butterfield" and likened his work to dissonant music and G. M. Hopkins's poetry.[42] In a calmer vein, Basil F. L. Clarke, in his 1938 study, *Church-Builders of the Nineteenth Century*, stressed the original and surprising qualities of the church.[43] Five years after Summerson's essay appeared[44] Reginald Turnor elaborated on Kenneth Clark's idea: "Most Victorian architects, of course, delighted in horrid materials, but Butterfield, with his craze for stripes of black and yellow brickwork against feverish red, outdid them all. [His buildings are] an affront, which nevertheless batters the critic into vain imaginings of what the architect might have done in a better age." Turnor also quotes Christopher Hobhouse, who speaks of "Butterfield's worst buildings [as having]

[40] Eastlake, *Gothic Revival*, pp. 252–53.

[41] "The State of English Architecture," p. 161.

[42] Clark, *Gothic Revival*, p. 262 and n.

[43] Pp. 119–21. Whitworth, in *Quam Dilecta*, had also seen it as graceful and beautiful (p. 2).

[44] It is interesting that Summerson, in a later essay on Le Corbusier (1947), sees him too as a destroyer who caused "a ruthless dismemberment of the building *programme* and a reconstitution on a plane where the unexpected always, unfailingly, happens" (*Heavenly Mansions*, pp. 189–90).

a certain power, a certain evil fascination."[45] Hitchcock, writing in 1954, was more moderate, but he did mention "the strikingly novel character of the exterior" and the "startling" polychrome.[46]

More recently still, as noted in the Preface, Paul Thompson at first hewed to the Emmett-Eastlake-Clark-Turnor line and then abandoned it. In his 1963 article he described not All Saints but Butterfield's equally High Victorian Gothic church at Babbacombe, Torquay (1868–74), with its "nave held tightly horizontal . . . the nave floor of harsh wasp-yellow, red and black tiles," etc., and spoke of another building's raw red brick. Thompson related this architectural savagery to a personality change in the architect in 1850, as a result of which Butterfield suddenly became quarrelsome and bitter. In fact Thompson took the sadomasochistic reading as far as it had gone up to then. But two years later Thompson not only denied all this but explained away the phenomenon his theory was intended to account for—i.e., the non-High Victorian Gothic character of Butterfield's earlier work: he asserted that All Saints is *not* harsh, violent, or bizarre—that Summerson's essay is all wrong.[47] Obviously I have allied myself with the Summerson school, though perhaps pushing things rather further than its namesake would like.

Actually, the argument can be resolved. Thompson at present sees in All Saints its basic English shape, executed, he says, in "a soft dusty pink" which, on the interior, transforms itself into a joyous spectacle of color.[48] However, he is seeing this against an architectural backdrop dominated by the New Brutalism. As he writes, All Saints emerges from a context of *brut* concrete, purple brick, and dour industrial forms, and in such a context Butterfield's church *is* relatively dainty. Summerson, on the other hand, when he wrote in the 1940s, was equally influenced by the Bauhaus aesthetic exemplified in England by the pale, papery buildings of F. R. S. Yorke and of Mendelsohn and Chermayeff. In that setting All Saints is relatively sadistic, or at least brutal.

This background may help us to understand the quarrel, but the question of who is right must be answered in Summerson's favor. He saw All Saints in a

[45] *Nineteenth Century Architecture in Britain,* p. 68. Turnor also quotes the Kenneth Clark passage given above.

[46] Hitchcock, *Early Victorian,* 1:581.

[47] The two views appear in Thompson's "William Butterfield" and "All Saints Reconsidered," both cited earlier.

[48] Here "dusty" must have a different meaning than it would have in the United States. The American usage implies a whitish, powdery quality in the color; Thompson evidently means something more like coal dust.

context that was a reasonable approximation of the original setting, i.e., the one, in his own phrase, provided by "smooth Mr. Wilkins, dull Mr. Smirke or facetious Mr Nash." Into this world, not greatly disturbed by Pugin, All Saints burst like a Congo chieftain into a performance of *Les Sylphides*. The best proof of this assertion is the contemporary reaction described above.

Another point raised by these questions is that Butterfield's church—and works of architecture generally, for that matter—are nowadays more often seen in published form than directly; that is, engravings such as Figs. IV–7 and IV–10, through frequent reproduction, have superimposed themselves on the visitor's actual experience of the building. The engravings, after all, are always the same, whereas the building, no matter how often visited—indeed the more often it is visited—is a changing entity. One remembers engravings and photographs of All Saints more vividly than the building itself, just as one remembers a set form of words, often heard, more accurately than an improvised speech.

These famous early portrayals do have a more "sadistic" look than the building itself now does. Fig. IV–10, for example, which is the original conception of the baptistery, really does look rather like a chamber for bizarre tortures—the sanctum of some ecclesiastical pervert. The victim would be sealed into the font and the cover lowered on top of him as his cries filled the marble church. Thus does Butterfield's sensibility, more through his official imagery than his actual works, move toward that of Beardsley or Huysmans. In our own period both the church and the style of its portrayals have varied. All Saints has indubitably softened over the years, and its exterior has taken on a brittle, almost sugary quality. Modern published photographs, with their reticulation and graded tonalities, emphasize this change. This is even truer now than it was a quarter-century ago: compare the hardness and precision of the 1943 photograph in Fig. IV–12 with the much softer, grayer images in 1965 photographs (Figs. IV–9, IV–14). The later style of photography almost exactly suits the observations in Thompson's 1965 article.

An intermediate stage is reflected in a drawing published in 1953 on the

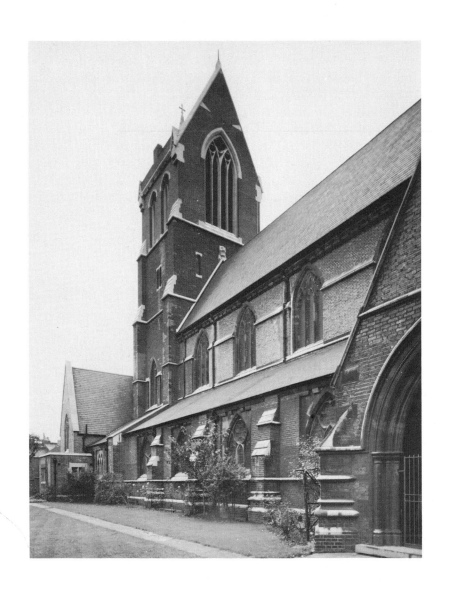

IV–15. St. Matthias, Stoke Newington.
William Butterfield. 1851–52. Photo NMR.

cover of the booklet for sale at the church (Fig. IV–13). Here, instead of the needle spire and sutured brickwork of Fig. IV–7, we have a doughy, demure essay which brings All Saints back toward its Pugin prototype (Fig. III–5). Not only is all the rigidity and sharpness gone but the all-important stripes are omitted. More than Pugin, indeed, this recent portrayal suggests Butterfield seen through the eye of a Mackintosh. And yet Fig. IV–14 is very clearly based on Fig. IV–7 rather than being an independent perception. It is an interpretation of an interpretation, a correction of a standard portrayal, just as Thompson's 1965 article is a correction of Summerson's.

The exoticism and *bizarrerie* of All Saints must now be linked more firmly to the ecclesiologists' overseas mission program. The relationship is not merely one of detail and color. The unusual plan of All Saints, for example, is close both to that of Carpenter's wooden church for Tristan da Cunha, designed a year after Butterfield's building was begun (Figs. III–16, IV–8), and to Slater's iron mission church of 1853–56 (Fig. V–18). Both have a squat three-bay nave, with the same proportions of main to side aisles, and in both the chancel is half swallowed or telescoped by the rest of the church, resulting in a "basilican" choir. The locations of font and south porch are also similar. In the two interiors (Fig. III–15, IV–9) there is even a somewhat similar treatment of the paneling, which gets increasingly compressed as it advances from nave through choir to sanctuary—reminding one of the increasing degrees of holiness and deprivation these spaces express. Even the broad, clumsy proportions of the nave arcades have a comparable rhythm.

If this much of All Saints tends to be Hyperborean, its outer walls recall the Speluncar—thick brick planes laced with polychrome. The same may be said of the interior, where the nave arches are cavernous, the piers stubby, the general effect one of profusion and iridescence. In sum, as the *Gentleman's Magazine* noted, Butterfield has placed a vertical northern roof on a horizontal southern wall system, driving Speluncar and Hyperborean into a "Catholick" embrace.

Butterfield developed these effects in later churches. In St. Matthias, Stoke

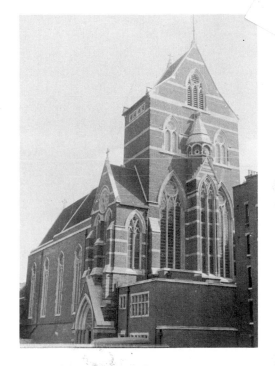

IV–16. St. Alban's, Holborn.
William Butterfield. 1862–63. Photo author.

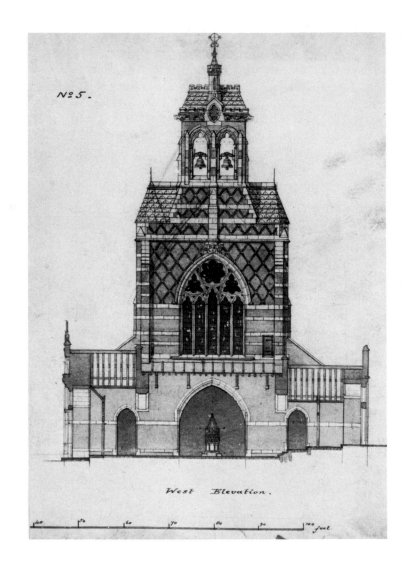

West Elevation.

IV–17. North-south section through
vestibule, St. Augustine's, Queen's Gate.
William Butterfield. Ca. 1865.
Courtesy R.I.B.A.

cover of the booklet for sale at the church (Fig. IV–13). Here, instead of the needle spire and sutured brickwork of Fig. IV–7, we have a doughy, demure essay which brings All Saints back toward its Pugin prototype (Fig. III–5). Not only is all the rigidity and sharpness gone but the all-important stripes are omitted. More than Pugin, indeed, this recent portrayal suggests Butterfield seen through the eye of a Mackintosh. And yet Fig. IV–14 is very clearly based on Fig. IV–7 rather than being an independent perception. It is an interpretation of an interpretation, a correction of a standard portrayal, just as Thompson's 1965 article is a correction of Summerson's.

The exoticism and *bizarrerie* of All Saints must now be linked more firmly to the ecclesiologists' overseas mission program. The relationship is not merely one of detail and color. The unusual plan of All Saints, for example, is close both to that of Carpenter's wooden church for Tristan da Cunha, designed a year after Butterfield's building was begun (Figs. III–16, IV–8), and to Slater's iron mission church of 1853–56 (Fig. V–18). Both have a squat three-bay nave, with the same proportions of main to side aisles, and in both the chancel is half swallowed or telescoped by the rest of the church, resulting in a "basilican" choir. The locations of font and south porch are also similar. In the two interiors (Fig. III–15, IV–9) there is even a somewhat similar treatment of the paneling, which gets increasingly compressed as it advances from nave through choir to sanctuary—reminding one of the increasing degrees of holiness and deprivation these spaces express. Even the broad, clumsy proportions of the nave arcades have a comparable rhythm.

If this much of All Saints tends to be Hyperborean, its outer walls recall the Speluncar—thick brick planes laced with polychrome. The same may be said of the interior, where the nave arches are cavernous, the piers stubby, the general effect one of profusion and iridescence. In sum, as the *Gentleman's Magazine* noted, Butterfield has placed a vertical northern roof on a horizontal southern wall system, driving Speluncar and Hyperborean into a "Catholick" embrace.

Butterfield developed these effects in later churches. In St. Matthias, Stoke

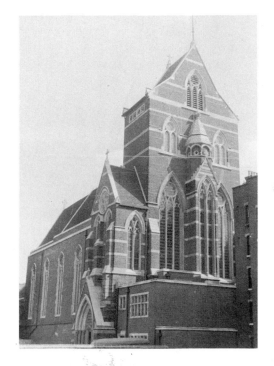

IV–16. St. Alban's, Holborn.
William Butterfield. 1862–63. Photo author.

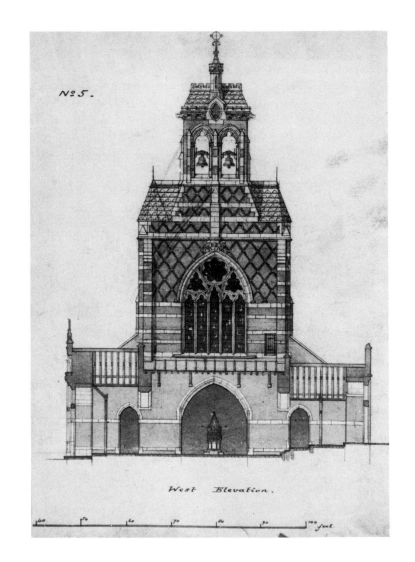

No 5.

West Elevation.

IV–17. North-south section through vestibule, St. Augustine's, Queen's Gate. William Butterfield. Ca. 1865. Courtesy R.I.B.A.

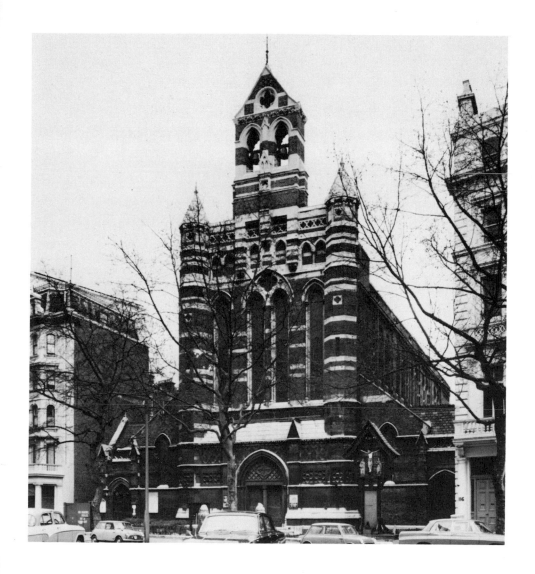

IV–18. Exterior, St. Augustine's.
William Butterfield. 1865–71. Photo NMR.

Newington (1851–52), designed after All Saints and consecrated in the same year (Fig. IV–15), he erected another minster-like carcass, with an enormous clerestory straddled by a saddleback tower.[49] Here the very low porch walls support exceedingly high-pitched roofs: in a similar spirit the shoulders of the western door's tympanum are pushed down to the springing point of the arch within. As in All Saints there is the interlocking of volumes—e.g., the porches and side aisles, or in the western door, which is also the base for the buttress climbing up the middle of the western window. But now the architect abandons the black brick lacings of All Saints and contents himself with puncturing the pink and yellow surfaces with white stone polyhedrals, now discolored, as in the buttress setbacks, the gable shoulders, and the triangular insets in the spire. But the plan is symmetrical, narrow, and compartmented—i.e. more Puginian than minster-like.

Butterfield's third famous town church, St. Alban's, Holborn, of 1862–63, was damaged, like St. Matthias, during World War II; it has been bizarrely restored (Fig. IV–16).[50] But this later-day oddity matches the beauty-and-the-beast way the *Building News* critic saw it in 1861:

There is no blacker spot upon the map than that on the east of Gray's-inn-lane. . . . It is the haunt of the lowest prostitutes and of the worst thieves. Filth, squalor, ignorance, and sin are here huddled together without distinction of age or sex, and with the same compactness as they nestled [*sic*] formerly on the confines of Fleet-ditch. . . . Let any man button up his coat, empty his pockets, and walk through the several alleys or "gardens" which form the dirty channels between Gray's-inn and Leather-lane, and he will see work enough for the church. . . . It was a noble idea which animated the founder of this church in this neighbourhood. If the harvest be not gathered therein it must go to the gaol.

The writer continues that St. Alban's is Butterfield's finest work and that "he will embellish it in the same style as All Saints', Margaret-street, but, we think, with even still better taste."[51] However, J. T. Emmett, as we might expect, at-

[49] For Butterfield's buildings other than All Saints, see nn. 26 and 28 above; for St. Matthias, see *Ecclesiologist* 11 (1850):142, and J. M. Neale, *"He said, Come." A Sermon Preached at the Dedication Festival of St. Matthias, Stoke Newington, June 30, 1859.*

[50] *Ecclesiologist* 22 (1861):317–27; H. S. Goodhart-Rendel, "Gothic Revival Casualties: St. Alban's, Holborn."

[51] *Building News* 7 (1861):46.

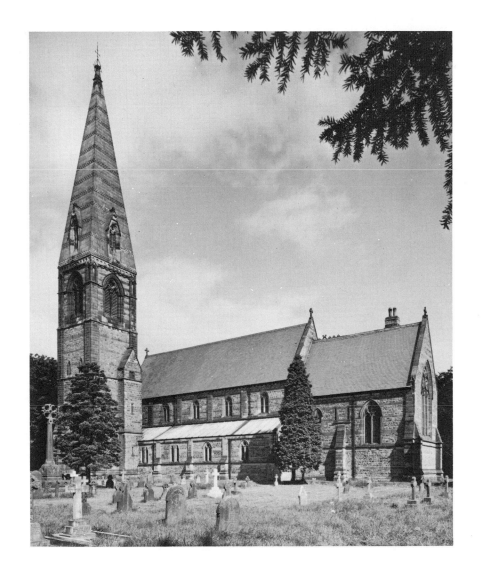

IV–19. Baldersby St. James church, Yorkshire. William Butterfield. 1856–58. Photo NMR.

tributed the filth and corruption not to the surroundings but to the building: it expressed Butterfield's "mind . . . weakened by subordination to a vain imagination [so that] he became a feeble worshipper of his own poor work."[52]

One still gets an impression of Butterfield's hand in the west front. The material is yellow stock brick faced with red and purple. Here again a wide, slab-like tower rises into a saddleback, subduing lower masses. Subordinate features repeat this form. Volumes are either squelched (the doors and buttresses) or as arbitrarily stretched upward (windows, tower, transepts). Indeed, the transepts have become so high and narrow that they act as hollow buttresses, and this pun is repeated by the hollow, windowed buttress across the wide part of the tower. The *Ecclesiologist* identified the arrangement as a "transeptal narthex" similar to that at St. Cunibert, Cologne.[53]

A drawing now in the R.I.B.A. library (Fig. IV–17) preserves a similar west front treatment, apparently intended for St. Augustine's, Queen's Gate, of 1865–71 (Fig. IV–18). A large western window without hollow buttress is provided, with a sort of *westwerk* above, from which in turn rose a double bell cote. Light pencil lines would indicate the nave roof and the profile of a saddleback tower not unlike the one at St. Alban's. The drawing, an interior elevation, also shows red and white horizontal stripes of brick and stone flanking the tower window, which in turn recalls a nickname for High Victorian Gothic, the "streaky bacon style."[54] The term suggests the particular organic quality architecture could then have, as do the frequently used terms "saddleback" and "carcase," for that matter.

In later work Butterfield retired to a gentler manner, but even in the 1850s his country churches, for example, that at Baldersby St. James, Yorkshire (1856–58), lack the meatiness of the city ones (Fig. IV–19).[55] But Baldersby is far from a Puginian pastoral: high and mighty, it is articulated into a hard, rugged framework paneled with soft, rubble-faced ashlar. The disposition of buttresses, caps, and corbels also suggests the encasement of softer matter, while characteristically weighty upper solids press down on the foundations.

[52] "State of English Architecture," p. 161.

[53] *Ecclesiologist* 22 (1861):319.

[54] Eastlake, *Gothic Revival,* p. 279. Paul Thompson and Henry-Russell Hitchcock both tentatively suggest that the drawing represents St. Augustine's but note that the latter has no narthex.

[55] Hitchcock, *Architecture: Nineteenth and Twentieth Centuries* (Baltimore, 1958), p. 177; Nikolaus Pevsner, *The Buildings of England: Yorkshire: The North Riding* (Harmondsworth: 1966), p. 70. But Pevsner says it is like a town church.

The churches of Butterfield have been interpreted, through associationism, as harsh and violent creatures. Their brilliant surfaces, machine dressing, ranges of materials, and square, telescoped volumes all went to suggest, as well, the idea of a machine. Street's churches are rather different. Street was softer and more scholarly than Butterfield. His churches are also more informative from the point of view of function.[56]

Street's first High Victorian Gothic church was All Saints, Boyne Hill (1854–57), but his first true slum minster was St. James the Less, Thorndike Street, Westminster, built in 1860–61 (Figs. IV–20-IV–21). For this debut the *Illustrated London News* offered a fanfare not unlike the one in the *Building News* three years earlier for Butterfield: "In one of the poorest parts of Westminster has been built during the past year one of the most remarkable and beautiful of modern Gothic churches—St. James the Less, in Upper Garden-street, Westminster—the lofty tower of which rises from amid the squalor and poverty around it as a lily among weeds. Were it not a church, such a building in such a locality would have been little better than a mockery."[57] Emmett, who had so disliked Butterfield's church in the same borough, saw similar contrasts, but again saw them as aberrations on the architect's part: it was "but a baby house. . . . The interior, chequered all over with bits of colour, is not the serious effort of a man, but mere effeminacy and child's play, giving the same wide-mouthed pleasure as a new trick of sleight of hand. . . . The mental debasement which we have already referred to has in this and in many other churches shown itself by making it what children would call 'a place for bogies.'"[58]

In St. James, Street followed a more Speluncar or southern line than Butterfield had, as the *Ecclesiologist* pointed out.[59] And where Butterfield in the Margaret Street exterior had concentrated on laminated vertical shafts ending at different heights, Street anchored his tower at the sidewalk and swung the original

[56] For Street see Chapter II, n. 65, above. It is curious that one reviewer of Eastlake's *Gothic Revival* (*Builder* 30 [1872]:3–4) finds Street French, and perhaps under the influence of Viollet-le-Duc here.

[57] *Illustrated London News* 40 (1862):121.

[58] Emmett, "State of English Architecture," p. 163.

[59] *Ecclesiologist* 22 (1861):320–21. See this whole article, pp. 317–27, and *ibid.*, 20 (1859): 205–6, 21 (1860):322–23. The first section is a remarkable and brilliant essay on Street vs. Butterfield and on St. James the Less vs. St. Alban's. I think that the article is by Hope. See also Hitchcock, "G. E. Street in the 1850s," pp. 163–66, and John Summerson, *Victorian Architecture: Four Studies in Evaluation*, pp. 47–76, an essay much like Hope's, but contrasting St. Alban's with Lamb's St. Martin's, Gospel Oak.

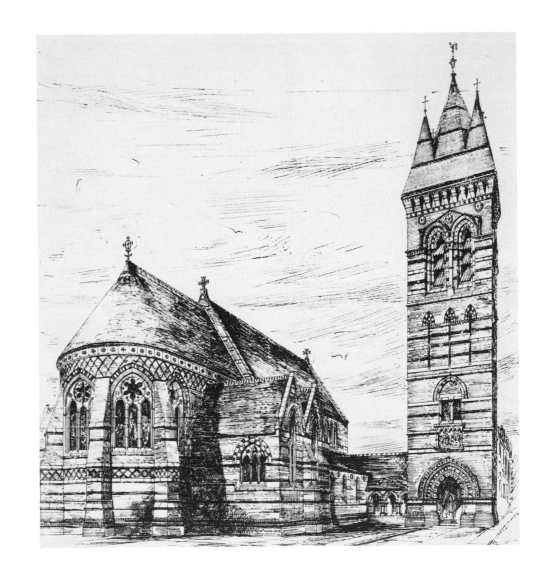

IV–20. Project for St. James the Less, Westminster. G. E. Street. 1860–61. Ecclesiologist, 1861.

IV–21. (opposite page) Interior, St. James the Less. G. E. Street. Photo NMR.

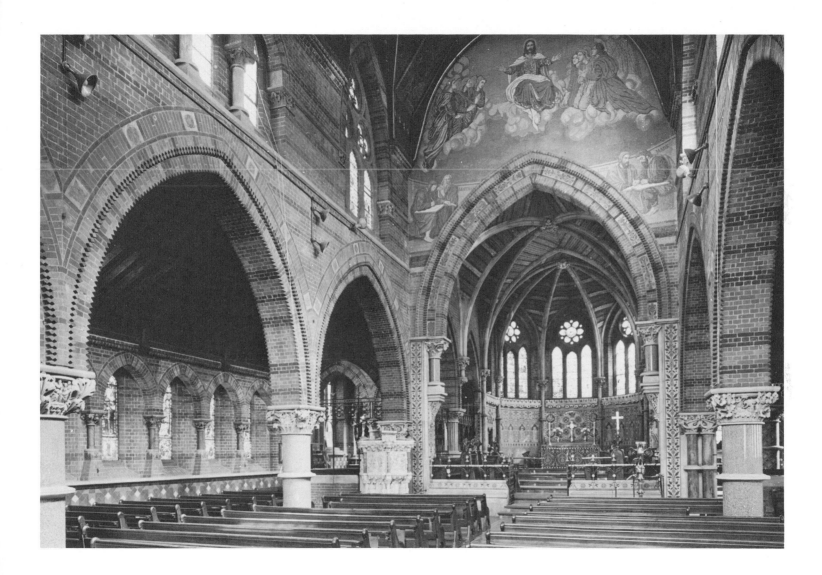

buildings back. The latter are composed of split volumes rather than planes, as in Butterfield. The base of the tower is an entrance porch leading through a short cloister to the church. In the published project (altered in execution) this tower-porch actually straddled the sidewalk. There is a chapel at the east end of the north aisle, covered with a pair of narrow gabled roofs running at right angles to its main axis, while the chancel is a deep, buttressed apse with a vestry projecting from its south flank. The material is soft red brick, now cold in color, black brick, and glazed yellow tile. The parish hall (1860) and school (1890) are higher and flatter and now fill the outside corners of the lot, somewhat cramping the site.

Street was rather a specialist in elaborate towers, and that belonging to St. James is worth consideration. The levels are, typically, marked by an alternate squeezing and stretching of windows. At the base is a sturdy Sicilian arch with splayed reveals, its voussoirs exploding into a wild headdress. Above, a Venetian two-light balconied window was to have been set into an equilateral-headed panel with herringbone tympanum, corbeled out over a rectangular sculptured relief (the feature was executed differently). Above this level comes a trio of needle lancets with wide heads, and finally a grandiose pair of louvered windows grouped under a triangular panel: the belfry stage. The cornice is supported by a corbel table; a polychromed slate spire consists of four huge pyramidal pinnacles, almost swallowing a stubby octagonal spike.[60]

The interior (Fig. IV–21), which, like All Saints, originally had neither box pews nor benches, is of the same materials as the exterior, and, as in All Saints, one has the sense of being inside an iridescent shell. Similar enrichments of polished granite and marble are to be found. The *Ecclesiologist* admired the "barbaric bulk" of the short granite nave shafts.[61] The plan is minster-like, very square, of only three bays, and with wide aisles. The apse is vaulted, the nave cradle-trussed. There is a good deal of Street's characteristic slithery ironwork, while sometimes the masonry detail, e.g., the pier bases (apparently modeled on some at Bourges),[62] is equally curvaceous. Neo-primitive glass, including a

[60] Traditionally this spire has been traced to an unnamed Genoese church; and it greatly resembles that of San Giovanni de Prè. But Hitchcock ("G. E. Street," n. 81) says that it is based on the Gothic of the "Isle [sic]-de-France," while Summerson (*Victorian Architecture*, p. 66) says it is Norman Gothic. There is no reason, however, to discredit the Genoese source, since the resemblance is almost exact.

[61] *Ecclesiologist* 21 (1861):322.

[62] Similar bases appear in Ruskin's *Stones of Venice I* (*Works*, 9: pl. xii). The bases at Bourges are in the chevet, north side, intermediate aisle arcades.

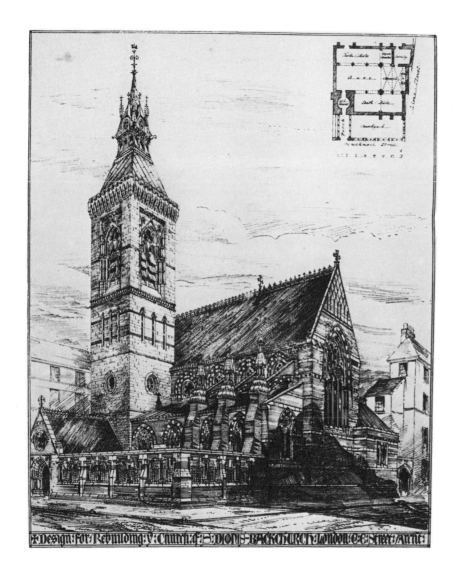

IV–22. *Project for rebuilding St. Dionis Backchurch, London. G. E. Street. Ecclesiologist, 1860.*

IV–23. Vestry door, St. James the Less.
G. E. Street. Photo author.

63 Whose Doom is by a real Nazarene, Ed-
uard Hauser. Ruskin had remarked (*Stones
of Venice III* [*Works*, 11:36]) that Watts was
the only English painter capable of "design in
colour on a large scale." For a design per-
haps derived from St. James the Less, see the
proposed St. Philip's Church, Miltown, Dub-
lin, by T. Drew (*Dublin Builder* 6 [1864]:
opp. p. 244).

64 *Builder* 16 (1858):508; *Ecclesiologist* 21
(1860):88–90; Hitchcock, "G. E. Street," p.
163.

Crucifixion in the south clerestory designed by the architect, mitigates the red-
ness of the whole. The only jarring note is the Nazarene-like Last Judgment by
G. F. Watts above the chancel arch, which constitutes throwback to the at-
mosphere of St. Giles, Cheadle (Fig. III–4).63 As a whole this interior has a
juicier quality than that of All Saints. The colored zones seem sharp and astrin-
gent, but the white sculptured stone—much of it by Street's collaborator Earp—
tends to be lush. The general effect is of a translucent pink cave resting on mush-
roomy supports.

An unexecuted project for rebuilding Wren's wrecked St. Dionis Backchurch
in the City also dates from 1858–60 (Fig. IV–22).64 Here Street manipulated
planes in a somewhat more Butterfieldian way. The idea was to preserve the
original tower, containing a circular vestibule and upper lunettes, so as to adjoin
an entrance porch. Despite its diminutive size the project has considerable monu-
mentality of effect. The nave rises along the inner side of the lot, supported by
powerful triangular subsidiaries, like a jumbo boiler with attendant ducts. In
comparison with St. Barnabas (Fig. IV–1), how much wilder, and less woolly,
Street is! There is a low, hip-roofed vestry on the northeast that restrains the
buoyant main vessel, as does the raked cap of the water table along the eastern
end. To look at the design more abstractly, the wall of the tiny churchyard forms
the lowest step in a series of superimposed raked planes of increasing slope, the
highest being the nave roof. The low churchyard wall was to have been topped
with a dense buttressed colonnade with openings filled with decorative iron—
more containment of ductile matter—its resulting caged effect not unlike the
arcade on top of Butterfield's wall on Margaret Street. Here, as in St. James the
Less, Street has kept his tower and church separate. The latter gets richer as it
rises, shaping itself with flatly internalized decorations, emphasizing, framing,
and embellishing its form. The spire is stubby, a pyramid belted just short of its
peak with a band of tiles which splinters it into a crown of pinnacles and spire-
lights.

Compared with the Butterfield of All Saints, Street in these designs reveals

a greater amount of recognizable historical borrowing, with perhaps fewer of those "universalizing" factors of which the diapered brickwork on the apse and the simplified plate tracery are examples. The total effect, as noted, is more Speluncar and volumetric, also richer and softer; the Italianism is not only more apparent but more affectionate. And (despite his Speluncar proclivities) if there is a reflection in Street of overseas Anglicanism it is more that of the Continental spa than that of the colonial outpost.

Compared with a similar Butterfield door in St. Augustine's, Queen's Gate (Fig. IV–24), the vestry door of St. James (Fig. IV–23) well exemplifies the major contrasts between Street and Butterfield. Street's door is narrowed by pronged archivolts, making it a symmetrical, layered grotto, while Butterfield characteristically resorts to shaped laminations. Both doors have fanciful hinges, but Butterfield's have a Disneyesque simplicity compared to the mannered luxuriance of Street's, which anticipates Art Nouveau.

Many of Street's effects derive from the associations of their prominent volumes. Their form encapsulates the activities taking place within them. They have the air of processing their users. To put it perhaps too extremely, at St. James the worshipers were to be absorbed from the sidewalk by the tower-porch, shunted through the cloister, and set up for a sequence of plotted liturgical positions—kneeling, bowing, marching, motionlessly listening. St. James is thus an evangelizing machine in the manner of Ledoux's inspection machines for the *barrières*.

IV–24. *West door, St. Augustine's. William Butterfield. 1867–71. Photo author.*

E. B. Lamb

With this architect we come to a figure who stands outside the central group of ecclesiologists and High Victorian Goths. He will be a measure of the impact of the new style on a designer who was not even High Church, let alone ecclesiological. He was, however, as noted, an associationist, and he did build impressive

missions in the slums. In his own way, too, he was a master of the creature metaphor.

Goodhart-Rendel's famous epithet "rogue architects of the Victorian era" defines the group to which Lamb belongs.[65] Goodhart-Rendel was fascinated by the sadomasochistic side of their work—calling it bizarre, grotesque, discordant, peculiar, naughty, and savage; he thought of their buildings in terms of "lapses," and even said that Lamb almost, but not quite, made him vomit. He quotes with ill-disguised approval the *Ecclesiologist* on Lamb's church at West Hartlepool, which was termed ghastly—an uncouth, grotesque, incongruous tour de force. Goodhart-Rendel rounds out his picture by saying that the rogues, because of their unexplained perverseness, were lonely rebels lacking approval or followers. Some of this is a little doubtful: Lamb, for example, was habitually praised by the *Building News* and the *Builder*, while the *Ecclesiologist* usually had warm feelings for another of their number, S. S. Teulon.

As an architect Lamb was really more of a Dissenting prophet than a rogue elephant; but his churches do have pachydermatous aspects. One of his most famous stands on a magnificent traffic island site in West Hartlepool, Christ Church, built in 1854 (Figs. IV–25-IV–27).[66] Like so many of his larger city churches this plays an upward-trumpeting west tower—Pevsner says it is "excessively high"—against a cluster of recumbent volumes and angular planes. Lamb omits the spire, preferring a phallic silhouette, here made almost naturalistic by the deep pent roof at the belfry stage. He eschews the polychrome, brick, and foreign detail of Butterfield and Street. He does borrow English thirteenth-century detail but uses it so originally as to be effectively anti-archaeological. Thus in a backhanded manner Lamb achieves both the universalizing and the organic qualities of High Victorian Gothic.

What also makes Lamb's church High Victorian Gothic is that it telegraphs its functions with such sculptural vim. Main and auxiliary entrances, chapels, vestry, congregational space, and chancel are all introduced with memorable individuality. From the rear, for example (Fig. IV–26), one sees an apsidal chancel

[65] H. S. Goodhart-Rendel, "Rogue Architects of the Victorian Era." Some of the other architects—John Shaw, James Wild, Alexander Thomson, Edward Prior, and James Maclaren —were not really High Victorian Goths. For Lamb see his lecture on composition, *Building News* 3 (1857):185–90; *ibid.*, 4 (1858):36, 102, 142, 940; *Builder* 23 (1866):781; *ibid.*, 27 (1869): 720 (obituary); Hitchcock, *Early Victorian*, 1:32–33, 158–60, where Lamb's proto-High Victorian qualities are mentioned; and Summerson, *Victorian Architecture*, pp. 47–76.

[66] *Builder* 12 (1854):213; Nikolaus Pevsner, *The Buildings of England: County Durham* (London, 1953), p. 160. In the *Guardian* for August 6, 1856, we learn of a conflict between the incumbent and the donor—the latter tried to brick the clergyman into the building during a service!

IV–25. Exterior, Christ Church, West Hartlepool,
County Durham. E. B. Lamb. 1854. Photo NMR.

IV–26. Rear, Christ Church. E. B. Lamb. Photo author.

IV–27. Detail of basement entrance,
Christ Church. E. B. Lamb. Photo author.

[67] *Builder* 24 (1866):778; Pevsner, *London except the Cities,* pp. 360–61. In 1864 Lamb had been more characteristically High Victorian Gothic by building in moderately polychrome brick as well as wood in St. Mark, St. Mark's Road, Paddington.

butting against a tall chapel which functions as a kind of transept's transept, backed by a low corridor leading to an entrance. This interior configuration is perfectly expressed in every way—in plan, elevation, fenestration, and gable size and placement. At the same time Lamb's building is a creature, though not one of Emmett's bogies. The quarry-faced lintels and arch voussoirs—all the framings (Fig. IV–27)—are orifices, also managing to recall Ruskin's glandular chimneys (Fig. II–1). The interior has a heavy arrangement of timber arches, Low Church yet "basilican," which culminate in a tiny cupola at the crossing. The thrusts of the arches are sculptured imaginatively into the stone crossing piers that support them.

In a later church, St. Martin's, Gospel Oak, London (Figs. IV–28-IV–31), Lamb was even less ecclesiological, yet recognizably High Victorian Gothic.[67] This, says Pevsner, is "the craziest of London's Victorian churches." Here again, in a complex including parish hall and vicarage (both now destroyed), are the phallic or trunklike tower (lacking the designed upper finials), the hide-like rubble cladding, and the toothless mouths anticipating Gaudí. But now a Bath stone skeleton interpenetrates and, especially in the tower, frames the mass. Often these elements, at least on the south side, form themselves into gratuitous gables and pinnacles, squeezing the panels of softer stone and pressing down vertical features such as turrets, tower, buttresses, etc. The vicarage (now destroyed) was composed of thinner and more symmetrical volumes, but its entrance front nevertheless managed to be creaturely: in fact, it had cap, eye, nose, mouth, and ear.

Moving to the interior of the church, we find an unaisled vestibule continuous with a three-aisled nave, transepts, and an apsidal chancel. There is a duct-like skeleton of stone (Figs. IV–30-IV–31) making a framework into which colonnettes weave upward to support the wooden roof cage. This is as intricate as E. S. Medley's New Brunswick churches, and as resourceful. In ecclesiological terms the effect here (as, for that matter, at West Hartlepool) is of a batwing Hyperborean roof on a Speluncar base. In plan, indeed, the church at Vicars

Oak is not without its resemblance to Carpenter's proposed Colombo Cathedral of a decade earlier (Fig. III–11). There would also have been a similar cavernousness and a similar graduation of roof pitches. Nor is even the earliest urban minster, St. Barnabas, Pimlico (Fig. IV–1), without its Lamb-like aspect: Lamb's general rocky lowness and jam-packed massing are anticipated. This later work of Lamb's even echoes some of his early designs for Loudon, especially the school (Figs. I–16-I–17), which is not unlike St. Martin's vicarage. With Lamb as with no other architect we have an instructive link between Loudon, early ecclesiology, and the urban minster.

Civil Buildings

With the application of High Victorian Gothic, that most principled of styles, to civil architecture, we reach a difficult point. There was a great deal of such building; nonetheless, one cannot help but feel that the houses and museums, office buildings and shops executed in the High Victorian Gothic manner are weaker and less associational than the churches. In the smaller genres a vernacular tradition, and in the larger ones the holdover from Neoclassical planning, interfere with High Victorian Gothic volumetric variety. In domestic architecture the lexicon of forms is strained by having too little to say; it is returned to a Loudonian simplicity. Similarly, in monumental civil buildings there is usually not much variety of function to express. From now on, in fact, we will become aware of the creeping formalism that is ultimately to dissolve High Victorian Gothic.

For simplicity's sake, High Victorian Gothic civil buildings may be said to have originated in a churchly atmosphere that varied to a collegiate one and finally to that of a walled city. Thus they too preserved an urban flavor. As one critic said of Street's Law Courts: "It looks . . . like a street in a collegiate town— some goodly houses, a church, and a town hall."[68] To understand what was happening we must return briefly to Pugin. His "Antient Poor House" from *Con-*

[68] Quoted by A. E. Street, *Memoir*, p. 161.

IV–28. Exterior, St. Martin's, Vicar's Road.
E. B. Lamb. 1866. Photo author.

IV–29. Main entrance, St. Martin's.
E. B. Lamb. Photo author.

Plan.

IV–30. Plan, St. Martin's.
E. B. Lamb. Builder, *1866.*

IV–31. Interior, St. Martin's.
E. B. Lamb. Photo NMR.

trasts (Fig. IV–32) is meant to be very different from the "Modern Poor House" —a Neoclassical panopticon—that he also illustrates. Yet in High Victorian Gothic terms the one is almost as Neoclassical as the other. The church is axial and symmetrical and is separated from the main group by a prolonged and uneventful domestic wing. Throughout, gate towers are on axis, axes are on center, bays repeat at equal intervals, and chimneys and windows appear with predictable regularity. From an associational viewpoint one can spot the hall, the church, perhaps the kitchen, and the master's headquarters, but they are far from being eloquently differentiated. There is no compression, no truncation, no slicing, no hyperbole.

If we turn to a collegiate essay by Butterfield, the rebuilding and restoration of St. Augustine's College, Canterbury (Fig. IV–33),[69] we immediately sense a different spirit. While the group is an exercise in the style of Pugin, and while Butterfield uses Puginian materials—Kentish rag with freestone trim—and, for the most part, Middle Pointed vocabulary, he forms up masses and volumes freely for expressive purposes. The dormitory is long, low, domestic, repetitious. In this it resembles parts of Pugin's fabric, e.g., the lower story, hollowed out by stretched arches filled with tracery. But in the context of its neighboring structures it much more clearly signifies "cloister," while its upper parts give us stair, chambers, and corridors. There is a willful contrast between this and the tall hall to the right, with its *piano nobile* of traceried windows. This in turn is entered by a wide-portaled porch with heavy buttresses, plane-positive but with one large void, whereas the hall is fretted and subdivided. The range of forms (and there are also the restored gatehouse, not shown, and the wellhead in the center of the court), with their manifold idiosyncrasies, are all in great contrast to Pugin. While a good deal of this would have been dictated by the existing buildings, the fact is that one way or another Butterfield has come up with solutions which exploit the heterogeneity of what he found and which not only embody (as in Pugin) but express and dramatize function.

[69] *Builder* 4 (1846):34, 521. Already in this early work the critic sees coarseness of detail. See also *Builder* 6 (1848):161, 163; *Guardian*, June 6, 1849.

IV–32. *"Ancient Residences for the Poor."*
A. W. Pugin. 1841. Pugin, Contrasts, *1841.*

The earliest truly High Victorian Gothic collegiate group I know of is Street's Cuddesdon Theological College, Oxfordshire (Fig. IV–34). However, here as with All Saints there is prototypical work that is Puginian, provincial, and Roman Catholic: I refer to two Irish structures by William Atkins, the Sisters of Mercy Convent, Cork (about 1850), and the Eglinton Lunatic Asylum (1852), both published in the *Builder* in their respective years. The system of projecting jerkin-headed bays irregularly clustered along a principal spine seems unusual for the early 1850s.

At Cuddesdon, Street's original work dates from 1853–54. Additions were made in 1874 and later. Hitchcock has described the buildings, so that there is no point in doing so here.[70] I will simply note that dormitory, hall, library, and

[70] *Illustrated London News* 24 (1854):607–8; *Ecclesiologist* 15 (1854):238–41; Anon., *Cuddesdon College, 1854–1904: A Record and Memorial*, pp. 13–38; Hitchcock, "G. E. Street," p. 151.

IV–33. St. Augustine's College, Canterbury. William Butterfield. 1845–48. Photo NMR.

original chapel are independent volumes, dividing the flat, paneled façade into an irregular grid. There is a low scholastic wing on the left with a large gabled frontispiece in the middle containing the hall and the original chapel. The dormitories occupy a higher building and are vertically divided into angular hip-roofed bays by prominent flat chimneys. All the chimneys are different, and the fenestration of the dormitory bays also varies a good deal. Cuddesdon develops the idea of independent volumes that we saw in St. Augustine's, but here they are compressed and heightened, and uniform ranges are abolished. The roofs are pulled down severely over the walls but are penetrated by rising chimneys. Thus does

[71] If we glance at two other quadrangle groups, both by R. C. Carpenter, we see this same straining away from Pugin. St. John's College, Hurstpierpoint, Sussex, dates from 1851–53 (H.S. Goodhart-Rendel, *English Architecture since the Regency: An Interpretation*, p. 120; Hitchcock, *Nineteenth and Twentieth Centuries*, pp. 100–101), and Lancing College, in the same county, dates from 1854 (Hitchcock, *Nineteenth and Twentieth Centuries*, pp. 100–101). The style is basically Puginian but at Lancing there is more vigorous "expression," e.g., in the roofs of the masters' houses. The High Victorian Gothic chapel, the finest element in the group, was built later.

[72] "G. E. Street," pp. 160–62. See the references in the *Builder* and the *Building News* for 1856–57, too numerous to give here; *British Almanac* (1858), pp. 222–25; *ibid.* (1859), p. 230; *ibid.* (1860), p. 225; Summerson, *Victorian Architecture*, pp. 77–90; and Chapter V, n. 79, below.

[73] "This design had much beauty, but the influence of Italian travel was perhaps too obvious to make it wholly appropriate for a national building. The same may be said in a lesser degree of the church of St. James the Less, Westminster" (A. E. Street, *Memoir*, p. 103).

[74] Summerson (*Victorian Architecture*, pp. 77–117) gives the more important contemporary bibliography. See also Scott, Recollections, pp. 273–78; Joseph Kinnard, "G. E. Street, the Law Courts and the 'Seventies," in Ferriday, ed., *Victorian Architecture*, pp. 223–34; and

the plane-positive quality that Pugin liked in architecture disappear in favor of expressive High Victorian Gothic volumes and silhouettes.[71]

Hitchcock has also recently discussed Street's next big collegiate group, a project for the Foreign Offices competition of 1856.[72] For this Street devised a huge pile for a site near Westminster Abbey (Fig. IV–35). Here once more we have an irregular grid, but this time the tall compressions of Cuddesdon are softened into serene, isolated volumes. Though the walls are still fairly flat, the contrast between total blanks and concentrations of detail is more evident. Street did everything possible to avoid the uniformity of the single grille, grouping windows into larger units either vertically or horizontally and then playing these groups against isolated ranges of openings. Such variety of fenestration is one of the hallmarks of High Victorian Gothic. At the same time the Italian flavor of the project brought criticism from even Street's loyal son.[73] If one reads the style as a reference to Italy, A. E. Street's comment is justified, but we know that Street himself saw Italian Gothic less as a national mode than as a sort of basic international style, and it could also be argued that such a "foreign" manner is appropriate to a "foreign" office.

The most important competition involving the High Victorian Goths was that for the Law Courts of 1867. Among the invited competitors were Street, Seddon, Burges, Scott, Waterhouse, Henry Lockwood, E. M. Barry, and J. R. Brandon.[74] There was only one classicist, who did a domed High Victorian Gothic hybrid (Barry), and one Puginian (Brandon,) though Brandon's design was also rather High Victorian Gothic. So in fact they all form a cross-section of the state of the style at the time.

The appointed site fronted on the Strand and was bounded by Clements Inn on the west, on the north by Carey Street, and on the east by Bell Yard. At its southwest corner stood St. Clement Danes. The program was to build a large edifice around several quadrangles which would make full practical and monumental use of this irregular plot and which would contain large and small courtrooms, office hives, and towers for the storage of documents.

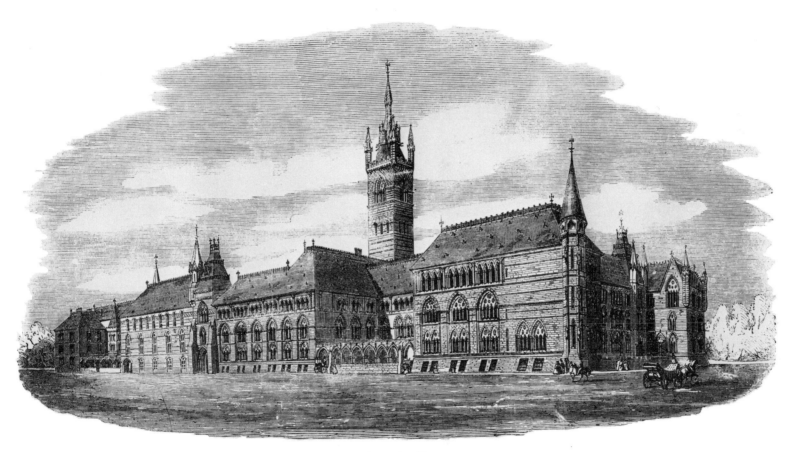

IV–35. Project for Foreign Office. G. E. Street. 1857. Illustrated London News, 1857.

The striking thing about most of the projects is their unwonted symmetry (except for the towers) and homogeneity. Scott's design, for example, consisted of four scaled-up variations of the symmetrical Oxford Museum façade (Fig. V–24) or, rather, of his own 1856 Foreign Office project's long façade (Fig. V–29), which had in turn been derived from the Oxford Museum. Burges's design was a veritable history of medieval architecture: a Franco-Italian castle rising from a base of massed town halls, with a Palazzo Vecchio tower, Viollet-le-Duc towers, a Blois stair tower, a seven-story duplex apse, and an encyclopedia of roofs (Fig. IV–36). Here, as a concession to irregularity, one-half of the arcaded Strand front was jogged back one bay from the barbican. But again the sense of disguised or repressed Neoclassicism is present: the arcades were perhaps intended to evoke medieval Belgium, but more probably would have summoned up the Rue de Rivoli. In his version of the Strand front Seddon designed a series of high, gabled Franco-Flemish house façades, a little like Cuddesdon but more repetitive, flanking a massive *westwerk* and pyramidal arcaded spire. Here again on the ground floor were arcaded loggias set out from the fronts of groups of houses. The will tower, apparently thirty stories high, is a bundle of *tourelles* melting into a tall, gabled parallelepiped.[75] Throughout, although Seddon strives manfully for Gothic verticality, frontality and repetition prevail.

Street's original design, almost unrecognizable as a forerunner of the present building, was actually *more* symmetrical than these other conceptions: it is a baroque wing-and-frontispiece composition (Fig. IV–37). Only the sixteen-story will tower, standing away from the mass of the building as does the tower of St. James the Less, gives the project a certain asymmetry. Indeed, all these projects are conceived as cities within the City, walled and turreted enclosures whose only irregularities come in the placement of the towers. To this extent, though they are also reactions to or corrections of Westminster Palace, they resort to the means of achieving Picturesqueness used by Barry.

But Street's design nonetheless has the germs of a more genuinely High Victorian Gothic solution. First of all, he uses much more expressive forms than

M. H. Port, "The New Law Courts Competition, 1866–67."

[75] By many definitions some of these towers are skyscrapers, though power elevators, so far as I know, were not envisaged. In style they presage American commercial buildings of the 1920s and 1930s. An earlier tall tower —more like late than early Cass Gilbert— was designed in 1852 by C. Burton, utilizing the *disjecta membra* of the Crystal Palace (*Builder* 10 [1852]: 280–81). See also the iron tower 1,000 feet high proposed by Clarke, Reeves and Company for the Philadelphia Exhibition of 1876 (*American Builder* 10 [1874]: 66).

the others. In his bird's-eye view is a clerestoried great hall embedded in lower structures. The device is appropriately suggestive of concourses of litigants walled in by squads of lawyers. But the real point is that his project has such a variety of openings—presumably echoing the interior hierarchies of chambers and their occupants. Thus while Street employed symmetry in the large he created expressive variety in the small. His office grilles are there, but they vary in scale, spacing, placement, and extent. To make a chart of the rhythms of Burges's or Seddon's façades would be simple. Street's chart would be complicated; it would be like a table of organization for the legal processes within.

In discussing the completed building (Figs. IV–38-IV–39), A. E. Street well brought out the associations of these irregular grids: "Now the new Law Courts were meant to accommodate people and fulfil needs of the most varying descriptions. There were primarily the Courts, the judges' rooms in connection with them, consulting rooms, offices in immediate connection with Courts, offices not necessarily so near, and so forth." These facts, he says, are expressed on the exterior elevations as follows:

The building, as it has come from his hands, explains itself. To the east you have what is obviously a wing of offices, distinct from the rest, but connected with it. Westward is a symmetrical block, the nucleus of which is the central hall, with its dependencies grouped round it. The building is thus roughly divisible into two parts, but these two parts are ingeniously and beautifully welded into one group by the entrance to the office quadrangle. There is then to the west the central hall with its wings, next the entrance to the office quadrangle, also with wings, but with that to the east more important, and terminating in a tower, and lastly, the office block, forming a whole by itself.[76]

Thus Street's executed building is not in this sense so very different from his winning design. For that matter, the whole of the Strand front is strictly symmetrical in its basic layout.[77] But now instead of the projecting frontispiece Street has a lowering and a recession: the building literally steps back and bows. Its

[76] A. E. Street, *Memoir*, pp. 163, 167. Here the son, who helped complete the complex after his father's death, echoes the idea behind White's criticism of the Houses of Parliament, i.e., that the façades did not express the variety of functions within (see above, p. 39). Yet the *Builder* was not satisfied even with these improvements on the earlier building, and criticized the Law Courts as being essentially classical in their symmetry, while failing to express the interior fact that they were a *collection* of innumerable courts (*Builder* 30 [1872]:25–26). In other words, one presumes that the architectural centrality suggested a more centralized legal system than was the case.

[77] Pevsner (*The Buildings of England: London. I. The Cities of London and Westminster* [Harmondsworth, 1962], p. 291) says: "Street's façade to the Strand is an object lesson in free composition, with none of the symmetry of the classics, yet not undisciplined where symmetry is abandoned." Yet the left-hand two-thirds of the Strand front—300 out of 490 feet—is in fact strictly symmetrical. For contemporary criticism of Street's executed Strand front, see *Builder* 29 (1871):949.

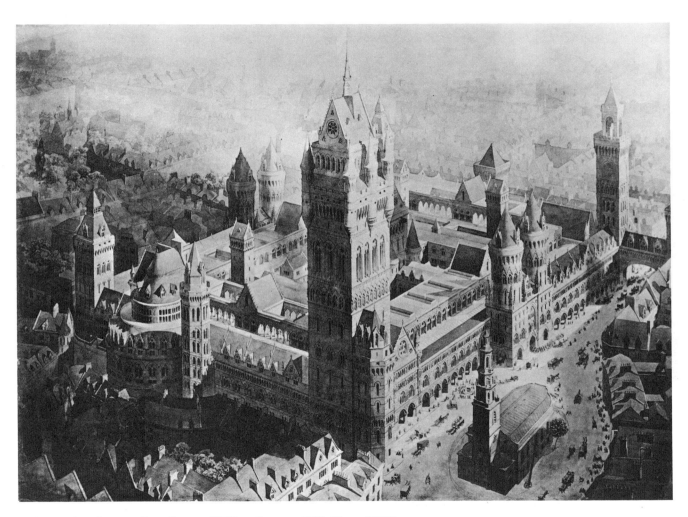

IV–36. Project for new Law Courts. William Burges. 1867. Photo NMR.

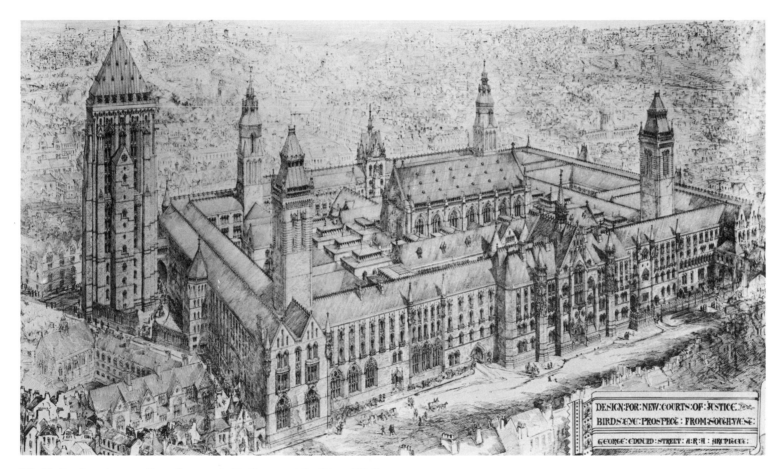

IV–37. Project for new Law Courts. G. E. Street. 1867. Photo NMR.

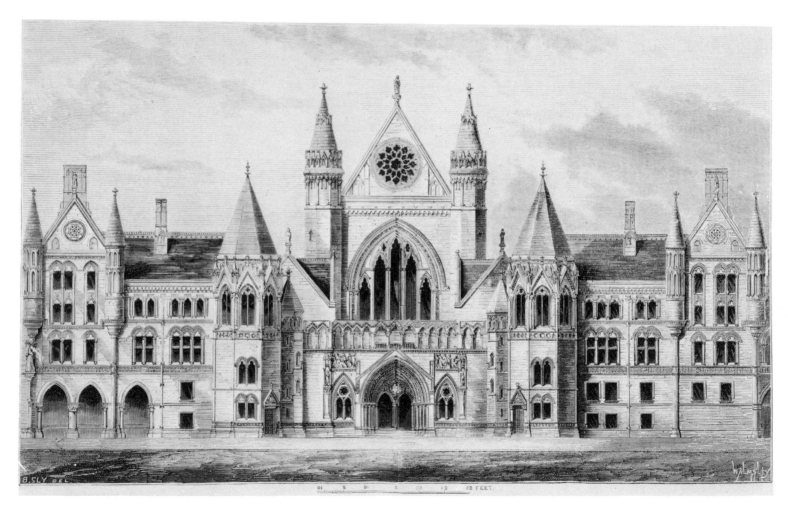

IV–38. *Strand front, new Law Courts. G. E. Street. 1868–82.* Builder, *1870.*

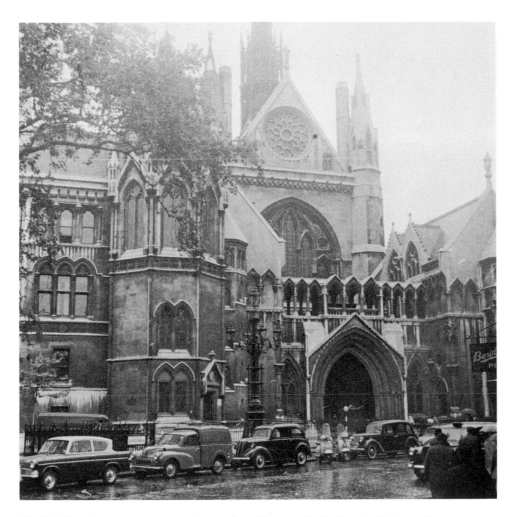

IV–39. Strand front as executed, new Law Courts. G. E. Street. Photo author.

associations are with an abbey west front with free-standing arched gate, flanked by octagonal towers set between domestic-looking wings that terminate in northern European gabled bays. The wings vary mainly in the treatment of their ground floors. The earlier, larger façade symmetry has recoiled to the center, while the executed building is also lower and more plastic than the project (Fig. IV–39).

Within all this, associational expression is achieved by vivid heterogeneity and by extremely long, active stretches between the repetitions and mirrorings that establish the symmetry. Beginning at the west end of the Strand front, for example, one moves almost 150 feet before encountering a repeated bay (the right-hand window flanking the entrance). But then the earlier features of the structure begin to be seen again, and the whole coheres at last, like a cyclical symphony. Even so, within the completed, axial symmetry there is a whole town's worth of different structures. The continual interruption and shifting, the abruptness and piercing detail, recall Wightwick's crammed and mangled forms, as is especially clear in Fig. IV–38. The atmosphere of suffering is perhaps appropriate: Street was designing a fit home for the Chancery Court in *Bleak House*.[78]

Less painful readings are also possible. Street may have sacrificed the rich, Italianate universalism of his Foreign Office project and chosen Early English on the grounds that the law was essentially English—and indeed Early English—as diplomacy was Italianate. Early English would have been particularly appropriate as the style in force when the Magna Carta was signed.[79] (One is reminded of the ecclesiologists' claim that the Statute of Mortmain produced Perpendicular.) Street's informal entrance could be held to signify the relative accessibility of the British judicial system and the informality of the British Constitution.

Typically, Emmett saw something of these meanings but placed a different valuation on them. If Street's buildings, which he said seem to have been "designed by some sacerdotal epicene," are strikingly non-majestic, neither is British

[78] In a similar vein Summerson evokes what he calls the "nightmarish" qualities of the original plan (*Victorian Architecture,* p. 110) and climaxes his description with a splendid image of the architect destroying himself as he designed the exterior, which expresses "the pathetic collapse of an overstrained imagination" (*ibid.*, p. 115).

[79] Ruskin in 1872 claimed credit for influencing Street's changes from the original to the final designs (*Works,* 10:459), but in *Stones of Venice I* (*ibid.*, 9:140–41) he condemned Early English capitals, if not the style as a whole, in no uncertain terms.

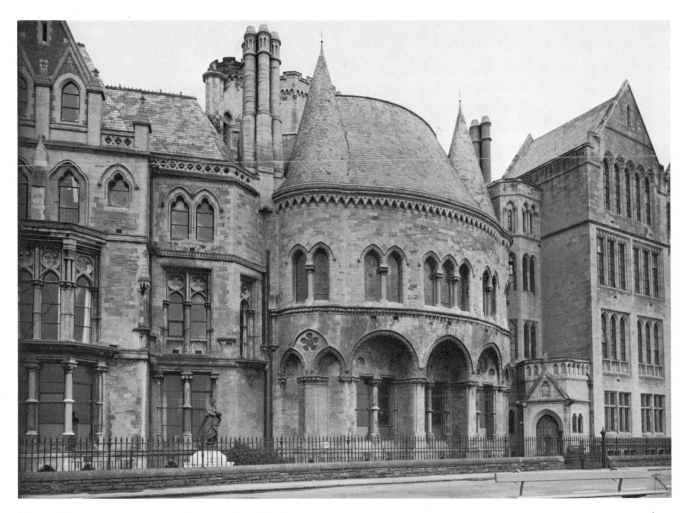

IV–40. Aberystwyth University College. J. P. Seddon. 1869–72. Photo NMR.

law: "We are now concerned with no ideal, but with a very homely common law, and precarious Chancery practice. We are providing a place for the settlement of miserable disputes, originating in folly and knavery, or in the very imperfection of the law, or it may be all three combined. . . . In fact, the association of Courts of Law seems to be rather with lunatic asylums and debtors' prisons, than with palaces and temples."[80]

A last building in which some of these principles appear is Seddon's Aberystwyth University College, Cardiganshire (Fig. IV–40),[81] remodeled into what was then called the University of Wales between 1869 and 1872, and crammed into an awkward, dagger-shaped lot. Where in Cuddesdon and Street's Law Courts the vocabulary is pretty much limited to compressed orthogons, here the latter are beginning to blend with complex cylindrical shapes. Seddon's slightly earlier will tower has already hinted at this effect. But at Aberystwyth the *tourelles* have bubbled out of the central curved front and flow into its tall pavilion roof. Underneath, the three arches of the main floor dutifully belly out with the wall, but the doors behind them are set back along a cord of this arc. On either side double lancets, filled with stained glass, follow the epicyclical curves of the *tourelles*. Flanking, buttressing, and squeezing this are more straitlaced buildings on either side. On the right, regiments of lancets stand in narrow formations; on the left a series of overlapping frontispieces controls another façade fragment, octagonal in plan, by means of a weighty centered gable.

Compared to Cuddesdon's, Seddon's façade at Aberystwyth is almost sudsy. Its comical adiposity could even reflect Burges's influence. Though the psychology is still one of breakage and distension, the rhetoric of Cuddesdon and the Law Courts—so solemnly appropriate to Victorian religion and Victorian law—is here drained of meaning, inappropriate, even flippant. Shaw and Lutyens are being prepared for.

The slum minster, that lily among weeds, was, then, the associational magnet that attracted the cultural and topographical experiments of overseas ecclesiology

[80] Emmett, "State of English Architecture," pp. 157, 159.

[81] *Building News* 13 (1866):868–69, 20 (1871):278. Hitchcock (*Nineteenth and Twentieth Centuries,* p. 187) gives further information: the original building was an L-shaped Nash villa, which in 1866 was greatly extended on two sides to become the Castle House Hotel. The change to a university was made, within this latter structure, in 1871.

to Britain. Its principles were elaborated in writings and buildings between about 1840 and 1860. All Saints, Margaret Street, a Hyperborean-Speluncar hybrid, is the first and best of these urban minsters. It became the model for Modern Gothic. The contemporary reaction to All Saints reveals the shocking quality it was thought to have, and the later controversy over Butterfield's sado-masochism arose partly over portrayals of the church that emphasized this mangled eclecticism and brutality and partly over the changes in the architectural contexts in which All Saints was seen.

In any event, the spirit behind All Saints gradually departed from High Victorian Gothic, both in Butterfield's later churches and in the sweeter, more Italianate work of Street. At the same time, beyond ecclesiology proper such "rogue architects" as Lamb practiced their own version of the style, creating a different link to Loudon and to the forms, if not the meanings, of early ecclesiology. In civil architecture, in the development from St. Augustine's College through the Law Courts to Aberystwyth, we find the expressive formulas developed for the urban minster applied to long stretches of secular façade. An image of the building as a city, and as a comprehensive architectural historiography or encyclopedia, comes into being. Street's almost Corbusian variety of grille densities is another striking innovation, which I can connect associationally with the bureaucratic organizations that occupied the Courts.

All of this suggests how High Victorian Gothic in its secular forms suffered from blunted energies and relatively narrow, or strained, meanings. In large buildings the logic and ease of Neoclassical planning overwhelmed the desire for variation and idiosyncrasy. But High Victorian Gothic did not dissolve only because it was less than ideally applicable to a variety of genres. It was also overlaid by a counter-style known as "Ruskinian Gothic." Ruskin, in fact, who had contributed so much to Victorian associationism in the 1850s, and who had so often been admired by the ecclesiologists, was now to appear as their subverter.

V·THE STYLE DISAPPEARS

The Crystal Palace

We have already noted some of the weakening elements in High Victorian Gothic. Although Ruskin ultimately proved to be the most obvious of these, he was not the only one. Much more than with the Law Courts, and much earlier, the Crystal Palace and its immediate progeny had taken some of the basic ideas of High Victorian Gothic and applied them so as to create a very different architecture— at once more exciting and more useful. So before we can return to Ruskin we must examine Paxton's building from this viewpoint.

The Crystal Palace was High Victorian Gothic in its centripetal eclecticism, its didactic purpose, its progressiveness, its primitivism, its "appreciation of vastness." While in itself hardly an "affective creature," it did exemplify the other branch of associationism: more than any earlier building the Palace was an informational appliance, a storage machine for universal practical knowledge—in short,

a brain. Nonetheless, its possession of these qualities was conditional, even off-hand. If I write about them in that manner, therefore, it is to reflect this fact, and also to prepare for other events that will further drain High Victorian Gothic of its force.[1]

Associationally, first of all, Paxton's palace was not only a palace but a green-house and a cathedral of human progress (Fig. V–1). Particularly in its Hyde Park context, it was quite obviously still a garden structure. As the German ecclesiologist Reichensperger put it, "A hot-house provided the design, and a hot-house on a colossal scale was erected."[2] This indeed had given Paxton, that High Victorian Loudon, an essential freedom: like a temple at Hagley, a pantheon at Chiswick, a pagoda at Kew, and even like his own structures at Chatsworth, the Crystal Palace had a resourcefulness and hyperbole not possible in completely serious monumental architecture. Also like a hothouse, the Palace was a controlled environment for a world of heterogeneous foreign products, an ambient for exotic growths.

But many Victorians preferred to regard it in a religious way, as a cathedral of commerce and the Empire. Its interior, after all, consisted of aisles, nave, vault, and transepts. Along this nave, moreover, lodged in compartments like votive chapels, each to a special saint, were the ex-votos of the tributary nations, honoring themselves but in so doing honoring Britain. Again to quote Reichensperger, "The earth-encircling power of England is alone capable of uniting so many and such different objects under one roof."[3] Even in its architecture the Palace was Gothic to some. Well before 1851 Hope had praised "intersecting lines disposed in parallelograms" as a basis for Modern Gothic; with his usual assurance he later claimed that this idea had been embodied by Paxton in the Crystal Palace, which represented in fact a variety of Perpendicular.[4]

The religious perception blended into a magical one. Thus Reichensperger continues, "The total effect . . . is magical, I had almost said intoxicating. The incessant and never ending motley of forms and colours, the transparency on every side, the hum and buzzing in every direction, the splashing waters of the

[1] For the Crystal Palace, see Hitchcock, *Early Victorian*, 1:530–71, 607–8. Continuous comment appears in the *Builder, Illustrated London News*, etc., in 1850 and 1851. See also Charles Downes and Charles Cowper, *The Building Erected in Hyde Park for the Great Exhibition of the Works of Industry of All Nations, 1851*; Christopher Hobhouse, *1851 and the Crystal Palace*; P. Morton Shand, "The Crystal Palace as Structure and Precedent"; C. H. Gibbs-Smith, *The Great Exhibition of 1851. A Commemorative Album*; Yvonne ffrench, *The Great Exhibition: 1851*, pp. 89–178; and K. W. Luckhurst, *The Story of Exhibitions*, pp. 83–116. For discussions of the Crystal Palace's place in architectural history, along with Hitchcock and Shand see George F. Chadwick, *The Works of Sir Joseph Paxton, 1803–1865*, pp. 72–159; Elias Cornell, *De Stora Utställningarnas Arkitekturhistoria*, pp. 49–91; Pevsner, "Early Iron 2. Curvilinear Hothouses"; Werner Hofmann, *Art in the Nineteenth Century* (London, 1960), pp. 165–98; and anon., "Glass Buildings of Sir Joseph Paxton," *Journal of the Royal Institute of British Architects* 73 (1966):59–60.

[2] A. Reichensperger, "A Word on the Crystal Palace," *Ecclesiologist* 12 (1851):385.

[3] *Ibid.*, p. 389.

[4] *Common Sense of Art*, p. 18 and n. 7, referring to an 1846 article in the *Ecclesiologist*.

fountains, and the heavy measured beat and whirl of the machinery, all together combine to form a spectacle such as the world will scarcely behold again."[5] The *Ecclesiologist*, publishing these remarks, added similar observations by an unnamed Englishman: "We are lost in admiration at the unprecedented internal effects of such a structure:—an effect of space, and indeed an actual space hitherto unattained; a perspective so extended, that the atmospheric effect of the extreme distance is quite novel and peculiar; a general lightness and fairy-like brilliancy never before dreampt of; and, above all,—to our minds one of the most satisfactory of attributes—an apparent truthfulness and reality of construction beyond all praise."[6] Such approval in the pages of the *Ecclesiologist* was usually saved for more overtly Christian cathedrals.

Victoria herself gives us a detailed picture of opening day which also stresses the sense of a religious festival, as at a modern, magic Westminster Abbey. Indeed, the Queen says that the opening service is the most moving she has ever attended. And the *Times* said, "Above, rose a glittering arch, far more lofty than the vaults of even our noblest cathedrals. On either side the vista was almost boundless. It was felt to be more than what was seen or what had been intended. . . . Some were reminded of that day when all ages and climes should be gathered round the Throne of their Maker."[7] Thackeray in his *May-Day Ode* embraced similar ideas:

As though 'twere by a wizard's rod
A blazing arch of lucid glass
Leaps like a fountain from the grass
To meet the sun!

. .

A palace as for fairy Prince,
A rare pavilion, such as man
Saw never since mankind began,
And built and glazed!

A peaceful place it was but now,
And lo! within its shining streets

[5] "A Word," p. 389. Even the workaday William White saw the building as a "fairy palace," though he thinks this effect was the result of a geometrical or arithmetical progression (*Ecclesiologist* 16 [1855]:162–63).

[6] *Ecclesiologist* 12 (1851):269.

[7] Quoted in Hobhouse, *1851 and the Crystal Palace*, p. 69. See also Pevsner, "High Victorian Design," in his *Studies in Art, Architecture and Design*, 2:41.

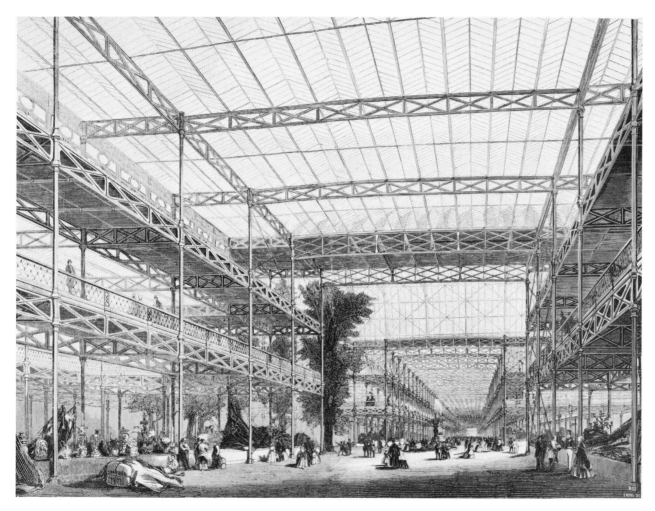

V–1. Crystal Palace. Joseph Paxton. 1851. Builder, *1851.*

A multitude of nations meets;
A countless throng!
. .

This moment round her empire's shores
The winds of Austral winter sweep,
And thousands lie in midnight sleep
At rest today.

Oh! awful is that crown of yours,
Queen of innumerable realms
Sitting beneath the budding elms
Of English May!

The *Ode* goes on to fill out the picture of universal dominion and of the bringing of gifts to the Queen in an imperial Epiphany.[8]

In these ways the Palace constituted the greatest of all urban minsters, dedicated to a catholicism even more flexible and universal than the Anglican kind. But not only was the Palace a metaphorical minster; it was more concretely High Victorian Gothic. Hope had decreed that it belonged to the Gothic Revival; it also possessed the structural differentiation in materials and the attitude to polychrome we have associated with Butterfield and Street. Its components were clearly expressed—the glass panels, the wooden mullions and gutters, and the iron posts and girders were sculpturally evident, their joints emphasizing the way in which they had been assembled. Differentiations were further pointed out—or coded—by the painted color: red on the undersides of the girders and behind the gallery railings; yellow on the diagonal faces of the columns and on certain projections; blue on the concave parts of the columns. "Polychrome," said the *Ecclesiologist*, "may be admitted here, though elsewhere we are not *yet* allowed to use it" (their italics; this was still eight years before the consecration of All Saints).[9]

Even the herringbone pattern of the roof panes echoes typical High Victorian Gothic brickwork, while Paxton's modulation from skeleton to reticulated surface

[8] Quoted in Hobhouse, *1851 and the Crystal Palace*, pp. 169–73.

[9] "On the Exhibition Building in Hyde Park," *Ecclesiologist* 12 (1851):273.

is comparable to a number of High Victorian Gothic buildings (e.g., Figs. IV–17, V–1). In some renderings (Fig. IV–7) Butterfield's banded zigzags resemble Paxton's trusses, and in this context, in turn, the brickwork takes on the character of prefabricated truss-like components assembled, like Paxton's, from uniform interchangeable parts. At other times (Fig. IV–10) there is, in a church interior, an equivalent visual metaphor of embedded colored lattices and fringes. The Palace, when filled with its polyglot contents, becomes very much of a discoursing appliance—indeed, a veritable Babel, as the *Builder* pointed out.[10]

Even the cult of ruin and dismemberment had fine hours here. The serene and misty vision of the great hall, so monumental in scale, so inflexible in materials, so memorable, was to be shattered. The vast surfaces of the interior were made of thousands of tiny fractures, a kind of architectural craquelure always much emphasized in engravings. The Victorian public took endless delight in this feature, for it suggested not only how quickly the Palace had been created, but how quickly it would be destroyed. It was Paxton's Golden Bowl. When the cracks triumphed over the volumes and the building came down, the *Illustrated London News* called it "the finest wreck in the world."[11]

Finally, the Palace had a primitive component. In contrast to its theme of the triumph of industry, a large number of "undeveloped" countries and colonies sent products, many of which were favorably commented on. In fact, Reichensperger held these primitive goods to be generally better than the industrially manufactured ones.[12] Even more than All Saints, the Palace was thus an encyclopedia of trophies.

And yet certain key elements of High Victorian Gothic are not present in the Palace. Contemporary critics, as is well known, found the building too lacking in mass and sculptural solids to constitute architecture at all. Its endless uniform façades with their minute repetitions were a far cry from the idiosyncratic volumes and silhouettes the ecclesiologists wanted. In a way, this very emptiness, as of an unwritten page or blank canvas, emphasized the heterogeneity, color, textural variety, and irregularity of the contents when they were installed. These

[10] *Builder* 9 (1851):293–94.

[11] Henry-Russell Hitchcock meanwhile paints Sydenham as an "increasingly inglorious" humiliation of the Hyde Park building (*Early Victorian*, 1:547).

[12] "A Word," pp. 388–89.

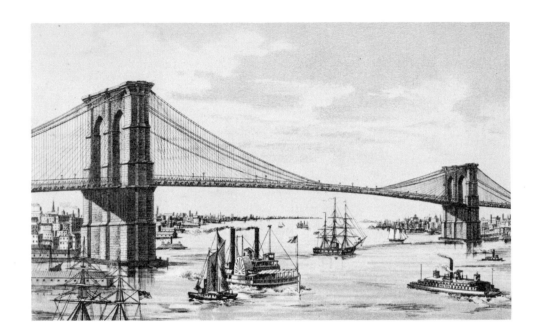

V–2. Brooklyn Bridge.
John and Washington Roebling. 1869–83.
Yale Photo Collection.

objects, symbols of their cultures, were thus associational signifiers almost in an architectural sense, providing the "discourse" needed to make the Palace meaningful. There are innumerable contemporary reports in the *Illustrated London News*, the *Builder*, and the *Building News* during the exhibition year that emphasize how the machines, foodstuffs, fabrics, and furniture filled out the possibilities of Paxton's mute and neutral container; even the crowds constituted part of the "expression."

In any case, the High Victorian Gothic qualities of the Palace are relatively trivial when compared to the role these same qualities play in High Victorian Gothic proper. At Hyde Park Paxton inhabited a world only partly permeated by

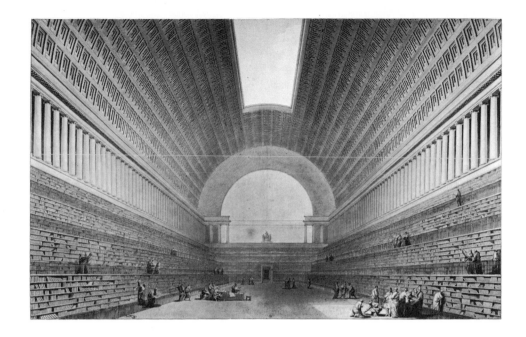

V–3. Project for Bibliothèque du Roi.
L.-E. Boullée. 1785. Bibliothèque Nationale.

High Victorian Gothic; his world also derived from Neoclassicism, from civil engineering, from a tradition of vast structures, of uniformity and calculation. All this was antithetical to High Victorian Gothic. In particular, the Palace must be linked with two traditions: (1) the mainly French, American, and British development of wide-span metal structures, and (2) the urge, dating at least from the French Revolution, to design huge halls for democratic assemblies.

I named America in connection with wide-span arches because it was there that the German-born engineer John Roebling drew ahead in the competition for size in suspension bridges.[13] His structures, which began to appear in the 1840s and culminated in the 1860s with the Brooklyn Bridge (Fig. V–2) are important

[13] David B. Steinman, *The Builders of the Bridge: The Story of John Roebling and His Son,* pp. 78–106, 157–93; Charles A. Johnson, "Development of the Suspension Bridge."

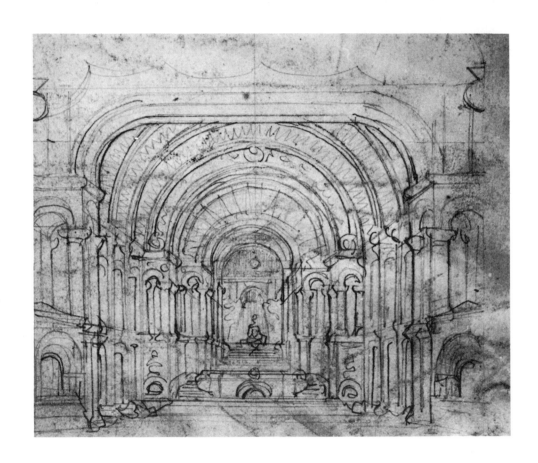

V–4. Drawing (of hall of Leicester Castle?).
A. W. Pugin. Ca. 1838. Courtesy R.I.B.A.

not only for this but because they exploited the skeletally formed vaults and planes that we see also in the Crystal Palace. There is the same marriage of wiry reticulation and huge surfaces; both the Brooklyn Bridge and the Crystal Palace dwarf Nature. Also, more effectively than rigid-truss bridges, Roebling's dramatize the crossing of a river or abyss; there is hardly a more thrilling way of bringing

two sections of road together. Such bold linkages are akin to the Victorian development of roads and railways connecting one end of the country with the other, and to that vaster network that was the Crystal Palace, beneath whose "blazing arch" innumerable realms symbolically assembled.

The second tradition in earlier architecture involving the Crystal Palace is really a poetical anticipation of this dramatic effect. Instead of gradually exploiting the limits of technology it bursts into the realm of dreams. Usually these architectural dreams, those of Boullée, for instance, imply a gigantic, perhaps unbuildable masonry structure. They are like Ledoux's conceptions, except that the latter are socially rather than structurally impossible, depending as they do on a revolutionized society.[14] But what strikes us more specifically in considering Boullée's 1785 drawing—in itself vast—for an added room in the Bibliothèque du Roi (i.e., the Bibliothèque Nationale) is that, like the Crystal Palace or Brooklyn Bridge, it is primarily a place for mass man (Fig. V–3).[15] It too is a universal microcosm, though organized linguistically rather than topographically and ethnographically. It is an "amphitheatre of books," as the architect called it. And the symbol of this new universality is already the supervault. Curiously enough, even Pugin reveals a kinship with Boullée in this respect. In his unnamed spectacle design for Covent Garden with its concentric Romanesque arches (Fig. V–4) there is again the suggestion of a mass ritual as well as the possible connection, noted earlier, with the ideals of Speluncar Gothic.[16]

Later Life of the Glass Roof

A number of contemporary critics, including Ruskin and Pugin, condemned Paxton's building as not being architecture at all.[17] They saw in it too much of Brunel and not enough of Boullée—"a hot-house on a colossal scale." This is understandable, for in the 1850s architecture was still almost completely a masonry art. Up to 1851 the most common use of glass and iron, outside of gardens, involved domes and rotundas (e.g., Bunning's Coal Exchange, Lower Thames St., of 1846–

[14] It is interesting that the first truly national industrial exhibition (held in Paris in 1798) was a child of the French Revolution. See Cornell, *De Stora*, pp. 13–18; Patrick Geddes, *Industrial Exhibitions and Modern Progress*, p. 3; M. Tamir, "Les Expositions internationales à travers les âges," p. 20; Paul Dupays, *Vie prestigieuse des expositions. Historique*, pp. 1–2. For the question of glass-vaulted shopping arcades, see J. F. Geist, *Passagen: Ein Bautyp des 19. Jahrhunderts*, passim.

[15] For the Boullée project see Boullée, *Architecture*, pp. 126–32. The room was to have had a wooden vault, though Boullée claims that with reinforcement of the existing courtyard walls a masonry vault would have been possible. The dimensions were 300 *pieds* by 90.

[16] For Pugin at Covent Garden, see Benjamin Ferrey, *Recollections of A. N. Welby Pugin, and His Father Augustus Pugin*, pp. 57–61. The opera for which Pugin designed settings seems to have been Donizetti's *Castello di Kenilworth*, which received its world premiere in Naples in 1829 and was performed in London in 1831. The setting is not Kenilworth but Leicester Castle. Act 1, scene 5, takes place in a "galleria magnifica nell'interne del Castello," which in a Pugin version could well be a reconstruction of the Norman Great Hall, 84 by 58 feet, at Leicester, which, like the sketch, is aisled and divided into bays. However, the Leicester hall had a timber roof.

[17] Pevsner, "High Victorian Design," n. 48 (for Pugin); for Ruskin, see his *Works*, 3:450 and 9:455–56.

49) or railroad station sheds. Before about 1851 the latter were almost always masked by their masonry foreparts or headhouses rather than being formally integrated. Indeed, I have not been able to find a single example of the genuine formal integration of these two parts of the station before the Crystal Palace.

On the other hand, examples of such integration are frequent enough afterwards, and Paxton's building was no doubt a factor in the change. After all, it raised the question of glass and iron architecture as it had not been raised before. Paxton's colossus was no train shed on the outskirts of town. There it gleamed in the middle of Hyde Park, the largest building ever built. Its only drawback was its "unarchitectural" materials. How logical, then, to think of putting proper masonry walls beneath its glass vault.[18]

Contemporary and later reactions to the Palace and its progeny suggest that the real fascination was precisely this glass roof. Thus the article "Architecture" by Street and T. H. Lewis in the *Britannica* said:

Of an entirely novel design and construction was the Crystal Palace, admirably adapted, no doubt, for the purpose for which Paxton designed it, or for any other purpose for which a flood of light without impediment is required. But the manner in which the second, at Sydenham, has been altered is instructive . . . the result showing plainly that the top lights are of the chief value, the side ones being little required except for the prospect through. [The curved roof] is, however, very pleasing, and the brilliancy of the light glass roof will ensure its being adapted in many buildings where a vivid light is required.[19]

The actual changeover from vertical juxtaposition to horizontal layering is a little hard to follow. One clearly sees the pre-Crystal Palace type in Euston Station I of 1837–39, which consists of a simple pair of trussed coverings held aloft on iron supports. At King's Cross, also in London, of 1851–52 (Fig. V–5), by Lewis Cubitt (who was officially involved with the Crystal Palace), a pair of less economical, wider, 105-foot spans cover six or seven tracks as well as passenger walks on either side. The vault is paneled mostly with glass and is supported on

[18] This was not necessarily to be confined to public buildings. Paxton himself said in 1850, "I am now, in fact, engaged in making the design for a gentleman's house to be covered wholly with glass" (*Builder* 8 [1850]:544–45). Yet most critics continued to think of the Palace as engineering rather than architecture. It may not have been until Morton Shand's article of 1937, cited in n. 1 above, that the Palace was placed in the mainstream of architectural history. By then, however, this was not being done because of its Victorian context but to make it a prototype for Mies. Shand, like Giedion, Paxton's other early apologist, wrote during the great period of the International Style, while Hitchcock (*Early Victorian*, 1:547) was writing at the beginning of Mies's heyday in the United States. Hitchcock even deplored the Palace's immediate progeny as the result of a "miscegenation" with masonry; nowadays, however, even architectural miscegenation is no longer disturbing.

[19] T. H. Lewis and G. E. Street, "Architecture," *Encyclopaedia Britannica*, 9th ed.

semicircular trusses bracketed into masonry walls. Four years later, at Padding-ton,[20] the more definitive impact of the Palace produced a trio of spans, more monumental in scale though no wider than those at King's Cross, and with a good deal of E. B. Lamb-like ironwork to boot; there are even a pair of "transepts." In such ornament and terminology, and in the masonry arms from which the roof springs, architectural as opposed to engineering intentions begin to be present.

This impulse toward glass-vaulted monumentality is also shown in the chang-ing silhouettes of headhouses. These tend to get more and more elaborate as the image of the glass vault absorbs designers' aesthetic desires. If one glances at five such silhouettes published by Meeks in *The Railroad Station* (Fig. V–6), i.e., Derby Trijunct, Newcastle Central, Gare du Nord II, St. Pancras, and Frankfurt (built over the period 1839–88), one observes a kind of eruption, where out of flat sheds—not dissimilar, incidentally, to Paxton's first sketches for the Palace—spiked verticals and canted roofs arise and, having poked through, begin to dominate the silhouette (as at St. Pancras). Then, at Frankfurt, the flanking volumes curve up into vaults and domes, and a rigid, multi-bulbed, transparent shell is created. The same thing happens in dozens of other nineteenth-century buildings. The interior effects are not unlike that of a Hyperborean roof on a Speluncar base (compare, for example, Figs. IV–30 and V–13). This technique provided sculptural matter, which could be polychromed, for the vault to light. It solved the problem of the Crystal Palace, which, as noted above, was that it was a device for lighting an interior, but without a sufficiently opaque interior to light.[21]

The apogee of this version of the indoor street—"where," as Thackeray put it, "A multitude of nations meets;/A countless throng!"—was, I believe, Waterhouse's project for the Law Courts, published in 1867.[22] The whole was to be a city of towers and vaults, a complex skeletal plane floating over lower layers of halls and offices. The central concourse (Fig. V–7) was 478 feet long, 60 feet wide, and 90 feet high. Arched trusses were to spring from four-and-a-half-story masonry walls. Wide bays, glass-roofed, were to alternate with narrow, solid-roofed ones, so that

[20] See Henry-Russell Hitchcock, "Brunel and Paddington"; Hitchcock, *Early Victorian*, 1:553 (where both King's Cross and Paddington are said to have been influenced by the Palace); Carroll L. V. Meeks, *The Railroad Station: An Architectural History*, p. 68; Summerson, *Victorian Architecture*, pp. 19–46 (King's Cross and St. Pancras).

[21] Thus the *Ecclesiologist* felt the Palace ought not to be repeated in toto because it was form-less and without solidity (12 [1851]:269). Viollet-le-Duc's influence may also have guided people to build masonry side walls for skeletal roofs. More fancifully, even landscape painting of the Constable or Crome variety, with its dense, impenetrable *repoussoir* fore-grounds and sumptuous skies, may have had an influence.

[22] See Chapter IV, n. 74, above and *Builder* 25 (1867):69–70, 144, 151.

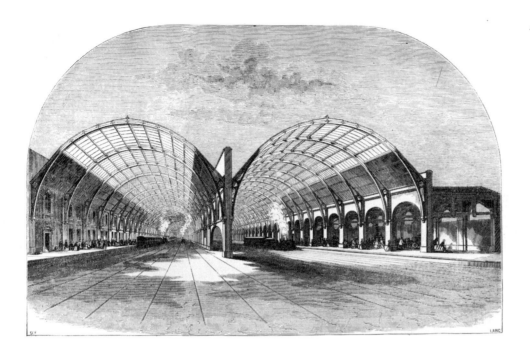

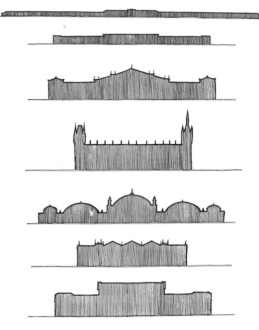

V–5. (left) *King's Cross Station.*
Lewis Cubitt. 1851–52. Builder, *1852.*

V–6. (right) *Silhouettes of railroad stations:*
(from top) *Derby Trijunct, Newcastle*
Central, Gare du Nord II, St. Pancras,
Frankfurt. 1839–88. Meeks, The Railroad
Station.

166 HIGH VICTORIAN GOTHIC

light would have poured into the topless nave as into a ruined abbey. Below, rising in well-muscled masonry tiers, the walls are handled somewhat like a cathedral interior with triforium and clerestory, but on a street-front base. It is a High Victorian Gothic version of Mengoni's more timid Milan gallery (Fig. V–8), begun in 1863 though not published in the *Builder* until 1868. But above all Waterhouse's interior recalls, and transcends, the Crystal Palace. However, fifteen years later, the landscape was urban rather than pastoral, so that the parallel with the urban minster is closer.

There are certain associational aspects to Waterhouse's conception. In the center of his "city" was embedded a great Latin cross formed by two halls. The

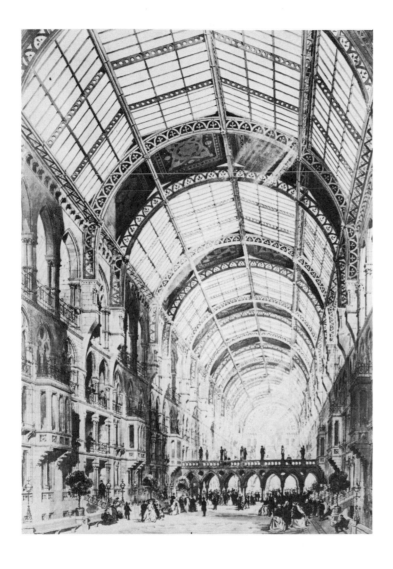

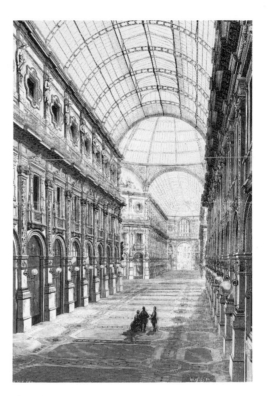

V–8. Victor Emmanuel Gallery, Milan.
Giuseppe Mengoni. 1863. Builder, *1868.*

V–7. Central hall of proposed new Law
Courts. Alfred Waterhouse. 1867. Water-
house, Courts of Justice Competition, *1867.*

"nave" (Fig. V–7) was called the "Central Hall"[23] and the "transepts" were the "Transverse Hall." The latter was at a lower level than the Central Hall and was equipped with triforium galleries that crossed the Central Hall by means of bridges at the level of 18 feet. These are visible in Fig. V–7, forming a sort of double choir screen. Other bridges extended from the ends of the Transverse Hall to the outer perimeter office hives. Thus the circulation system, at its different levels, was in part open. The moving herds could see each other but not mingle. As Summerson says, "The whole arrangement was reminiscent of a railway cutting between two tunnels, crossed by a footbridge."[24]

The street façades lining the Central Hall were equally hierarchic. They began at the bottom with attorneys' rooms in the areaways, the semivisible foundation of the whole system: buried rooms with small windows. Stoops led to plaintiffs' and witnesses' waiting rooms on the main floor. Above them anticipations are fulfilled, so to speak, behind the domestic, cantilevered bay windows of the consultation rooms. Finally, defense witnesses were to be placed behind the ecclesiastical plate-traceried arched windows above. Above this, climaxing the sequence of increasing openness, was open-arched circulation space bounded by corbels for the trusses and chimneys, and containing buttresses joined to the outer (aisle) wall. Thus both the circulation system and the façades expressed distinctions between the general public and various classes of litigants and staff. But despite such associational qualities Waterhouse's Central Hall is essentially a neoclassical Salle des Pas Perdus; in fact he called it that in his presentation. Its superiority to Mengoni's hall is not because of the High Victorian Gothic detail but because of Waterhouse's ability to shape and articulate monumental spaces and to orchestrate light and crowds. It is an ability he shares with the Bibienas and Piranesi rather than with Butterfield.

Another development takes us from the incipiently classical glass-vaulted street to the truly classical glass-domed rotunda. I have noted that after Hyde Park the Sydenham Palace was considered an anticlimax,[25] and it is agreed that the same may be said of the structures that housed the Exhibition of 1862. How-

[23] For the similarity of this hall to the Italian *galleria* see Summerson, *Victorian Architecture*, p. 112.

[24] *Ibid.*

[25] See n. 11 above.

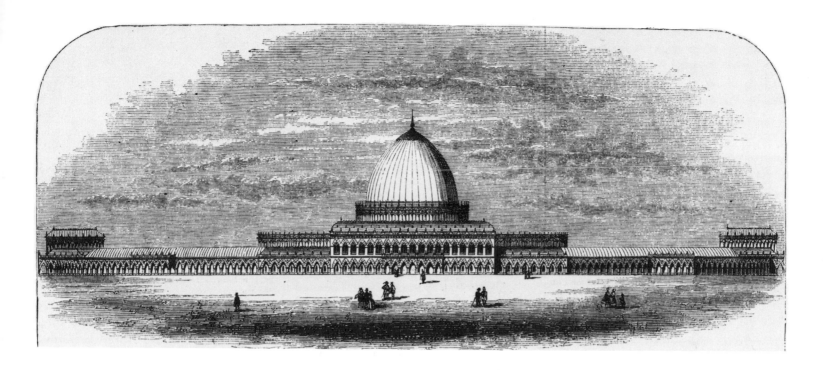

ever, a fascinating unrealized idea for the latter was published in 1861 by Edward J. Payne, architect, and a certain George Maw of Birmingham.[26] Payne provided the architectural setting (Fig. V–9) and Maw the classification system for the artifacts. Thus the project was apparently envisaged from the start as an ethnographic system, with contents and form mutually interlocked. The *Builder* implies that this was expressed on the exterior. Somehow this central ribbed dome with hierarchies of flanking wings and with their uniform surface articulation of High Victorian Gothic arches constituted a model of human knowledge. If so, the spirit would have been that of Loudon or Street; but the form is purely Baroque, or

V–9. Project for 1862 Exhibition, London. E. J. Payne. 1861. Builder, 1861.

[26] *Builder* 19 (1861):106–8.

V–10. Glass house. J. C. Loudon. 1827.
Loudon, Encyclopaedia of Gardening, *1827.*

[27] John C. Loudon, *An Encyclopaedia of Gardening . . . with Suggestions for Its Future Progress, in the British Isles,* 5th ed. (London, 1827), p. 16.

[28] Loudon also describes a Paxtonian ridge-and-furrow roof in the 1835 edition of the *Encyclopaedia of Gardening.* See Chadwick, *Paxton,* p. 75.

[29] *Ibid.,* pp. 157–58.

[30] Published in *American Builder* 10 (1874): pl. 33 and pp. 19, 43–46, 66, 226–27; also in the *New York Sketchbook of Architecture* 9 (1874):1–6. The *American Builder's* plate is said to be reproduced from the English *Builder,* but I was unable to find it there. For Vaux see J. D. Sigle, "Bibliography of the Life and Works of Calvert Vaux."

even Boullée-like. Unfortunately, the short *Builder* article goes into no further detail, and I may have extrapolated too much already. But it would be interesting to pursue the careers of Messrs. Payne and Maw. In any case, the dome can hardly have been anything but glass—possibly many-colored. And the plan makes clear that the space beneath was a rotunda or public indoor piazza of noble scale.

The glass roof seems thus always to lead to classicism, however Gothic the walls supporting it. When one sets Paxton's Palace of 1851 in the procession of glass and glass-roofed buildings and designs leading from the Palm Stove at Kew on into the 1860s, it is apparent that domes or domical forms were extremely common. Indeed, in this setting, both Hyde Park and Sydenham are atypical, "Gothic" mavericks. For example, in what may have been the aboriginal conception leading to Paxton's great achievement, Loudon had in 1827 postulated a trio of duplex domes, the upper domes in each case being onion-shaped (Fig. V–10).[27] (Loudon, by the way, did not limit this principle to hothouses; he even prophesied whole towns covered with glass.[28]) Paxton also was at least partly aware of the classicism of this tradition, as is shown by one of his less well-known designs, said to be for the 1867 Exhibition at St.-Cloud (Fig. V–11).[29] In many ways this is the climax of his imaginative career. Yet the scheme with its three tiered domes is more like Loudon's than like either of his own famous earlier structures.

The ambiguous linkages between High Victorian Gothic and various forms of nineteenth-century classicism are finally illustrated by a stunning unexecuted project, in glass and metal, for the main hall of the Philadelphia Exhibition of 1876. This is the work of an immigrant Englishman, Calvert Vaux, assisted by the engineer G. K. Radford (Figs. V–12-V–14).[30] It is the clearest expression yet of the industrial-universal tendencies of High Victorian Gothic. The exterior view—which is only a preliminary study—may owe something to the Law Courts projects, especially Waterhouse's. The base is a vast 22-acre rectangle rimmed with gabled, many-windowed minster fronts that rise into towering pavilion roofs. Each of these has the name of a country or region inscribed on its frieze.

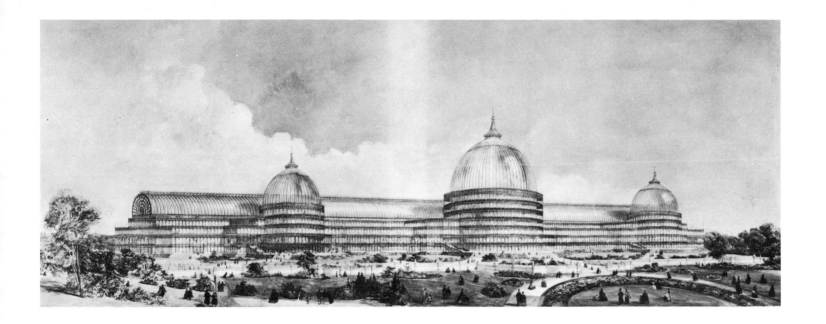

The roofs were to be shingled, the gables and domes set with fluted glass, and the walls wood-sheathed. The central gates on each side are triumphal arches, classical in detail but with rose windows in their center openings. They are topped with bulbous duplex roofs, probably glass-paneled. In the center of the whole, flanked at the corners by smaller, spiked domes, rises a central tower-dome. It is the perfect Victorian compromise between Gothic and classical, tower and dome, and like the other domes is derived from R. M. Upjohn's recently erected capitol for Hartford. Vaux's rendering, as reproduced, suggests lots of metal and glass throughout, and the innumerable finials and crestings puncturing the lower echelon of curved and canted planes anticipate the silhouette of the station at Frankfurt (Fig. V–6). Morphologically, the exterior is a continuous

V–11. Project for St.-Cloud Exhibition.
Joseph Paxton. 1867.
Yale University Art Gallery.

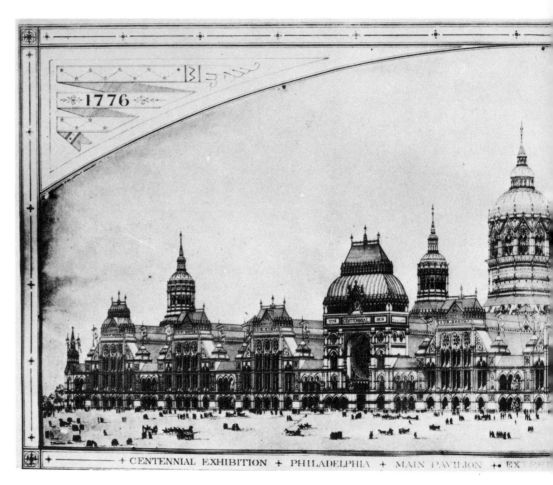

*V–12. Exterior, proposed main pavilion for Philadelphia Exhibition of 1876.
Calvert Vaux and G. K. Radford. 1874.* **New-York Sketchbook of Architecture,** *1874.*

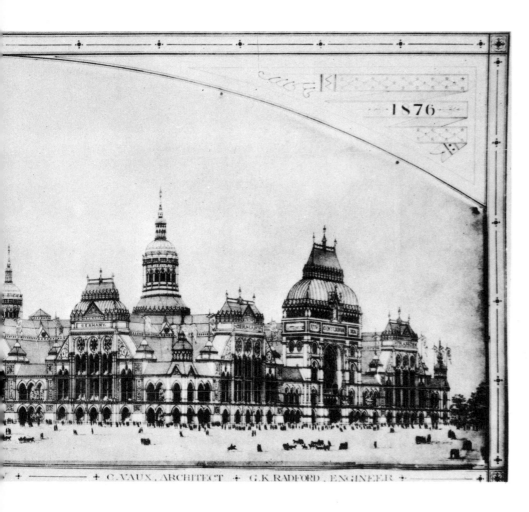

1876

C. VAUX, ARCHITECT G.K. RADFORD, ENGINEER

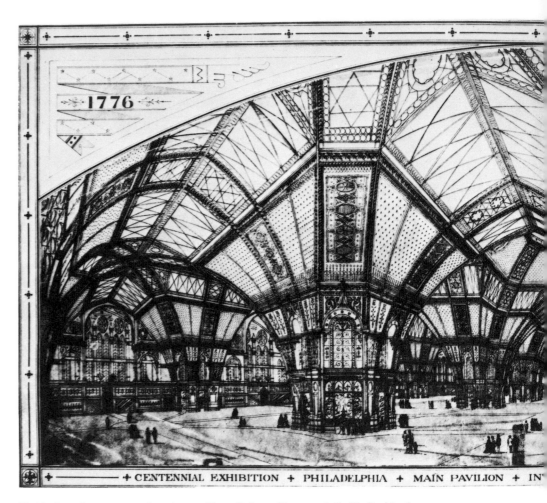

Within the illustration: **1776**

CENTENNIAL EXHIBITION ✦ PHILADELPHIA ✦ MAIN PAVILION ✦ IN

V–13. Interior, proposed main pavilion. Calvert Vaux and G. K. Radford.
New-York Sketchbook of Architecture.

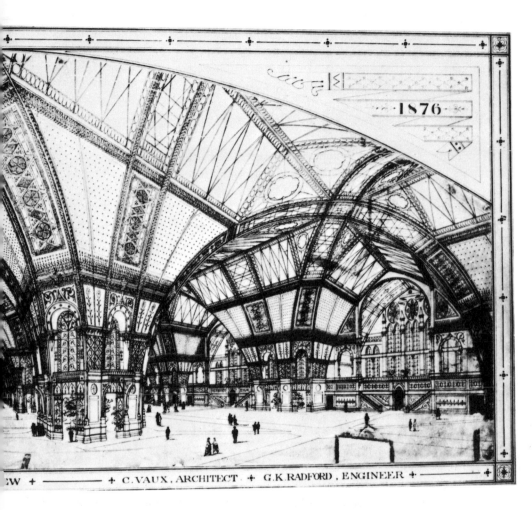

1876

EW · — · C. VAUX, ARCHITECT · ✦ · G.K. RADFORD, ENGINEER · ✦ ·

ring of headhouses—an appropriate image because the structure was to contain a railway. Yet the whole of this exterior is invaded by the spirit of compromise that characterizes the tower-domes: all its elements are securely framed and independent; the jerky transitions and amputations of High Victorian Gothic are absent.

And, having been awed by all this richness, what is our surprise on entering! The plan (Fig. V–14) is quite simply a modular set of twenty-one timber-framed vaults, 240 feet in diameter, with arches of 150-foot span, and interspersed with fountain courts. The arrangement, measuring three such bays by seven, is as abstract and simple as the plan of a steel-framed warehouse. In other words Vaux's megalopolitan exterior is a shell, a bulbous plane raised by a simple trussed skeleton. In the interior, moreover (Fig. V–13), like Paxton twenty-five years earlier, Vaux has integrated Speluncar contours with Hyperborean ossatures. But at the same time, unlike Paxton or, for that matter, Waterhouse, Vaux has cast his metal structure into traditional masonry forms. It is a gigantic cross-vaulted undercroft, a huge Lower Church at Assisi. The conversion of sculptural solids into glass- and wood-sheathed volumes is complete.

The bases of the arches form hollow courts 60 feet in diameter, decorated with painted canvas panels rich in linear patterns. Wide bands rise past their arched openings, forming soffits for the fuller valleys of the vaults and making tight ribbons that join and edge all surfaces. This interior would, I believe, have been full of color and opalescent light and the lower parts of it would have been opaque, so that a garden of color would have presented itself for the upper light to illuminate and suffuse. In such ways Vaux's project is at the very least the climax of High Victorian Gothic in the United States. On the other hand, its modular plan, its symmetry, and its apparent lack of associative values make it like the other pavilions and glass-roofed concourses we have looked at. It is really a classical conception. Even the detail, looked at closely, while it has the sutured appearance of High Victorian Gothic, is equally reminiscent of Percier and Fontaine.[31]

[31] This combination of complex husk and simple modular skeleton could have been suggested by Vaux's work in the Stick Style, in which the patterns of the outer shell seldom correspond to the actual frame within. The outer planes are instead an independent diagram of the true structure, hyperbolic inscriptions whose function is not to reveal but to re-express the frame.

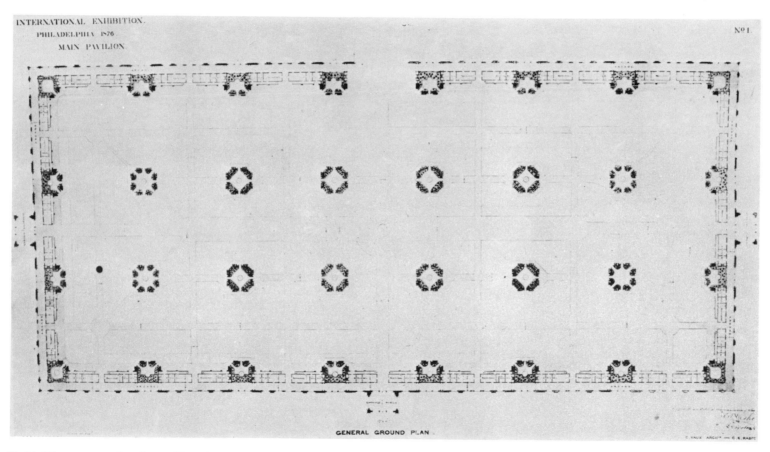

V–14. Plan, proposed main pavilion. Calvert Vaux and G. K. Radford. New-York Sketchbook of Architecture.

The structures we have been discussing are in many ways Neoclassical buildings in High Victorian Gothic trappings. Similarly, when the machine dressing notion is pushed too far it too turns High Victorian Gothic into something else. It is one thing for Butterfield to express the kind of surfaces machines make, thus amplifying his conception of the building as a machine. It is quite another thing when, with the Crystal Palace, the machines literally *become* the building. The same distinction holds when designers of metal structures, rather than merely evoking the casting process in their forms, sought to use normal industrial components as ornament—to promote flanges, sockets, and rivets to the level of art. Such ideas had been presaged in 1842 by Samuel Clegg in his book *The Architecture of Machinery*,[32] where he illustrates, for example, "a gudgeon of considerable diameter" (Fig. V–15) with a cast brass cap, which he claims as an example of efficiency that also "makes a good job," i.e., is handsome. Such beveled shapes, helical threadings, clamps, sockets, and forced tightenings belong at once to the machine aesthetic and to Victorian architects' love of the imagery of pressure. The concept of industrial ornament was also reinforced by the Great Exhibition, which had excluded works of art that did not in some way reflect an industrial process.[33] In a similar vein Thackeray, in his *May-Day Ode*, stressed that machines were the weapons of Britain's imperial conquest.[34] Added to this must be the High Victorian Goths' conviction that Gothic was the most mechanically and technically capable of past styles, the most progressive—Hope, as we have seen, actually considered that the Crystal Palace *was* a Gothic building.[35] Scott in 1857 had described Gothic as capable of embracing any system of construction at all,[36] while other writers claimed that the Palace and metal buildings in general had a scriptural warrant.[37] Most of this talk came from anti-Ruskinians, but even Ruskin, in spite of himself, dramatized the idea of a mechanical architecture in contrasting organic Continental skyline treatments with English ones: "Our spikes have a dull, screwed on, look; a far-off relationship to the nuts of machinery; and our

[32] However, Clegg's book is entirely Neoclassical in its taste and ornamental vocabulary, which shows how "industrial ornament" could be the common property of both Greek and Goth.

[33] See *The Great Exhibition: Official Description and Illustrated Catalogue*, 2:819.

[34] As quoted by Hobhouse, *1851 and the Crystal Palace*, p. 173.

[35] I have noted Street's reference to the pointed arch as a technological improvement over the round (see p. 46 above). See also Street's "The True Principles of Architecture and the Possibility of Development," *Ecclesiologist* 13 (1852):247–62.

[36] *Remarks*, p. viii.

[37] "L. L. Y.," "Iron Architecture," *Building News* 3 (1857):10–11, 34–36, quoting a paper by F. A. Skidmore.

roof-fringes are sure to look like fenders, as if they were meant to catch ashes out of the London smoke-clouds."[38]

Such notions were expressed all through the mid-Victorian period. By 1875 C. H. Driver, writing in the *Builder*, could restate the case for industrial ornament even more boldly: "Surely architects, if they would, could so design their girders in wrought or cast iron that they should be pleasing and effective. Let them but take the trouble to draw them out and calculate for themselves, they would soon find it was easy enough to arrange flanges, webs, cover-plates, and angle and tee irons so symmetrically as to be pleasing, and still preserve the necessary scientific proportions."[39] Such ideas simply apply to metal Street's precept that buildings should explain their structure in their ornament.

For an early, definitive embodiment of these notions we turn once again to ecclesiology, and to a prefabricated cast-iron mission church, destined, no doubt, for some treeless ocean rock. It was published in *Instrumenta ecclesiastica* in 1856, and had originally been commissioned from Carpenter. On his death it became the intellectual property of his successor, Slater.[40]

The vocabulary of the iron church is fully industrial—more so, I think, than any earlier monumental buildings (Figs. V–16-V–19). Throughout, machine forms wittily do duty for standard Gothic; indeed the erected building would have resembled a steel engraving of a Gothic Revival stone church. The exterior is composed of corrugated iron plates with cast-iron frames, and the interior frame is of I-beams forming pointed arches, each pier being made of four detached rods cored by a strap-iron helix. The suggestion is of Late Gothic Solomonic columns; the punctured trefoils in the arch ribs are "Gothic" radii (Fig. V–17). The chancel screen, on the other hand, is more orthodoxly Curvilinear (Fig. V–19). But the church as a whole, with its riveted exterior and punched detail, clearly expresses what Hope called the "vast wholesale methods" of Victorian industry. And its iron texture and pronged framework (and, no doubt, had it been built, brazen acoustics) would well satisfy any desire for self-punishment a potential incumbent might feel.

V–15. Cast-iron and brass gudgeon. Samuel Clegg. 1842.
Clegg, Architecture of Machinery, *1842.*

[38] *Works*, 9:403. For a brief modern account of the mechanical analogy, see Collins, *Changing Ideals in Modern Architecture*, pp. 159–66.

[39] "Iron as a Constructive Material," *Builder* 33 (1875):352.

[40] *Instrumenta ecclesiastica* (1856 ed.), pp. 67–72; *Ecclesiologist* 17 (1856):280–81.

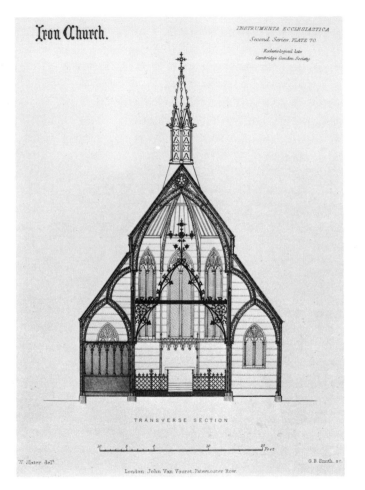

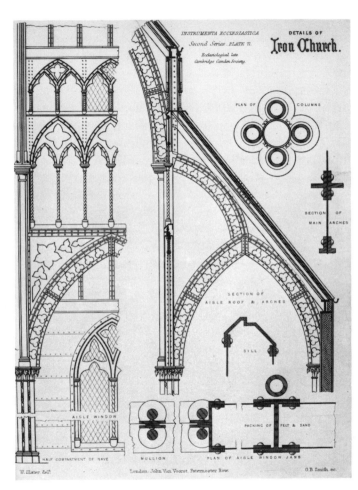

V–16. Interior section, project for cast-iron chapel.
William Slater. 1853–56. Instrumenta ecclesiastica.

V–17. Details of framing, project for cast-iron chapel.
William Slater. Instrumenta ecclesiastica.

INSTRUMENTA ECCLESIASTICA
Second Series. PLATE 67

Ecclesiological late
Cambridge Camden Society.

VESTRY

NAVE

CHANCEL

PLAN

PORCH

W. Slater. delt

London. John Van Voorst, Paternoster Row.

G. B. Smith. sc.

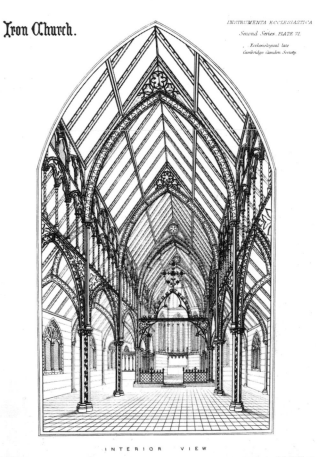

Iron Church.

INSTRUMENTA ECCLESIASTICA
Second Series. PLATE 71.

Ecclesiological late
Cambridge Camden Society.

INTERIOR VIEW

W. Slater. delt

London. John Van Voorst, Paternoster Row.

G. B. Smith. sc.

V–18. Plan, project for cast-iron chapel.
William Slater. Instrumenta ecclesiastica.

V–19. Interior, project for cast-iron chapel.
William Slater. Instrumenta ecclesiastica.

At the time it was suggested by one of the bidding contractors, F. A. Skidmore of Coventry, that the panels be filled with marble, that crystals and gems be used in decorating the interior, and that the walls be hung with tapestries.[41] Such enrichments would presumably have pointed the comparison to Gothic metalwork, but the very idea is also an illustration of how seriously "architectural" this post-Paxton conception was, i.e., how the implications of the sobriquet "Crystal Palace" might now be more literally fulfilled. Here I must mention too that Beresford-Hope was advocating iron vault ribs for cathedrals, with panels of decorated porcelain or enameled terra cotta.[42] The characteristic flavor of this desire for the hardest, sharpest, most brilliant of materials is obvious.

So far as I know, Slater's church was never erected. But the interior does bear a resemblance to the glass court of the Oxford Museum of 1856–59 (Fig. V–22), which was probably not yet under construction when *Instrumenta* was published. Such a court had been intended by the architects, Deane and Woodward, as early as 1855.[43] It is therefore interesting that the present roof was built by Skidmore,[44] who, as well as being an ecclesiologist, was a friend of the museum's prime mover, Henry Acland.[45]

The notable feature of the glass court is its industrial ornament. The planned color scheme, white and buff with maroon details, was intended to integrate this ornament with the masonry surround, emphasizing Acland's idea that the court should combine Gothic art and "railway materials."[46] Compared to the iron church there is, at Oxford, richer foliage in the capitals, spandrels, and trusses,[47] and, of course, unlike Slater's church, the court is plugged into a two-story arcaded brick socket, complete with striped voussoirs and Italianate columns, piers, and colonnettes (Fig. V–23). Finally, the roof is of iron and glass, with imbricated panes.

There is considerable associationism of a rather Ruskinian sort in this interior. Keeping for the moment to the metal parts alone, as Acland pointed out, the cast columns and wrought ornaments express both their capacities and modes of production: "The rigid (cast) material supports the vertical pressure; the malleable (wrought) iron is employed for the ornament, and is chiefly hand-wrought."

[41] Letter of March 10, 1856, *Instrumenta ecclesiastica*, pp. 67–72.

[42] *English Cathedral*, p. 228.

[43] Ruskin and Acland, *Oxford Museum*, pp. 30–31.

[44] *Ecclesiologist* 20 (1859):69.

[45] The *Builder* (13 [1855]:318) attributes both execution and design to Skidmore. However this may refer only to the clustered-rod columns, which turned out to be inadequate and were replaced by the present heavier ones, also made of clustered rods. See Peter Ferriday, "The Oxford Museum." Ferriday seems to say that there was an original single-column scheme by Woodward and that the clustered-rod design, both in its weak and strong versions, was Skidmore's (p. 412).

[46] *Builder* 13 (1855):291.

[47] See Ruskin and Acland, *Oxford Museum*, passim, and Skidmore's "theory of metal foliage" of 1855, as reported in *Ecclesiologist* 20 (1859):200.

These wrought-iron ornaments, filling the spandrels, also represent interwoven branches, "with leaf and flower and fruit, of lime, chestnut, sycamore, walnut, palm, and other trees and shrubs, of native or exotic growth; and in various parts of the lesser decorations, in the capitals, and nested in the trefoils of the girders, leaves of elm, briar, water-lily, passion-flower, ivy, holly, and many others."[48] The eighteenth-century idea of Gothic's forest origin is invoked, but as a universal forest, a "Catholick" grove of representative trees poetically suggesting both the extent of the Empire and the boundaries of knowledge.[49]

Thus the glass court, for expressive purposes, integrates a number of High Victorian Gothic elements—brick, stripes, Italian carving, glass roof, industrial ornament. However, if the court is thus a landmark of the style's impact, the masonry exterior into which it is set, as we shall see, is an early symptom of its downfall.

Ruskin Classiciste

We can now turn more definitively to the forces that broke up High Victorian Gothic. From the very beginning one can sense weaker associational possibilities in the buildings I have just discussed. A large multipurpose building like the Crystal Palace or Vaux's centennial pavilion can hardly support the specific meanings of a cottage or chapel. And Industrial Gothic, as far as its actual detail is concerned, could equally be called Industrial Classicism. Both movements, therefore lead away from High Victorian Gothic proper. But when we come to the destruction, as opposed to the mere dilution, of the style we encounter a paradox: it was once common to assign to Ruskin much of the responsibility for introducing High Victorian Gothic. Then in 1954 Hitchcock showed that Ruskin's role had really been less important than Butterfield's.[50] I will go further, and claim that Ruskin's influence was antithetical to the ecclesiologists' achievement. This may seem to contradict the presentation of Ruskin in Chapter II as a sort of prince of associationists, but, as I noted there, Ruskin's associationism, though important, was idiosyncratic, and in any case he pretty much dropped it after 1853.

[48] Ruskin and Acland, *Oxford Museum*, pp. 30–31.

[49] *Ibid.*, p. 34.

[50] *Early Victorian*, 1:572–613.

Ruskin's position on certain other fundamental issues was also different from that of ecclesiology. He of course favored Italian Gothic, but his attitude was puristic—as Neoclassical as Pugin's attitude toward English medieval architecture. Ruskin would have no truck with eclecticism, for example, which was a basic principle of High Victorian Gothic. He was totally uninterested in primitive architecture, he never dwelt on such things as timber roofs and, as is well known, opposed iron and "railway materials" with relentless vigor. He was, in fact, in disagreement with the ecclesiologists on every principle of their style, though rather inconsistently he could praise examples of it.

The creators of High Victorian Gothic occasionally allowed some of these differences with Ruskin to appear, though there was never an outright attack on the order of their 1846 article on Pugin. One bone of contention was Ruskin's preference for deformed and organic rather than precise, machinelike tracery; it is obvious from their churches that the High Victorian Goths preferred the latter and from Ruskin's illustrations that he liked the former. Street, for example, had been disappointed with the traceries at the Camposanto, Pisa, saying that they are, "as Pisano's always are, very unscientific and more like a confectioner's work than an architect's."[51] It would be difficult to imagine Ruskin agreeing with this. And here is Street speaking against another favorite Ruskin thesis, in remarks about Christ Church Cathedral, Dublin: "It is clear that . . . the workmen absolved themselves of all responsibility, worked the stones they were ordered to work, and ate their meals between with the same absolute *sang froid* that marks their successors at the present day. They had no more pleasure in their work, no more originality in their way of doing it, than our workmen have at the present time, all the pretty fables to the contrary notwithstanding."[52] This almost seems a direct slap at Ruskin.

A more important issue involves the precedence of All Saints as opposed to *The Seven Lamps of Architecture*, both of which date from 1849. It is often said that Butterfield must have been influenced by the book, and Ruskin's advocacy of irregular, independent polychrome is adduced as supporting evidence.[53] But if it

[51] *Notes and Papers*, p. 66.

[52] Quoted in A. E. Street, *Memoir*, p. 117.

[53] Collins, *Changing Ideals in Modern Architecture*, pp. 114–16. Ruskin also suggested that "geometrical colour mosaic" was the only type of "rich ornament" then possible (*Works*, 8:219); his inclusion of large-scale dogtooth moldings in the plates of *Stones of Venice I* might be counted as having borne fruit in High Victorian Gothic.

is true that the book had an influence on All Saints or on buildings derived from it, one would expect to find details of moldings, etc., frequently repeated from the book in actual buildings. This is not the case. The same must be said of the monuments Ruskin so vociferously praises here and in his later books. Replications of St. Mark's, the Fondaco de' Turchi, and the Doge's Palace seldom appear in mid-Victorian England. In *Seven Lamps* Ruskin praises one structure above all as embodying all "right" architectural principles—the Giotto tower. He describes it as "that bright, smooth, sunny surface of glowing jasper, those spiral shafts and fairy traceries, so white, so faint, so crystalline, that their slight shapes are hardly traced in darkness on the pallor of the Eastern sky, that serene height of mountain alabaster, coloured like a morning cloud, and chased like a sea shell."[54] To say that High Victorian Gothic is an attempt to embody such a vision would be grotesque. This opalescent dream, which is invoked throughout the book, conjures up the architecture in Prout or even Turner, or a Pugin vision applied to Italy.

If one looks beneath the surface of Ruskin's rules for architecture in *Seven Lamps* one invariably gets such an Early Victorian watercolor. The true colors of architecture, he says, are those of natural stone. "Every variety of hue, from pale yellow to purple, passing through orange, red and brown" is to appear. So are colored molded brick and porcelain tiles arranged in wide unbroken surfaces and smoothly polished. He also recommends what he calls "penetrative ornament of different sizes" (which I admit sounds a little like the punched and perforated tracery of High Victorian Gothic) and, as well, "varied and visible masonry, varied proportion in ascent," and vivid color in flat geometric patterns. But it turns out that by "penetrative ornament" Ruskin means richly carved naturalistic sculpture. His descriptions of color imply delicate tintings as well as vividness, and he does not even mention the basic High Victorian Gothic principle of structural polychrome.

These precepts come closer to High Victorian Gothic than anything else of Ruskin's up to 1849. His other rules from this period are either insufficiently pre-

[54] *Works*, 8:189.

cise or actually opposed to the new style. They are: projection toward the top, breadth of flat surface, square compartmentation of that surface, vigorous depth of shadow (exhibited especially in pierced tracery), enriched quantity of ornament at the top, and abstract sculpture in important places and in moldings.[55] Actually, taken together, Ruskin's principles imply or at least allow structures made of symmetrical upright planes. There is never the idea that form is determined by function, nor does he ever consciously suggest the amputations and compressions of High Victorian Gothic. His rules ignore volume and silhouette, qualities that were paramount to the ecclesiologists.

Indeed, the principles of this 1849 manifesto could with perfect ease be applied to a building by Léon Vaudoyer or—except for the color and the pierced tracery—to the Paris Opéra! One could erect a building with frontispiece, symmetrical wings, regular bays, uniform layered fenestration, striped masonry, colored tiles, and corbeled cornice; one could have a classicizing mass in which the basic disposition was determined by the façades, dressed in Venetian surfaces. Moreover, all this, we shall see, is the form actually taken by Ruskin's anti-High Victorian Gothic mode.

Ruskin's later books can be linked rather more firmly to High Victorian Gothic, but the influence now seems to flow from Butterfield to Ruskin rather than vice versa. In *Stones of Venice II*, for example, which appeared in 1853, when the outer shell of All Saints was almost finished, Ruskin produced another set of principles. This time they were ostensibly based on St. Mark's. They included light cornices, encrustations of color in the manner of armor, no expression of wall structure, and solid shafts that could be purely ornamental and of variable size. With its serpentine and jasper, and shallow carving, Ruskin says, St. Mark's is "a vast illuminated missal, bound with alabaster instead of parchment, studded with porphyry pillars instead of jewels, and written within and without in letters of enamel and gold."[56] Except for the prohibition of structural expression, these rules are far closer to High Victorian Gothic than the ones in *Seven Lamps*. In the

[55] *Ibid.*, p. 187.

[56] *Ibid.*, 10:99–113, esp. p. 112.

same book Ruskin gave further Butterfieldian prescriptions: the roof must rise to a steep gable; the principal windows and doors must have pointed arches with gables; arches must be cusped and apertures foliated, except for large structural arches or rows of small lancets; there must be lots of sculpture and rich moldings. "If there be no foliation anywhere, the building is assuredly imperfect Gothic."[57] While the connection with High Victorian Gothic is again close, it is now of the less pure type created by Scott or even Burges. Yet in *Stones of Venice III*, also published in 1853, Ruskin is capable of returning to his earlier water-coloristic vision; he describes, for example, the cloudy colors of the Doge's Palace façades.[58]

In the following year, as we noted, Ruskin advised Scott when the latter was remodeling the chancel of Camden Church, Peckham Road, Camberwell.[59] This chancel, as presented in the *Builder*, boasted polychrome masonry and other Byzantine features, so that it well suited Ruskin's concerns at the time, and, coming as it did considerably earlier than the first publication of All Saints, it may be the germ of the legend that Ruskin originated High Victorian Gothic.

When we come to Ruskin's attitude to other modern buildings we get the same picture: ambiguity, mixed with more than a hint of influence *from* High Victorian Gothic. In *Stones of Venice I* Ruskin praised Wild's Christ Church, Streatham (1841), for its striped and checkered brickwork.[60] But the earliest real "review" of any modern church from Ruskin's pen was in *Stones of Venice III* (1853) and was devoted to All Saints:

I am quite sure, for instance, that if such noble architecture as has been employed for the interior of the church just built in Margaret Street had been seen in a civil building, it would have decided the question [of whether neo-Gothic must be ecclesiastical only] at once; whereas, at present, it will be looked upon with fear and suspicion, as the expression of the ecclesiastical principles of a particular party. But, whether thus regarded or not, this church assuredly decides one question conclusively, that of our present capability of Gothic design. It is the first piece of architecture I have seen, built in modern days, which is free from all signs of timidity or incapacity. In general proportion of parts, in refinement and piquancy of mouldings, above all in force, vitality, and grace of floral

[57] *Ibid.*, pp. 266–67.

[58] *Ibid.*, 11:29.

[59] *Builder* 12 (1854):362–63.

[60] *Works*, 9:349–50.

ornament, worked in a broad and masculine manner, it challenges fearless comparison with the noblest work of any time. Having done this, we may do anything; there need be no limits to our hope or our confidence; and I believe it to be possible for us, not only to equal, but far to surpass, in some respects, any Gothic yet seen in Northern countries.

After the words "Margaret Street" above, Ruskin has appended the following note: "Mr. Hope's church, in Margaret Street, Portland Place. I do not altogether like the arrangements of colour in the brickwork; but these will hardly attract the eye, where so much has already been done with precious and beautiful marble, and is yet to be done in fresco. Much will depend, however, upon the colouring of this latter portion. I wish that either Holman Hunt or Millais could be prevailed upon to do at least some of these smaller frescoes."[61]

Thus in 1853 was Ruskin's approval precipitated out of Butterfield's achievement. The passage pays homage to a whole array of the High Victorian Gothic principles: it assigns credit to ecclesiology for the style of All Saints, affirms in it northern and masculine qualities, gives it its characteristic sense of sharp force—possibly leading to "fear and suspicion"—and urges further progress. Nor does Ruskin claim any credit for all this; he only asks that this ecclesiastical style be adapted to a new secular architecture.

However, as time went on the distinction between High Victorian Gothic and various other polychromatic neo-medieval modes was lost. At the same time Ruskin fell into the habit of claiming that he had had a vast but baleful influence on British architecture generally. In 1865, in *Sesame and the Lilies*, he said: "The architecture we endeavoured to introduce is inconsistent alike with the reckless luxury, the deforming mechanism, and the squalid misery of modern cities; among the formative fashions of the day, aided, especially in England, by ecclesiastical sentiment, it indeed obtained notoriety; and sometimes behind an engine furnace, or a railroad bank, you may detect the pathetic discord of its momentary grace, and, with toil, decipher its floral carving choked with soot. I

[61] *Ibid.*, 11:229.

felt answerable to the schools I loved, only for their injury."[62] This appropriation of the onus for such influence is, of course, basically self-congratulatory. But it is not really clear what style Ruskin is actually referring to, though the "ecclesiastical sentiment" has to be ecclesiology. By 1865, therefore, the latter had been demoted and become merely the great man's helper.

In 1872, Ruskin hoped that he had influenced Street to supplant his winning Law Courts design with the one that was actually built. Ruskin had high hopes for the new result, yet complained that his influence was evil, and had spread further: "I have had indirect influence on nearly every cheap villa-builder between this [Denmark Hill] and Bromley; and there is scarcely a public house near the Crystal Palace but sells its gin and bitters under pseudo-Venetian capitals copied from the Church of the Madonna of Health or of Miracles. And one of my principal notions for leaving my present house is that it is surrounded everywhere by the accursed Frankenstein monsters of, *indirectly*, my own making."[63] Here Ruskin goes very far. He blames himself for introducing not only Venetian Gothic but Venetian Renaissance and even Baroque!

These claims were unintentionally aided by Eastlake, who in his *Gothic Revival* provided a historical setting for Ruskinism. Eastlake gives Ruskin credit for advocating polychrome, Italian medieval detail, and the like, which is perfectly proper, but then he implies that foreign influence in general has been due to Ruskin.[64] Perhaps Eastlake only meant to affirm the non-foreign character of Butterfield's style, its universalism and lack of specific borrowings. Eastlake even adds that church building was at first not affected by Ruskin's advocacy of foreign styles. But if this was an attempt to dissociate High Victorian Gothic from Ruskinism, all it succeeded in accomplishing was to obscure All Saints' pioneer role. Eastlake's attribution of Italianism in general to Ruskin was widely echoed by his reviewers,[65] and soon Butterfield's church and the novelty of its style were buried under the Ruskin literature—so much so that All Saints was not even mentioned in the early editions of Clark's *Gothic Revival*.

[62] *Ibid.*, 18:150–51.

[63] *Ibid.*, 10:459 (letter to *Pall Mall Gazette*, March 15, 1872).

[64] *Gothic Revival*, p. 289.

[65] For instance, the *Pall Mall Budget* [*Gazette*] for March 16, 1872, pp. 25–26. And as early as 1854 the *North British Review* (21:172–200) had given Ruskin credit for advocating what sounds like High Victorian Gothic.

Encouraged, perhaps, by this apparent endorsement of his claims, Ruskin proceeded to inflate them. In 1874, in a preface to a new edition of *Stones of Venice*, he stated that "no book of mine has had so much influence on contemporary art as the *Stones of Venice*," which, he went on, "has mottled our manufactory chimneys with black and red brick, dignified our banks and drapers' shops with Venetian tracery, and pinched our parish churches into dark and slippery arrangements for the advertisement of cheap coloured glass and pantiles."[66] Now Ruskin paints a clearer picture of the ecclesiologists' church style and yet fully attributes it to his influence. On the other hand, the reference to banks suggests the work of Deane and Woodward, a firm that really was Ruskinian.

Later writers on the Gothic Revival have accepted Ruskin's claims. They have either failed to distinguish between High Victorian Gothic and Ruskinian architecture or have given Ruskin credit for both. This is particularly odd in view of the fact that Ruskin's own editors, Cook and Wedderburn, correctly made the distinction. In their preface to *Stones of Venice II* they state that Ruskin's writings had only a gradual influence, first among architectural students, then among architects. They add that it was only years after the appearance of *Stones of Venice* that anything constituting a true revival of Venetian Gothic could be said to have occurred, and that these buildings were not churches but warehouses and offices.[67]

In general, then, Ruskin's impact on All Saints was nil; on the contrary, he was himself probably influenced by it. It was only much later, in the 1870s, when the issues of the *Builder, Building News,* and *Ecclesiologist* of twenty years earlier were gathering dust on library shelves while Ruskin was still being copiously reprinted that, with his help, the story grew up of his responsibility for the style. By this time, in any case, little distinction was made between All Saints and the essentially different symmetrical, classicizing, polychromatic mode that has always been legitimately linked with Ruskin's name.

[66] *Works*, 9:11.
[67] *Ibid.*, 10:liii–liv.

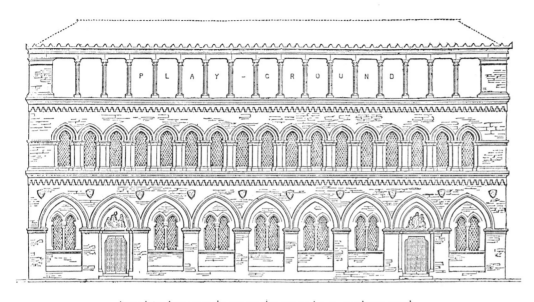

*V–20. St. Martin's Northern Schools, Soho.
James Wild. 1849. Builder, 1849.*

The Oxford Museum

Even this Ruskinian counter-style, despite Ruskin's crucial connection with it, may be said to have begun before him, i.e., with J. W. Wild's St. Martin's Northern Schools, Soho (Fig. V–20), now destroyed. These were designed in 1849, the year in which All Saints (Fig. IV–7) was built and *Seven Lamps* appeared[68] and well before Ruskin began his own investigations of Venetian architecture. The Schools had a symmetrical red brick façade with two lower floors of superimposed Gothic arcades and an upper attic belvedere (the playground) reminiscent of the upper-floor treatment of the Palazzo Guadagni, Florence. The two symmetrical doors

[68] See *British Almanac* (1851):240–42, which praises the building's "reality"; G. E. Street, "On the Revival of the Ancient Style of Domestic Architecture," *Ecclesiologist* 14 (1853):77. The elevation of the Fondaco de' Turchi published by Ruskin in *Stones of Venice II* (*Works*, 10:147, fig. 4) is not unlike the

Wild façade. Hitchcock makes St. Martin's Northern Schools the first Italian Gothic building in Victorian England (*Early Victorian*, 1: 578). Also to be noted are St. John's Schools, Liverpool, by William Hay, published in *Builder* 8 (1850):463. This is an English version of the same sort of thing.

[69] *Builder* 17 (1859):252–53, 335–36, 401–2, 408; *Building News* 4 (1858):1291, 5 (1859): 29, 59, 135, 161, 269, 278, 338, 819. See also Ruskin, *Works*, 16:xli–xlvii, li–liii, lxiii–lxxv (Cook and Wedderburn's descriptions), 431–36, 18:150; Ruskin and Acland, *Oxford Museum*, passim; Eastlake, *Gothic Revival*, pp. 283–87, 393; Clark, *Gothic Revival*, pp. 282–93; C. P. Curran, "Benjamin Woodward, Ruskin and the O'Sheas"; and Ferriday, "Oxford Museum."

[70] Quoted in Ruskin, *Works*, 16:xlii. The *Building News* called it Early Decorated "with a very strong tinge of Southern-Gothic, and somewhat more than a tinge of Southern-Gothic detail" (5 [1859]:29).

[71] See the *Builder* 12 (1854):426–27, which calls it "Venetian Cinquecento but with Trecento or Giottesque mouldings and carved work." At this time the firm was known as Sir Thomas Deane, Son and Woodward, but already Woodward was distinguished as the design genius. Ruskin said of the Trinity College museum that it was "the first realization I had the joy to see, of the principles I had, until

on the ground floor called for reliefs in their tympana, and shields were put in the spandrels. Unlike Lamb's schoolhouse (Figs. I–16-I–17) there was no functional or moral expression, nor was Wild's choice of motifs particularly eclectic, being based purely on North and Central Italian civic architecture of the fourteenth and fifteenth centuries. In massing, composition, ordonnance—in everything but detail—the design is classicizing.

The main front of the science museum at Oxford (Figs. V–21-V–23) is synthesized in this same way, using a classical palace layout with Italian Gothic detail.[69] But this time the process was undoubtedly conducted under Ruskin's guidance. The design was chosen after a competition held in 1854, and construction began in June of 1855 from designs by the Dublin firm of Deane and Woodward. The source is ultimately the North European town hall of the late Middle Ages, but there is also truth in the remark, attributed to a Professor Hort, that it is "Veronese Gothic of the best and manliest type, in a new and striking combination."[70] The building is relatively un-High Victorian Gothic in its materials—creamy Bath stone, with voussoirs of dark brown stone and gray marble. The projecting gallery originally intended for the tower is also more Italianate than Butterfieldian, as are the internal capitals, based on those of the Doge's Palace. The plan (Fig. V–23), a courtyard with central towered gateway, is indigenously Oxonian.

In 1852–57 Deane and Woodward had created a Wildean palazzo in granite and Portland stone: the museum (now library) of Trinity College, Dublin (Fig. V–24).[71] This earlier project could account for the symmetrical window groups of the Oxford building; the gabled, central-towered main façade might have been suggested by the original design of T. Penson, Jr., for the railroad station at Shrewsbury, illustrated at the time (Fig. V–25).[72] The use of a railroad station as a prototype for a science museum had certain associational relevance, especially in view of Acland's desire to integrate Gothic and "the railway style." So did the use of a medieval kitchen form (e.g., Glastonbury Abbey or Stanton Harcourt)

for the chemical laboratory. As Acland said, "All noxious operations are removed from the principal pile."[73] Functional expression of a different sort is found in the Early English tourelle that becomes a stair tower and in the tall, broad upper windows which light the exhibits, and the smaller first-floor lancets which illuminate offices and classrooms. But there is no real exterior distinction between the various kinds of study carried out behind the main façade—medicine on the left and chemistry on the right—and much of the eclecticism of detail seems gratuitous. The polychrome voussoirs in the second story may be considered Lombard, the roof is Franco-Flemish, and much of the carving is, as noted, Early English, but why? Then we must remember the glass court (Fig. V–22), that signal instance of Industrial Gothic. Is Industrial Gothic appropriate to Oxford science?

On the other hand, one could say that, associationally, the museum stretches rather than ignores the criteria I have mentioned. In normal associationism a variety of physical functions leads to volumes and masses and distributions of detail that vary; thus we get a Loudon cottage or a Butterfield church. But the Oxford museum in its main mass embodies physical activities that are similar: lectures, reading, and consultation. This leads to a uniform façade for reasons that, ironically, had elsewhere suggested contrasting volumes. Further, and also in line with an associational reading of the museum, the building was intended not so much to embody activities as knowledge. This knowledge is presented on its interior façades by using the metaphor of the building as the Book of Nature.

Street, writing in 1853 on the proposed museum, said that "there seems to be a peculiar propriety in selecting a style which, above all others that have ever existed, took nature and natural forms for her guide and her ornaments, in a Museum intended mainly for the reception of a collection illustrative of Natural History."[74] Here Street only meant Gothic as opposed to classical, but such an idea may have developed further in other minds as the Museum was designed and decorated. In 1859 Acland wrote that the purpose of the building was "to give

then, been endeavouring to teach!" (*Sesame and the Lilies* [1865–68], *Works*, 18:149–50). However, as Douglas Richardson points out in his Yale dissertation, "Gothic Revival Architecture in Ireland," some of the detail seems based on Venetian palaces as illustrated in the *Builder* in 1851, plates which appeared only a few weeks after *Stones of Venice I* and which Woodward could easily have seen first.

[72] Reproduced in G. M. Young, ed., *Early Victorian England*, 2 vols. (Oxford, 1934):2:opp. p. 198. Penson's station was actually built asymmetrically.

[73] Ruskin and Acland, *Oxford Museum*, p. 39.

[74] *An Urgent Plea*, p. 17.

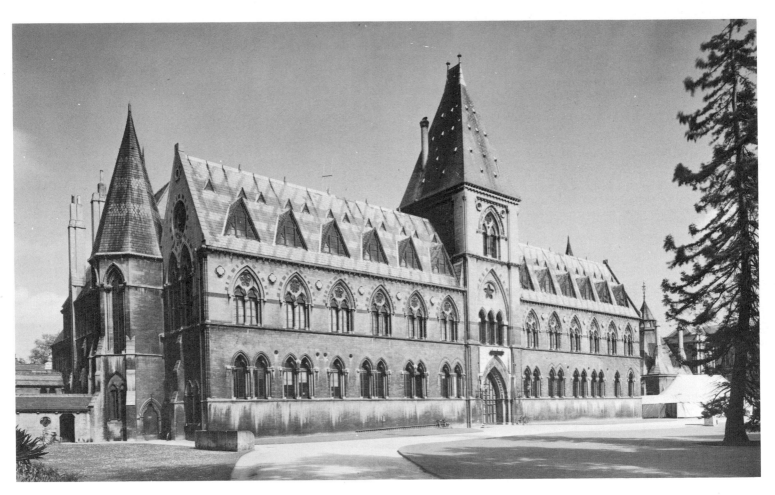

V–21. Exterior, new science museum, Oxford. Deane and Woodward. 1855–59. Photo NMR.

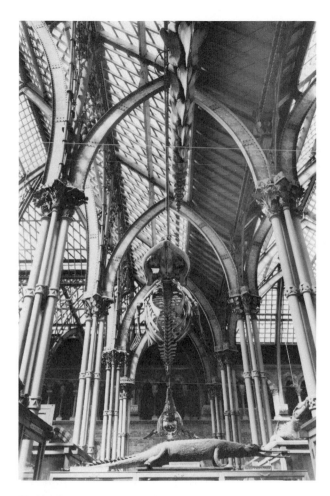

V–22. Glass court, new science museum.
Deane and Woodward. Photo Eric de Maré.

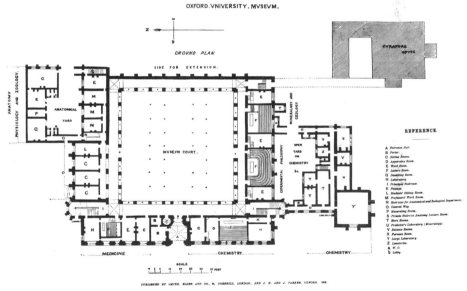

OXFORD. VNIVERSITY. MVSEVM.

GROVND PLAN

SIDE FOR EXTENSION.

ANATOMY PHYSIOLOGY AND ZOOLOGY

MINERALOGY AND GEOLOGY

EXPERIMENTAL PHILOSOPHY

MVSEVM COVRT.

ANATOMICAL YARD

OPEN YARD FOR CHEMISTRY

REFERENCE.

A *Entrance Hall.*
B *Porter.*
C *Sitting Rooms.*
D *Apparatus Room.*
E *Work Room.*
F *Lecture Room.*
G *Dissecting Room.*
H *Laboratory.*
I *Principal Staircase.*
K *Passage.*
L *Students' Sitting Room.*
M *Professors' Work Room.*
N *Staircase for Anatomical and Zoological Department.*
O *General Way.*
P *Macerating Room.*
S *Store Rooms.*
T *Prolector's Laboratory (Micrology).*
U *Balance Room.*
V *Furnace Room.*
X *Large Laboratory.*
Z *Lavatories.*
& *W.C.*
b *Lobby.*

MEDICINE CHEMISTRY. CHEMISTRY.

SCALE

PUBLISHED BY SMITH, ELDER AND CO., 65, CORNHILL, LONDON; AND J. H. AND J. PARKER, OXFORD. 1859.

V–23. Plan, new science museum.
Deane and Woodward. Ruskin and Acland, Oxford Museum, *1859.*

[75] *Builder* 17 (1859):401–2.

the learner a general view of the planet on which he lives, of its constituent parts, and of the relations which it occupies as a world among worlds."[75] In other words, like the Crystal Palace, it was to be a microcosm of knowledge.

This purpose was carried out with the greatest diligence and detail. Each side of the court had four upper arches supported by three shafts. Below that were two arches supported at their union by a single shaft. There were 125 shafts in all and, counting the piers as well, 190 caps and bases. This made a table of the

geology and flora of different quarters of the United Kingdom. The shafts, for example, were each made of a different British granite and were arranged in geological order. On the west side of the court were the granitics, on the east the metamorphics, on the north calcareous rocks from Ireland. The south wall consisted of marbles from the south of England. Within these major orders were appropriate botanical linkages: in the western arcade, south of the entrance, is Aberdeen gray granite surmounted by a sculptured capital carved with alis-

maceous plants. Next comes an Aberdeen red granite shaft whose capital is crowned with Butomaceae. To point up these associations, the *Builder* said, "there should be inscriptions everywhere to make the building speak."[76] Acland himself speaks, in his pamphlet, of the museum's "own peculiar notes, and strange, un-written speech."[77] In any case, precisely because of its associationism, the Oxford museum has the symmetry, axiality, and compartmentation of physical science itself, a quality it shares with the other informational appliances, or "brains," designed and erected for the industrial exhibitions.

In line with its serener style, the museum evoked responses in prose that echoed Ruskin in his dreamier moods. The Reverend William Tuckwell described the building thus:

The lovely Museum rose before us like an exhalation; its every detail . . . an object of art stamped with Woodward's picturesque inventiveness and refinement. Not before had ironwork been so plastically trained as by Skidmore in the chestnut boughs and foliage which sustained the transparent roof. . . . Every morning came the handsome red-bearded Irish brothers O'Shea bearing plants from the Botanic Garden to re-appear under their chisels in the rough-hewn capitals of the pillars. . . . Ruskin, whose books in 1850 the librarian of my College refused to purchase for the library, was read as he had not been read before; while he himself hovered about to bless the Museum work, and to suggest improvements which silent Woodward sometimes smilingly put by. . . .[78]

In considerable contrast to this wanly poetic hothouse is the *Ecclesiologist*'s picture of the Museum. In 1858 the magazine had rather liked it, but apparently its real significance ultimately got through. In 1861 it was called "a costly failure" (where Acland had called it an inexpensive success). The new roof of the glass court was found especially hideous, while the exterior was "prim and starved."[79]

Also in line with its basic classicism is the fact that the museum soon became what George Kubler would call the prime object in a series of replications, a fate which seldom overtook High Victorian Gothic buildings with their many idio-syncrasies. The earliest replication is probably Scott's design of 1857 for the new

[76] *Ibid.*

[77] Ruskin and Acland, *Oxford Museum*, p. 7.

[78] *Reminiscences of Oxford*, p. 49.

[79] *Ecclesiologist* 19 (1858):243, 22 (1861): 24–26.

Foreign Office (Fig. V–26).[80] Here, compared to Oxford, the scale is increased and the fenestration more plastically cavernous. The façade is powerfully framed by octagonal buttresses, possibly a legacy from Penson, and detail curls tightly around every edge in a Puginian manner. Deane and Woodward's more High Victorian Gothic roof treatment is gone: there is a heavy corbel table which functions as a cornice. The side elevations with their central paired towers are even more resolutely symmetrical than the front. The power of the design very obviously lies in its classical virtues: its rhythm, its regularity, its cumulative repetition.

If the Foreign Office was to be classical it was also to be Ruskinian. There was to be a great amount of "mammalian" sculpture, standing Virtues or warriors on the tops of the engaged columns along the *piano nobile* and reliefs in the tympana of the entrances. The prescriptions of *Seven Lamps* are here definitively followed: there is "penetrative ornament of different sizes," projection toward the top, breadth of flat surface, square compartments of that surface (on the flank), varied and visible masonry, vigorous depth of shadow, etc.

Two years later, in another project, Scott produced a variant on the same theme (Fig. V–27). This was for the town hall in Halifax, actually built in 1859–62 by Sir Charles and E. M. Barry to a different design.[81] Here again Scott shows his Ruskinian principles, applying them to a symmetrical carcass with modular façades, but now the tower is salient and approached by flights of steps, and there is an elaborate two-stage spire. The flanking volumes, with their varied silhouette and irregular plan, are more reminiscent of the science museum. Scott has copied Woodward's basic idea of designing a classicizing front that would elbow aside the more Picturesque parts of the structure. The uninterrupted horizontals of the string courses, parapets, and striped roof pattern only increase the essential blandness of the design. The upward gestures of the finials, it is true, suggest an extrinsic pronged framework and have perhaps their antler-like exuberance, but they fail of true ecclesiological rigor. An earlier rendering from this same period,

[80] See also Ruskin, *Works*, 16:xxxi-xxxiii, 466, 36:315–17; *Ecclesiologist* 19 (1858):281, 346, 20 (1859):366–70; *Saturday Review* 6 (1858): 303–5, 8 (1859):253–54. Other bibliography is cited in Chapter IV, n. 72, above. Despite the basic classicism of the design, Scott himself claims that the windows are sculpturally "suited" to their positions and that they vary expressively in size and grouping (*Recollections*, p. 178). I think Summerson (*Victorian Architecture*, p. 86) has misunderstood this passage. He interprets it to mean merely that the architect thought of his design as no more than a sum of details, unrelated to the plan (*Victorian Architecture*, p. 86).

[81] *Building News* 3 (1857):182–83, 1122–23.

V–26. First published design for Foreign Office. G. G. Scott. Building News, *1857.*

V–27. *Project for Halifax town hall.*
G. G. Scott. 1857. Building News, *1857.*

Scott's project for the Hamburg Rathaus of 1854, sets the seal of cryptoclassicism on this whole group (Fig. V–28).

Waterhouse, even more than Scott, specialized in classicizing versions of the museum. In the Assize Courts at Manchester of 1859–64, his first large commission, the composition is fortified at the corners and made a sort of skin to a Second

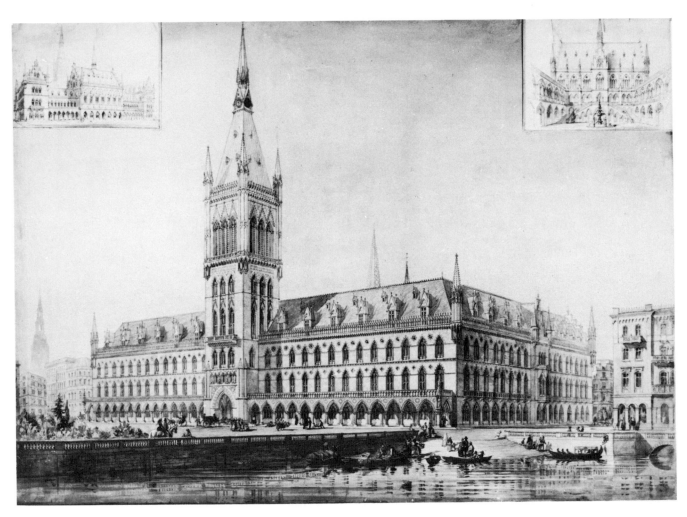

V–28. Project for Hamburg Rathaus. G. G. Scott. 1855–56. Courtesy R.I.B.A.

Empire carcass. There is also, in the Ruskinian manner, a great deal of mammalian sculpture.[82] With Waterhouse, in fact, the Oxford type resolved itself into a typical French academic palace with pavilions and wings like those of the New Louvre. Only the outer crust of striped masonry, the "penetrative ornament," and the Gothic arches remain from Butterfield and Street. R. L. Roumieu adapted the formula more asymmetrically for the French Hospital, Victoria Park Road, Hackney, 1865, where the high Franco-Flemish tower is off to one side.[83] G. C. Clarke used a similar asymmetrical version for his Merchant Seamen's Hospital (later Wanstead Hospital), Essex, in 1861.[84]

In the 1870s the formula was smoothed out and the detailing brought still more into line with the formula's classicism. Thus Waterhouse's Natural History Museum in Kensington of 1873–81 is like Scott's double-towered façade in his Foreign Office project.[85] The whole effect, however, is smoother and more abstract, though the ultimate source of the central frontispiece is not strictly classical but is rather the Abbaye-aux-Hommes, Caen. Waterhouse's first building for the University of Leeds (then Yorkshire College of Science) of 1877[86] was in the same vein. It is taller and thinner than the Scott Foreign Office project, and the dormers now rise directly from the top of the wall. Waterhouse also tried to unbalance the wings somewhat, slightly varying the size of the dormers, recessing the far wing and setting the two lower floors within a paneled arcade. But there is no point in continuing the list; Oxonian museums in the 1860s and 1870s are as common as Puginian churches in the 1840s and 1850s.

The Foreign Office

To supplement these fifth-column tactics, whereby the Oxford museum threw off its masquerade, revealing its real parents to be Visconti and Lefuel rather than Butterfield and Street, there was the Foreign Office, or government offices, competition of 1856–73. We have just glanced at Scott's first published contribution—

[82] *Ibid.*, 5 (1859):426, 427, 470–71, 492–93; *Builder* 17 (1859):286–87, 289–91, 307–9, 318, 323–24, 328–29, 339–40; Cecil Stewart, *The Stones of Manchester*, pp. 72–76. Among the unsuccessful competitors were Shaw and Nesfield (so designated) and E. B. Lamb. There were 107 others.

[83] Pevsner, *London except the Cities*, p. 167.

[84] Pevsner, *The Buildings of England: Essex* (Harmondsworth, 1954), p. 379. See also the New Boys' School, Wandsworth, by Saxon Snell (*Builder* 30 [1872]:486–87) and the proposed lunatic asylum, St. Anne's Heath, Virginia Water, by Alfred Smith (*ibid.*, pp. 607, 609).

[85] Pevsner, *London except the Cities*, p. 258; also *Builder* 31 (1873):13.

[86] Pevsner, *The Buildings of England: Yorkshire: The West Riding* (Harmondsworth, 1959), p. 239.

the first of many—to this epic struggle. Now classicism made a frontal attack, with Ruskin and Scott predictably playing key roles.

The story itself has often been told.[87] Lord Palmerston would accept nothing but what he called Palladian, and Scott, who had got himself appointed architect though he had only won third prize, would at first produce nothing but Gothic (Fig. V–26). Such Gothic, albeit cryptoclassical, was too much for Palmerston.[88] Therefore, after his early design had been rejected, Scott produced what might be called "classical" schemes which are really Venetian Quattrocento (Fig. V–29). As recorded in a drawing now in the R.I.B.A. library, this design reflects the style Scott himself was practicing in his remodeling of Camden Church of 1853–54 and in the restoration of St. Michael's, Cornhill of 1857–60. Here we have yet another Oxford museum variant, though we might look to the first Foreign Office design for the triple windows of the tower's third stage, while the latter's polychrome tile cornice has also been preserved. But much more, the design is a towered version of the Trinity College museum (Fig. V–24), with the tower adapted more or less from Carducci's clock tower in the Piazza San Marco. There are polychrome voussoirs in the arches of the lower-floor windows, but the scale is now so dainty that we are drifting into the urbane, Ruskinian-Venetian manner of Captain Fowke and the Albert Hall. Nothing could show Scott more clearly in his role as a Ruskinian, rather than a High Victorian, Goth.

If High Victorian Gothic abrasiveness was absent from Scott's designs, it was not absent from some of the criticisms they received. Palmerston himself called it "a regular mongrel affair"[89] and added, either of this or of one of the other designs of that year, that it was "frightful and disagreeable-looking." *Punch* commented with its usual excess of glee: "We think this defect, if true, is a very strong argument in favour of its erection, inasmuch as the more 'frightful' and the more 'disagreeable looking' the new Foreign Office is, the less likely is it to jar with the other buildings that at present adorn our lovely Metropolis."[90]

Before he became a complete devotee of the High Renaissance, however, Scott next went through what might be called a Venetian villa phase. Another

[87] See Chapter IV, n. 72, above; *Builder* 12 (1854):641–43; Hope, *The Expense of the Government and of Mr. Beresford-Hope's Plan of Public Offices Compared*, passim; *Builder* 15 (1857):178, 266, 221, 230, 246, 528, 24 (1867): 225; Scott, *Recollections*, pp. 177–201; Clark, *Gothic Revival*, pp. 254–59; *Builder* 36 (1878):343; Ruskin, *Works*, 8:231, n. 5. Like Woodward, Scott was more of a Ruskin devotee than were Butterfield or Street. Scott had tea with Ruskin in Venice in 1852 and there was "a great architectural séance" afterward (Ruskin, *Works*, 10:xxxiii).

[38] Kenneth Clark suggests that the Prime Minister was intractable because he was a man of the *ancien régime*, a Georgian in Victorian dress (*Gothic Revival*, p. 256). That he certainly was, and he was also aristocratically minded, so it is easy to think he would not like a style associated with slum missions and provincial training colleges. This very late Georgian classicism of Palmerston's and Scott's forms a link with the neo-Georgian classicism of later Whitehall, Lutyens, Baker, et al.

[89] *Ibid.*, p. 258.

[90] *Punch* 37 (1859):70.

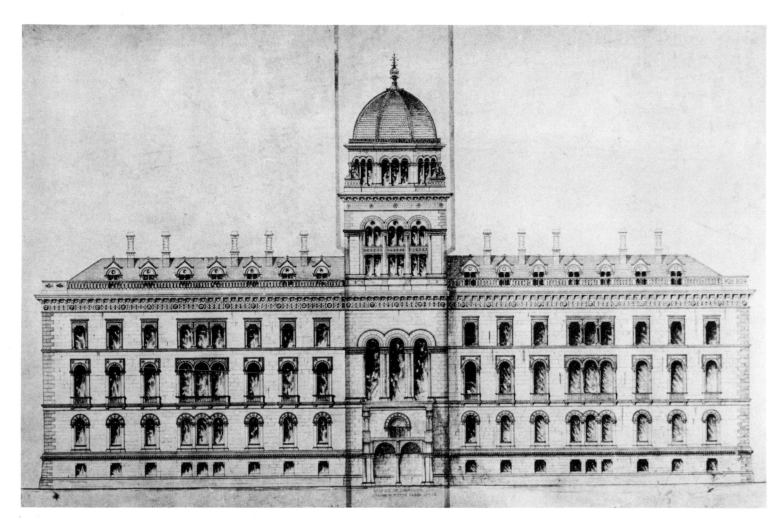

V-29. "Classical" design for Foreign Office. G. G. Scott. 1868. Courtesy R.I.B.A.

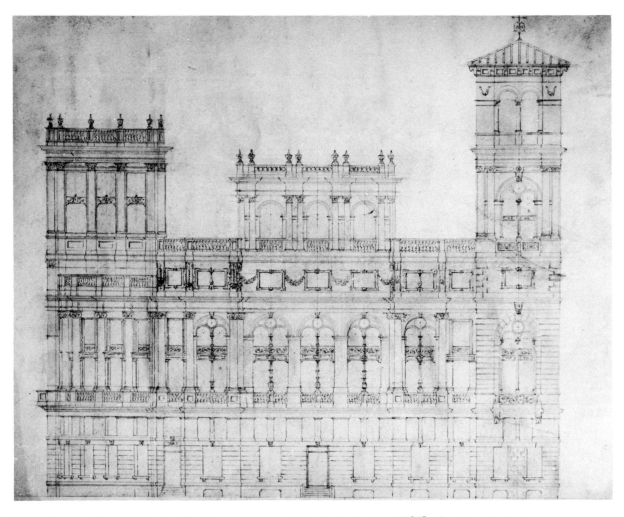

V–30. "Italian Villa" design for Foreign and India offices. G. G. Scott. 1868[?]. Courtesy R.I.B.A.

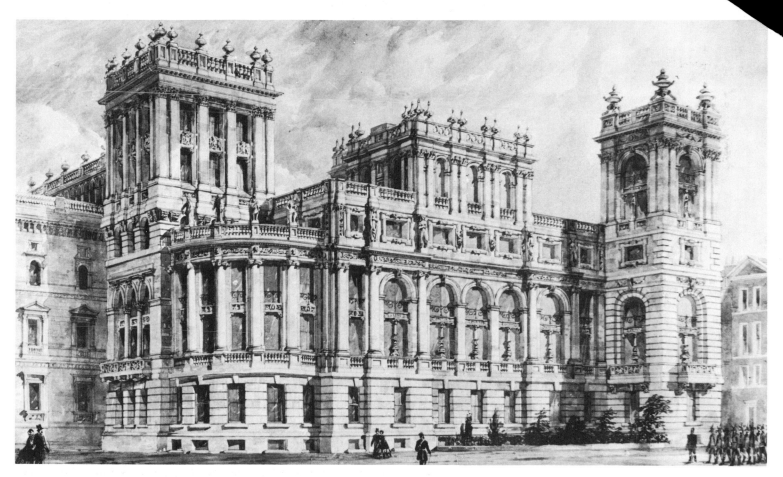

V–31. *"Sansovinesque" design for Foreign and India offices. G. G. Scott. 1868[?]. Courtesy R.I.B.A.*

little-known drawing, also in the R.I.B.A. library (Fig. V–30), shows the St. James Park façade. In detail it is more classical than the "Byzantine" design, though the towers do not match. The general style recalls Charles Barry: note especially the high basement and squat towers. Drawings of 1868, also slightly varied from the executed structure, show almost the same scheme in a more ebulliently Sansovinesque form (Fig. V–31). Now the top story of the right-hand tower is gone. We have the full potency of the double basement with its deep joints and recesses, the giant order of engaged Ionic columns, the central grouping of arches on the *piano nobile* (again a Venetianism), and the attic with its Michelangelesque mezzanine windows. In the center of the main façade rises a super-attic, repeating the arches from below but setting them between paired pilasters. The skyline is topped by weighty squads of urns. Whatever Scott's unconscious intentions, this design is a denial of *Stones of Venice III*, which had called such architecture an insolent jest. Yet it does climax Scott's series in a strangely Ruskinian way: now the architect has worked methodically through *Stones of Venice* from Venetian Gothic (Fig. V–26) to Quattrocento (Fig. V–29) and into High Renaissance (Fig. V–31). Stranger still, there is even an irregularity in the massing that recalls High Victorian Gothic. This occurs in the salient right-hand tower and curving quadrant that leads back to the encased left-hand tower—a configuration almost recalling Aberystwyth (Fig. IV–40). It is as if, to complete his insolent jest, Scott were giving Palmerston High Victorian Gothic in Renaissance dress rather than vice versa.

To sum up: the Crystal Palace was High Victorian Gothic in several respects —in its use of color, in its structural expression, and in its being an ordered collection of worldwide trophies. At the same time it also echoed the dramatic reticulated planes of suspension bridges and the supervaults of Boullée and Pugin. These impulses coalesced to produce a series of monumental glass vaults on High Victorian Gothic masonry bases—a technique recalling the superimposition of two different structural systems, one skeletal and wooden, the other Speluncar and

stone, in the churches of the period. Linked to this interest in metal macro-structures was an interest in industrial ornament. The ecclesiologists contributed to this through their iron church, later reflected in the glass court at Oxford.

But all these developments in various ways were covertly antithetical to High Victorian Gothic and even helped to denature it. The exhibition buildings and concourses were almost of necessity classicizing, while Industrial Gothic stretched the meaning of the term "Gothic" so far as to make it meaningless. Another, more direct factor in the dissolution of High Victorian Gothic was Ruskin: at first he admired All Saints and wished to introduce a complementary civic style, but eventually he was claiming that not only Butterfield's style but various other modes were mere parodies of his ideas. Ruskin's denunciations continued the Victorian invective tradition into our own era and have helped preserve the shell of contempt that still surrounds Victorian architecture. In any case, Ruskin's own prescriptions favored classicizing palace-type buildings, a fact made clear by his writings, by the Oxford museum, and by Scott's stylistic devolutions in the Foreign Office series.

CONCLUSION

High Victorian Gothic has left us a manifold legacy. It has contributed to the functional tradition and expanded our concept of organic architecture. Early patterns of imperialism and cultural manipulation can be seen in such things as overseas ecclesiology, the Crystal Palace, and in the Neoclassicism under the surface of Ruskin's counterstyle. High Victorian Gothic was also an important attempt to deal expressively with slums by contrasting machinelike splendor with existing squalor. The style's sexual associations brought into the area of practical design preoccupations that had earlier, and more passively, characterized the cult of ruins. Similar preoccupations transformed architectural criticism and even the historiography of Victorian architecture itself.

Much of this criticism was, of course, associational, and it is on this aspect of High Victorian Gothic that I have concentrated. I even try my hand at the technique myself. I hope my conscious exposition of a doctrine that, more subliminally, seems to have affected scholars as diverse as Summerson and Scully will lead to

its revaluation. I believe that there is a place in art history for it. Such neo-associa-tionism would deal with the history of art as the history of individual perceptions of particular works. After all, one cannot escape these earlier experiences. The most recent of them are what we build our own interpretations from, no matter how objectively we try to see. And nowadays we pretend to ignore these prece-dents, when we should be isolating them, following them back to their sources. For they are nothing less than Alisonian trains of imagery that have accreted not in one mind but in the writings of a succession of authors. They are society's per-manent records of the dramatic responses that Ledoux, Alison, Loudon, Ruskin, and others felt works of art should generate. As these trains of imagery build up, they redefine both their ostensible subjects and themselves. They are histories of works of art. We learn about the object itself through what it has been seen to be.

At the same time we must never take these responses completely on their own terms. Though they may pose as neutral information, they are full of their own values. They are sometimes secondary works of art themselves—translations of buildings, pictures, and statues into verbal or graphic equivalents. Thus the his-tory of the portrayal and criticism of All Saints—its published train of imagery—can never be dislodged from it, but the imagery must never be confused with the physical church. The two are in opposition, in fact, and should be studied dia-lectically. In the end, of course, our own perception may be as stylized as the earlier ones. But at least this new stylization will become more visible when measured against the others.

BIBLIOGRAPHY

This list omits a number of the articles cited in the text from the Ecclesiologist, *the* Builder, *the* Building News, *etc., some anonymous notes from modern periodicals, and, as well, all reference books, guidebooks, classics, and writings marginal to my arguments.*

Alison, Archibald. *Essays on the Nature and Principles of Taste*. Orig. pub. 1790. 5th ed. 2 vols. Edinburgh: A. Constable and Co., 1817.

Allen, Beverly Sprague. *Tides in English Taste (1619–1800): A Background for the Study of Literature*. 2 vols. Cambridge: Harvard University Press, 1937.

Andrews, A. B. de T. *A Guide to All Saints'*. All Saints' Booklet no. 3. London: n.p., 1953.

The Art Journal Illustrated Catalogue: The Industry of All Nations. London: The Art Journal, 1851.

Aslin, Elizabeth. "E. W. Godwin, William Burges and the Japanese Taste." *Apollo* 76 (1962):779–84.

——. *Nineteenth Century English Furniture*. London: Faber and Faber, 1962.

Beaver, Patrick. *The Crystal Palace, 1851–1936. A Portrait of Victorian Enterprise.* London: Hugh Evelyn, 1970.

Betjeman, John. *An American's Guide to English Parish Churches.* New York: McDowell, Obolensky, 1958.

———. *First and Last Loves.* London: John Murray, 1952.

———. *Ghastly Good Taste.* London: Chapman and Hall, 1933.

"Biographic Sketches. John Claudius Loudon." *Chambers's Journal,* n.s. 1 (1844):284–86.

Blondel, Jacques-François. *Cours d'architecture.* 9 vols. Paris, 1771–73.

Bøe, Alf. *From Gothic Revival to Functional Form: A Study in Victorian Theories of Design.* Oslo and New York: Oslo University Press and The Humanities Press, 1957.

Boffrand, Germain. *Livre d'architecture.* Paris, 1745.

Boullée, Etienne-Louis. *Architecture.* Edited by J.-M. Pérouse de Montclos. Paris: Hermann, 1968.

———. *Boullée's Treatise on Architecture.* Edited by Helen Rosenau. London: Alec Tiranti, 1953.

Bowden, J. W. *A Few Remarks on Pews.* London: n.p., 1843.

Burke, Edmund. *A Philosophical Enquiry into the Origin of Our Ideas of the Sublime and Beautiful.* London, 1757.

Bury, J. B. *The Idea of Progress: An Inquiry into its Origin and Growth.* London: Macmillan and Co., 1920.

Butterfield, William. *Church Seats and Kneeling Boards.* 2d ed. With an Appendix by Richard Foster. London: n.p., 1886.

Cadell, William A. *Journey to Carniola, Italy, and France.* 2 vols. Edinburgh: A. Constable and Co., 1820.

Caldwell, James R. *John Keats' Fancy.* Ithaca, N.Y.: Cornell University Press, 1945.

Cambridge Camden Society [Ecclesiological Society]. *Church Enlargement and Church Arrangement.* Cambridge: Cambridge University Press, 1843.

———. *A Few Words to Churchwardens on Churches and Church Ornaments. No. 1. Suited to Country Parishes.* 7th ed. Cambridge: Cambridge University Press, 1841. *Part 2. Suited to Town and Country Manufacturing Parishes.* 7th ed. London: J. Masters, 1851.

———. *A Hand-Book of English Ecclesiology.* London: J. Masters, 1847.

———. *The History of Pues.* Cambridge: n.p., 1841.

———. *The Statistics of Pues.* Cambridge: n.p., 1841.

————. *24 Reasons for Getting Rid of Church Pews (or Pues)*. Cambridge: n.p., n.d.

Carritt, E. F. *Philosophies of Beauty*. Oxford: Clarendon Press, 1931.

Castellan, Antoine Laurent. *Letters on Italy*. Phillips's New Voyages and Travels, vol. 3, no. 5. London: Sir R. Phillips and Co., 1820.

Chadwick, George F. *The Works of Sir Joseph Paxton, 1803–1865*. London: Architectural Press, 1961.

Clark, Kenneth. *The Gothic Revival: An Essay in the History of Taste*. Orig. pub. 1928. London: Constable, 1950.

Clarke, Basil F. L. *Anglican Cathedrals Outside the British Isles*. London: Society for the Propagation of Christian Knowledge, 1958.

————. *Church-Builders of the Nineteenth Century*. London: Society for the Propagation of Christian Knowledge, 1938.

————, and John Betjeman. *English Churches*. London: Vista Books, 1964.

Clegg, Samuel. *The Architecture of Machinery: An Essay on Propriety of Form and Proportion*. London: Architectural Library, 1842.

Collingwood, W. G. *The Art Teaching of John Ruskin*. London: Percival and Co., 1891.

Collins, Peter. *Changing Ideals in Modern Architecture, 1750–1950*. London: Faber and Faber, 1965.

Cornell, Elias. *De Stora Utställningarnas Arkitekturhistoria*. Stockholm: Akademiskavhandling-Uppsala, 1962.

Cuddesdon College, 1854–1904: A Record and Memorial. London: Longmans, Green and Co., 1904.

Curran, C. P. "Benjamin Woodward, Ruskin and the O'Sheas." *Studies* 29 (1940):255–68.

Dahl, Johan C. C. *Denkmäle einer sehr ausgebildeten Holzbaukunst aus dem frühesten Jahrhunderten in den innern Landschaften Norwegens*. Dresden: n.p., 1837.

DeZurko, Edward R. *Origins of Functionalist Theory*. New York: Columbia University Press, 1957.

Dolk, Lester C. *The Aesthetics of John Ruskin in Relation to the Aesthetics of the Romantic Era*. Urbana, Ill.: University of Illinois Press, 1941.

Donaldson, Thomas L. *A Preliminary Discourse on Architecture*. London: Taylor and Walton, 1842.

Downes, Charles, and Charles Cowper. *The Building Erected in Hyde Park for the Great Exhibition of the Works of Industry of All Nations, 1851*. London: n.p., 1852.

Dupays, Paul. *Vie prestigieuse des expositions: Historique*. Paris: H. Didier, 1939.

Durandus of Mende, Gulielmus. *The Symbolism of Churches and Church Ornaments.* Introduced and translated from the first book of the *Rationale divinorum officiorum* by J. M. Neale and Benjamin Webb [1842]. New York: Scribners, 1893.

Eastlake, Charles L. *A History of the Gothic Revival.* London: Longmans, Green and Co., 1872. Reprint, with introduction by J. Mordaunt Crook. Leicester: Leicester University Press, 1970.

Emmett, J. T. "The State of English Architecture." *Quarterly Review,* Am. ed., 132 (1872):155–76.

Fedeles, C. "Versuch über Alison's Ästhetik, Darstellung und Kritik: Ein Beitrag zur Entwicklungsgeschichte der Englischen Ästhetik im XVIII Jahrhundert." Ph.D. dissertation, University of Munich, 1911.

Fergusson, James. *A History of Architecture in All Countries, from the Earliest Times to the Present Day.* 3 vols. London: J. Murray, 1865–67.

Ferrey, Benjamin. *Recollections of A. N. Welby Pugin, and His Father Augustus Pugin.* London: E. Stanford, 1861.

Ferriday, Peter, 'The Oxford Museum." *Architectural Review* 132 (1962):408–16.

———. "The Revival: Stories Ancient and Modern." *Architectural Review* 121 (1957): 155–57.

———, ed. *Victorian Architecture.* London: Jonathan Cape, 1963.

Ferrier, J. F. "Reid and the Philosophy of Common Sense." *Works,* vol. 2: *Lectures on Greek Philosophy and Other Philosophical Remains.* Edited by A. Grant and E. L. Lushington. Edinburgh: W. Blackwood, 1866.

ffrench, Yvonne. *The Great Exhibition: 1851.* London: Harvill Press, [1950].

Fischer, W. *Geborgenheit und Freiheit. Vom Bauen mit Glas.* Krefeld: n.p., 1970.

Frankl, Paul. *The Gothic: Literary Sources and Interpretations through Eight Centuries.* Princeton: Princeton University Press, 1960.

Geddes, Patrick. *Industrial Exhibitions and Modern Progress.* Edinburgh: D. Douglas, 1887.

Geist, Johann Friedrich. *Passagen: Ein Bautyp des 19. Jahrhunderts.* Munich: Prestel-Verlag, 1969.

Gibbs-Smith, C. H. *The Great Exhibition of 1851. A Commemorative Album.* London: Her Majesty's Stationery Office, 1950.

Gilfillan, George. "The Late Rev. Archibald Alison, LL.B." *The Eclectic Magazine* 16 (1849):568–71.

Gilpin, William. *Remarks on Forest Scenery, and Other Woodland Views.* Edited by Thomas D. Lauder. 2 vols. Edinburgh: n.p., 1834.

Girouard, Mark. "Milton Ernest Hall, Bedfordshire." *Country Life* 146 (1969):1042–46.

Gloag, John. *Mr. Loudon's England. The Life and Work of John Claudius Loudon and His Influence on Architecture and Furniture Design.* London: Oriel Press, 1970.

——. *Victorian Comfort. A Social History of Design from 1830–1900.* New York: Macmillan, 1961.

——. *Victorian Taste. Some Social Aspects of Architecture and Industrial Design from 1820–1900.* New York: Macmillan, 1962.

——, and Derek Bridgwater. *A History of Cast Iron In Architecture.* London: G. Allen and Unwin, 1948.

Goetz, Mary Dorothea. *A Study of Ruskin's Concept of the Imagination.* Washington, D.C.: Catholic University Press, 1947.

Goodhart-Rendel, H. S. *English Architecture since the Regency: An Interpretation.* London: Constable, 1953.

——. "*English Gothic* of the Nineteenth Century." *Journal of the Royal Institute of British Architects* 31 (1924):321–45.

——. "Gothic Revival Casualties: St. Alban's, Holborn." *Architectural Review* 91 (1942):27–32.

——. "Rogue Architects of the Victorian Era." *Journal of the Royal Institute of British Architects*, 3d ser. 48 (1949):251–58.

The Great Exhibition: Official Descriptive and Illustrated Catalogue. 2d ed. 3 vols. London: Spicer Brothers, 1851.

Grote, L., ed. *Historismus und bildende Kunst.* Studien zur Kunst des neunzehnten Jahrhunderts 1. Munich: Prestel-Verlag, 1965.

Gwynn, Denis R. *Lord Shrewsbury, Pugin, and the Catholic Revival.* London: Hollins and Carter, 1946.

Hall, James. *Essay on the Origin, History, and Principles of Gothic Architecture.* Transactions of the Royal Society of Edinburgh 3. Edinburgh: The Royal Society, 1797.

Hamilton, William. "On the Philosophy of Common Sense," In Thomas Reid, *Works*, edited by Sir William Hamilton. 6th ed. 2 vols. Edinburgh: Maclachan and Stewart, 1863.

Hamilton-Gordon, George, fourth earl of Aberdeen. *An Inquiry into the Principles of Beauty in Grecian Architecture.* London: J. Murray, 1822.

Harris, Thomas. *Three Periods of English Architecture.* London: B. T. Batsford, 1894.

———. *Victorian Architecture: A Few Words to Show That a National Architecture Adapted to the Wants of the Nineteenth Century Is Attainable*. London: n.p., 1860.

Hautecoeur, Louis. *Histoire de l'architecture classique en France*. Paris: A. Picard, 1950–52. Vols. 3 and 4.

Herford, C. H. "Ruskin and the Gothic Revival." *Quarterly Review* 207 (1907):77–96.

Herrmann, Wolfgang. *Laugier and Eighteenth Century French Theory*. London: Zwemmer, 1962.

Hersey, George L. "Associationism and Sensibility in Eighteenth Century Architecture." *Eighteenth Century Studies* 4(1970):71–89.

———. "J. C. Loudon and Architectural Associationism." *Architectural Review* 144 (1968):89–92.

Hipple, Walter John, Jr. *The Beautiful, the Sublime, and the Picturesque in Eighteenth-Century British Aesthetic Theory*. Carbondale, Ill.: Southern Illinois University Press, 1957.

Hitchcock, Henry-Russell. "Brunel and Paddington." *Architectural Review* 109 (1951):240–46.

———. *The Crystal Palace: The Structure, Its Antecedents, and Its Immediate Progeny*. Northampton, Mass.: Smith College Museum, 1951.

———. *Early Victorian Architecture in Britain* 2 vols. New Haven: Yale University Press, 1954.

———. "G. E. Street in the 1850s." *Journal of the Society of Architectural Historians* 19 (1960):145–71.

———. "High Victorian Gothic." *Victorian Studies* 1 (1957):47–71.

———. "Victorian Monuments of Commerce." *Architectural Review* 105 (1949):61–74.

Hobhouse, Christopher. *1851 and the Crystal Palace*. New York: Dutton, 1937.

Hook, Walter F. *Our Holy and Beautiful House, the Church of England. A Sermon Preached at Leeds Parish Church, Sept. 3, 1848*. Leeds: n.p., 1848.

Hope, Anthony James Beresford Beresford-. *The Art Workman's Position*. London: South Kensington Museum, 1864.

———. "Cathedrals in Their Missionary Aspect." In *Essays on Cathedrals by Various Writers*, edited by J. S. Howson. London: n.p., 1872.

———. *The Common Sense of Art*. London, n.p., 1858.

———. *The Condition and Prospects of Architectural Art*. London: Architectural Museum, 1863.

———. *The English Cathedral of the Nineteenth Century*. London: J. Murray, 1861.

————. *The Expense of the Government and of Mr. Beresford-Hope's Plan of Public Offices Compared.* London: n.p., 1857.

Hope, Thomas. *An Historical Essay on Architecture.* Orig. pub. 1835. 3d ed. 2 vols. London: J. Murray, 1840.

Howell, Peter. *Victorian Churches.* R.I.B.A. Drawings Series. Feltham: Country Life Books, 1968.

Hussey, Christopher. *The Picturesque: Studies in a Point of View.* London and New York: G. P. Putnam, [1927].

Jack, Ian. *Keats and the Mirror of Art.* Oxford: Oxford University Press, 1967.

Johnson, Charles A. "Development of the Suspension Bridge." *Architectural Forum* 49 (1928):721–28.

Johnson, Wendell S. " 'The Bride of Literature': Ruskin, the Eastlakes, and Mid-Victorian Theories of Art." *Victorian Newsletter* 26 (1964):23–28.

Johnston, G. A., ed. *Selections from the Scottish Philosophy of Common Sense.* Chicago and London: Open Court Publishing Co., 1915.

Jones, Owen. *The Grammar of Ornament.* London: Day and Son, 1856.

Jordan, Robert Furneaux. *Victorian Architecture.* Harmondsworth: Penguin Books, 1966.

Kaufmann, Emil. *Three Revolutionary Architects.* Transactions of the American Philosophical Society, n.s. 42, pt. 3. Philadelphia: American Philosophical Society, 1952.

Kerr, Robert. *The Gentleman's House; Or, How To Plan English Residences, from the Parsonage to the Palace.* Orig. pub. 1864. 2d ed. London: J. Murray, 1865.

————. "Ruskin and Emotional Architecture." *Journal of the Royal Institute of British Architects.* 3d ser. 7 (1899–1900):181–88.

Klingender, Francis D. *Art and the Industrial Revolution.* London: N. Carrington, [1947].

Knight, Richard Payne. *An Analytical Inquiry into the Principles of Taste.* 2d ed. London: Printed by L. Hansard for T. Payne and J. White, 1805.

Ladd, Henry A. *The Victorian Morality of Art: An Analysis of Ruskin's Esthetic.* New York: R. Long and R. R. Smith, 1932.

Lamb, Edward Buckton. "Memoir of the Late J. C. Loudon, Esq., Read before the Royal Institute of British Architects on Dec. 18, 1843." London: Royal Institute of British Architects Library.

————. *Studies of Ancient Domestic Architecture, Principally Selected from Original Drawings in the Collection of the Late Sir William Burrell, Bart.* London: J. Weale, 1846.

Landow, George P. "Ruskin's Refutation of 'False Opinions Held Concerning Beauty.'" *British Journal of Aesthetics* 8 (1968):60–72.

Law, Henry William, and Irene Law. *The Book of the Beresford-Hopes.* London: H. Cranton, 1925.

Ledoux, Claude-Nicolas. *L'Architecture considérée sous le rapport de l'art, des moeurs, et de la législation.* 2 vols. Paris: H. L. Perroneaux, 1789–1804. Facsimile edition edited by F. de Nobele. 2 vols. Paris: n.p., 1962.

Lindsay, Alexander W. C., Earl of Crawford. *Sketches on the History of Christian Art.* 3 vols. London: J. Murray, 1847.

Loudon, John Claudius. *Encyclopaedia of Cottage, Farm and Villa Architecture.* Orig. pub. 1833. London: Longman, 1863.

Lough, A. G. *The Influence of John Mason Neale.* London: Society for the Propagation of Christian Knowledge, 1962.

Luckhurst, K. W. *The Story of Exhibitions.* London and New York: Studio Publications, 1951.

Macaulay, Rose. *Pleasure of Ruins.* London: Weidenfeld and Nicolson, 1953.

MacDermot, Martin. *A Critical Dissertation on the Nature and Principles of Taste.* London: n.p., 1822.

Madsen, Stephan Tschudi. "Viktorianske Dekorativ Kunst." *Kordenfjeldske Kunstindustrimuseums-Arbok.* Trondheim: n.p., 1952.

Mandler, Jean M., and George Mandler. *Thinking: From Association to Gestalt.* New York: John Wiley and Sons, 1964.

Markham, Violet. *Paxton and the Bachelor Duke.* London: Hodder and Stoughton, 1935.

Mayoux, J. J. "Richard Payne Knight et le pittoresque". Ph.D. dissertation, University of Paris, 1932.

Meeks, Carroll L. V. "Creative Eclecticism." *Journal of the Society of Architectural Historians* 12 (1953):15–18.

———. *The Railroad Station: An Architectural History.* New Haven: Yale University Press, 1956.

Middleton, Robin. "Jacques-François Blondel and the *Cours d'architecture.*" *Journal of the Society of Architectural Historians* 18 (1959):140–48.

Miller, Ralph N. "Thomas Cole and Alison's Essays on Taste." *New York History* 37 (1956):281–99.

Moles, Abraham A. *Théorie de l'information et perception esthétique.* Paris: Flammarion, [1958].

Moller, Georg. *An Essay on the Origin and Progress of Gothic Architecture Traced in and Deduced from the Ancient Edifices of Germany with References to Those of England.* London: Priestley and Weale, 1824.

Monk, Samuel H. *The Sublime: A Study of Critical Theories in XVIII-Century England.* Orig. pub. 1935. Ann Arbor: Ann Arbor Paperbacks, 1960.

Morris, William. *Gothic Architecture: A Lecture for the Arts and Crafts Exhibition Society.* Orig. pub. 1889. London: Kelmscott Press, 1893.

Murphy, James Cavanah. "Introductory Discourse on the Principles of the Gothic Architecture." *Plans, Elevations, Sections, and Views of the Church at Batalha.* London: J. and J. Taylor, 1795.

Neale, John Mason. *The Church's Extremity, Her Lord's Opportunity. A Sermon Preached at St. Barnabas', Pimlico.* London: n.p., 1850.

————. *"He said, Come." A Sermon Preached at the Dedication Festival of St. Matthias, Stoke Newington, June 30, 1859.* London: n.p., 1859.

————. *Hymns for the Sick.* Orig. pub. 1843. London: Joseph Masters, 1850.

Needham, H. A. *Taste and Criticism in the XVIII Century.* London: Harrap, [1952].

New-York Ecclesiological Society. *Annual Report of the New-York Ecclesiological Society No. 3.* New York: Sanford and Swords, 1851.

————. *Transactions.* New York: D. Dana, 1857.

Pace, G. G. "Pusey and Leeds." *Architectural Review* 98 (1945):178–80.

Petit, John L. *Architectural Studies in France.* London: G. Bell, 1854.

Pevsner, Nikolaus. "Early Iron 2. Curvilinear Hothouses." *Architectural Review* 106 (1949):188–89.

————. "German Crystal Palace." *Architectural Review* 148 (1970):257.

————. "Richard Payne Knight." *Art Bulletin* 31 (1949):293–320.

————. *Ruskin and Viollet-le-Duc: Englishness and Frenchness in the Appreciation of Gothic Architecture.* London: Thames and Hudson, 1969.

————. *Studies in Art, Architecture and Design.* 2 vols. New York: Walker and Co., 1968.

Piper, John. "St. Marie's Grange, the First Home of A. W. N. Pugin." *Architectural Review* 98 (1945):90–93.

Port, M. H. "The New Law Courts Competition, 1866–67." *Architectural History* 11 (1968):75–93.

Poston, Lawrence, III. "Ruskin and Browning's Artists." *English Miscellany* 15 (1964): 195–212.

Praz, Mario. *The Romantic Agony.* Orig. pub. 1933. New York: Meridian Books, 1956.

Price, Martin. "The Picturesque Moment." In *From Sensibility to Romanticism: Essays Presented to Frederick A. Pottle*, edited by Frederick W. Hilles and Harold Bloom. New York: Oxford University Press, 1965.

Price, Uvedale. *Essays on the Picturesque, as Compared with the Sublime and the Beautiful.* Orig. pub. 1794–98. 3 vols. London: J. Mawman, 1810.

Pugin, A. W. N. *The Present State of Ecclesiastical Architecture in England.* London: Charles Dolman, 1843.

———. *A Treatise on Chancel Screens.* London: Charles Dolman, 1851.

Reid, Thomas. *Works.* Edited by Sir William Hamilton. 6th ed. 2 vols. Edinburgh: Maclachan and Stewart, 1863.

Reik, Theodor. *Masochism and Sex in Society.* Orig. pub. 1941. New York: Grove Press, 1962.

———. *Ritual.* Orig. pub. 1928. London: Hogarth Press, 1931.

Richardson, Douglas S. "Gothic Revival Architecture in Ireland." Ph.D. dissertation, Yale University, 1970.

Ross, Malcolm Mackenzie. "Ruskin, Hooker and 'the Christian Theoria.'" In *Essays in English Literature from the Renaissance to the Victorian Age Presented to A. S. P. Woodhouse*, edited by Millar Maclure and F. W. Watt. Toronto: University of Toronto Press, 1964.

Rossi, Mario, ed. *L'Estetica dell' empirismo inglese.* 2 vols. Florence: G. C. Sansoni, 1944.

Ruskin, John. *Works.* 39 vols. Edited by E. T. Cook and Alexander Wedderburn. London and New York: George Allen and Longmans, Green and Co., 1903–12.

Ruskin, John, and Henry W. Acland. *The Oxford Museum.* London: Smith, Elder and Co., 1859.

Schimmelpenninck, Mary Anne. *The Principles of Beauty as Manifested in Nature, Art, and Human Character, with a Classification of Deformities, an Essay on the Temperaments with Illustrations, and Thoughts on Grecian and Gothic Architecture.* Orig, published in London in 1815 as *A Theory of Beauty and Deformity.* Edited by Christiana C. Hankin. London: Longmans, Brown, Green, Longmans and Roberts, 1859.

Schnaase, Carl. *Geschichte der bildende Kunst.* 7 vols. Düsseldorf: J. Buddeus, 1843–64.

Scott, George Gilbert. *Personal and Professional Recollections*. Edited by G. Gilbert Scott, Jr. London: S. Low, Marston, Searle and Rivington, 1879.

———. *Remarks on Secular and Domestic Architecture, Present and Future*. London: J. Murray, 1857.

Scully, Vincent J., Jr. "American Villas." *Architectural Review* 115 (1954):169–79.

———. "Romantic Rationalism and the Expression of Structure in Wood: Downing, Wheeler, Gardner, and the 'Stick Style,' 1840–1876." *Art Bulletin* 35 (1953):121–42.

———. *The Shingle Style*. New Haven: Yale University Press, 1955.

Seddon, John P. *Progress in Art and Architecture with Precedents for Ornament*. London: D. Bogue, 1852.

Seth, James. *English Philosophers and Schools of Philosophy*. London: J. M. Dent and Sons, 1912.

Shand, P. Morton. "The Crystal Palace as Structure and Precedent." *Architectural Review* 81 (1937):65–72.

Sigle, J. D. "Bibliography of the Life and Works of Calvert Vaux." *Papers of the American Association of Architectural Bibliographers* 5 (1968):69–73.

Stanton, Phoebe B. *The Gothic Revival and American Church Architecture: An Episode in Taste, 1840–1856*. Johns Hopkins Studies in Nineteenth-Century Architecture. Baltimore: Johns Hopkins Press, 1968.

———. "Pugin—Principles of Design *versus* Medievalism." *Journal of the Society of Architectural Historians* 13 (1954):20–25.

Stein, Roger B. *John Ruskin and Aesthetic Thought in America, 1840–1900*. Cambridge, Mass.: Harvard University Press, 1967.

Steinman, David B. *The Builders of the Bridge: The Story of John Roebling and His Son*. New York: Harcourt, Brace and Co., [1945].

Stekel, Wilhelm. *Sadism and Masochism: The Psychology of Hatred and Cruelty*. Orig. pub. 1925. 2 vols. New York: Liveright Publishing Corp., 1929.

Stephen, Leslie. *History of English Thought in the Eighteenth Century*. Orig. pub. 1876. 2 vols. London: J. Murray, [1927].

Stephens, W. R. W. *The Life and Letters of Walter Farquhar Hook*. 2d ed. 2 vols. London: R. Bentley and Son, 1879.

Stewart, Cecil. *The Stones of Manchester*. London: Edward Arnold, 1956.

Stewart, Dugald. *Works*. Edited by Sir William Hamilton. 2 vols. Edinburgh: T. Constable, 1854–60.

Street, A. E. *Memoir of George Edmund Street, R. A., 1824–1881.* London: John Murray, 1888.

Street, G. E. *Brick and Marble in the Middle Ages: Notes of a Tour in the North of Italy.* London: J. Murray, 1855.

——. *Unpublished Notes and Reprinted Papers.* With an essay by Georgiana Goddard King. [New York:] Hispanic Society of America, 1916.

——. *An Urgent Plea for the Revival of the True Principles of Architecture in the Public Buildings of the University of Oxford.* Oxford and London: J. H. Parker, 1853.

Summerson, John, ed. *Concerning Architecture: Essays on Architectural Writers and Writing Presented to Nikolaus Pevsner.* London: Allen Lane—the Penguin Press, 1968.

——. *Heavenly Mansions and Other Essays on Architecture.* Orig. pub. 1948. New York: W. W. Norton, 1963.

——. *Victorian Architecture: Four Studies in Evaluation.* New York: Columbia University Press, 1970.

Tamir, M. "Les Expositions internationales à travers les âges." Ph.D. dissertation, University of Paris, 1939.

Thompson, Paul, "All Saints Church, Margaret Street, Reconsidered." *Architectural History* 8 (1965):73–94.

——. "The High Victorian Cultural Achievement." In Victorian Society, *Conference Report.* London: Victorian Society, 1959.

——. "The Problem of Ugliness." Victorian Society, *Second Conference Report.* London: Victorian Society, 1965.

Towle, Eleanor A. *John Mason Neale, D.D. A Memoir.* London: Longmans, Green and Co., 1907.

Townsend, Francis G. *Ruskin and the Landscape Feeling.* Urbana, Ill.: University of Illinois Press, 1951.

Trappes-Lomax, Michael. *Pugin, a Medieval Victorian.* London: Sheed and Ward, 1932.

Tuckwell, William. *Reminiscences of Oxford.* London: Cassel and Co., 1901.

Turnor, Reginald. *Nineteenth Century Architecture in Britain.* London: B. T. Batsford, 1950.

Unrau, John. "A Note on Ruskin's Reading of Pugin." *English Studies* 48 (1967):335–37.

Vroom, William Frederick. *Christ Church, St. Stephen, N.B.* New York: The Thwing Co., 1913.

Webb, Benjamin. *Sketches of Continental Ecclesiology, or Church Notes in Belgium, Germany, and Italy.* London: n.p., 1848.

Whately, Thomas. *Observations on Modern Gardening.* Orig. pub. ca. 1770. New ed. London: Printed for West and Hughes, 1801.

Whewell, William. *Architectural Notes on German Churches, with Remarks on the Origin of Gothic Architecture.* Cambridge: J. and J. J. Deighton, 1830.

White, James F. *The Cambridge Movement, the Ecclesiologists and the Gothic Revival.* Cambridge: Cambridge University Press, 1962.

Whitworth, William A. *Quam Dilecta: A Description of All Saints' Church, Margaret Street, with Historical Notes of Margaret Chapel.* London: n.p., 1891.

Wiener, Norbert. *Cybernetics; or, Control and Communication in the Animal and the Machine.* Cambridge, Mass: The Technology Press, 1948.

Wightwick, George. *The Palace of Architecture: A Romance of Art and History.* London: J. Fraser, 1840.

Woods, Joseph. "Modern Theories of Taste." In *Essays of the London Architectural Society.* London: Architectural Society, 1808.

Zabel, Morton Dauwen. "The Romantic Idealism of Art, 1800–1848." Ph.D. dissertation, University of Chicago, 1938.

INDEX

Most churches are listed under "Churches and cathedrals." Topographical names have been kept to a minimum. Only books and periodicals not listed in the Bibliography are indexed.

in Lamb, 134; moral nature of, 16, 18–19; in Oxford Museum, 192–93, 196–98; in Pugin and the ecclesiologists, 62, 66–75, 92; rational, 27; revived, 210–11; in Rome, 11; in St. Augustine's College, Canterbury, 138; in Street's Law Courts project, 144–52; in Venice, 30–34; in Waterhouse's Law Courts project, 166, 168. *See also* Expression

Athens, 35

Atkins, William, 139

Babylonian architecture, 76

Bacchus: temples to, 1

Barclay, Charles, 16

Barry, Charles, 144, 199, 208

Barry, E. M., 142, 199

Barry, T. D., 102

Basilica, 104 and n, 119, 134

Bauhaus, 116

Beardsley, Aubrey, 117

Becket, Thomas à, 44

Beethoven, Ludwig van, 53n

Beresford-Hope, Alexander James Beresford. *See* Hope, Alexander James Beresford-Beresford

Bergamo: polychrome in, 41

Betjeman, John, 107n

Bibiena family, 168

Bibliothèque du Roi, Paris: project for, 163

Biological progress, 23, 43–48, 74

Birmingham: bishop's palace, 67, 106, 119

Blacket family, 73n

Bleak House, 150

Blois, Château, 144

Blondel, Jacques-François, 1, 3–7, 11, 12, 20, 22, 23

Blore, Edward, 71

Boffrand, Germain, 1, 2–4, 12, 22

Boisserée, Sulpiz, 43n

Boullée, Etienne-Louis, 8, 9, 76, 163, 208

Brandon, John Raphael, 142

Brick, expression of, 26; in ecclesiological mission program, 82–83; in urban minster, 99 and n, 102

British Almanac, The, 108

Britton, John, 66

Brooklyn Bridge, 161–63

Brunel, Isambard Kingdom, 163

Builder, The, 72, 103, 132, 139, 187, 190; on All Saints, 114; on Crystal Palace, 159, 160; on industrial ornament, 179; on Payne project for 1862 Exhibition, 169, 170

Building News, The, 39, 47, 49, 104, 122, 125, 132, 190; on All Saints, 114; on Crystal Palace, 160

Bunning, J. D., 163

Burges, William, 47, 152; compared with Ruskin, 187; project for Law Courts, 142, 144, 145

Burke, Edmund, 14, 53, 54

Burns, Robert, 12n

Burton, C., 144n

Butterfield, William, xvii, xviii, 66, 73n, 74, 82, 188, 193, 203; brick in work of, 99; as choice for All Saints, 105; on church seating, 55; compared to Ferrey, 103; compared to Lamb, 132; compared to Street, 125; contrasted with Waterhouse, 168; machine surfaces of, 178; mission architecture of, 105n; and Ruskin, 186; sadomasochism of, 106–8, 114–16, 117, 124, 153; St. Augustine's College, Canterbury, 138; style anticipated in *Builder*, 102–3; teacher of E. S. Medley, 84; window in Christ Church, St. Stephen, N.B., 84–85; work compared to Crystal Palace, 158, 159

Byron, George Gordon, Lord, 12n

Caesar, Julius, 11

Cambridge Camden Society. *See* Ecclesiological Society

Camposanto, Pisa, 184

Cape Town, Diocese of, 83

Caractère, 8n, 3–5, 9, 12

Carducci, Mauro, 204

Carpenter, Richard C., xvii, 78, 80, 82, 119, 142n, 179; compared to Lamb, 135; St. Mary Magdalene, Munster Square, 98–99; wooden church, 84

Cast-iron church by Slater, 119, 179, 182, 209

Catherwood, Frederick, 58

Cave Thomas, W., 102

Chantrell, R. D., 94

Character, 3–5, 9, 12

Chateaubriand, François René de, 66n

Chatsworth, 155

Chermayeff, Serge, 116

Chinese architecture, 76

Chiswick, 155

Choir: laymen in, 114n

Christian Theoria, 27–28, 56, 60

Chunam, 78, 80

Churches and cathedrals: Abbaye-aux-Hommes, Caen, 203; All Saints, Boyne Hill, 125; Amiens, 49; Arley Park Chapel, Cheshire, 73 and n; Austin Friars', London, 80; Babbacombe, Torquay, 116; Batalha, 76; Beauvais, 49; Bourges, 128 and n; Bristol, 52–53; Broletto, Como, 41; Bury St. Edmunds abbey, 49; Camden, Camberwell, 102, 187, 204; Canterbury, 49; cast-iron church by Slater, 119, 179, 182, 209; Certosa, Pavia, 78; Christ Church, Alexandria, Egypt, 78n; Christ Church cathedral, Dublin, 184; Christ Church cathedral, Fredericton, N.B., 74; Christ Church, Hoxton, 71; Christ Church, St. Stephen, N.B., 84, 85; Christ Church, Streatham, 78n, 187; Christ Church, West Hartlepool, 132, 134; Colombo, Ceylon, 78, 80, 82, 135; Constantinople, 82n; Hagia Sophia, Constantinople, 74; Heckington, 74; Hobart Town, Tasmania, 73n; Holy Sepulchre, Jerusalem, 74; Honolulu, 82, 92; Jamaica, B.W.I., 82n; Melrose Abbey, 35; Monza, 108; Nikolaikirche, Hamburg, 75n;

Numara Eliya, Ceylon, 78, 80; Oldbury, Worcestershire, 72; Pont-de-Galle, Ceylon, 80; Prossers Plains, Tasmania, 73n; Saint Alban's, Holborn, 122, 124; St. Andrew's, Wells St., Marylebone, 66; St. Anne's, Keighley 73n,; St. Augustine's, Queen's Gate, 124, 131; St. Barnabas, Pimlico, 66, 98, 107, 130, 135; St. Clement Danes, London, 142; St. Cornelius the Centurion, New York, 84n; St. Cunibert, Cologne, 124; St. Dionis Backchurch, 130; St. George's, Southwark, 62; St. Gervais, Paris, 4; St. Giles, Cheadle, 62, 66, 98, 99, 130 and n; St. Helena, 82n; St. James, Baldersby, Yorkshire, 124; St. James the Less, Philadelphia, 74; St. James the Less, Westminster, 125, 128, 130, 131, 144; St. John's Cathedral, St. John's, Newfoundland, 84n; St. Kitts, B.W.I., 82n; St. Marie's, Bridegate, Derby, 73n; St. Mark's, St. Mark's Road, Paddington, 134n; St. Mark's, Venice, 49, 58, 185, 186; St. Martin's, Gospel Oak, London, 134–35; St. Mary Magdelene's, Munster Square, London, xvii; 98–99, 103, 104, 107; St. Matthias, Stoke Newington, London, 119, 122; St. Michael's, Cornhill, London, 204; St. Michael's, Long Stanton, Cambridgeshire, 74; St. Peter's, Leeds, 94; St. Philip's, Miltown, Dublin, 130n; St. Stephen's, Hammersmith, 66; St. Stephen's, Westminster, 66, 103; San Clemente, Rome, 74; San Francesco, Assisi, 176; SS Giovanni e Paolo, Venice, 31; Sant' Agata, Cremona, 41; Santa Maria dei Miracoli, Venice, 189; Santa Maria della Salute, Venice, 189; San Michele, Lucca, 57; San Pietro, Pistoia, 57; Shoreham Abbey, 49; Sisters of Mercy Convent, Cork, 139; Spitalgate, Grantham, 71–72; Than, near Caen, 78; Tristan da Cunha, 84, 119; Westminster Abbey, 35, 142, 156; Woodlands, South Africa, 80; York Minster, 74. *See also* All Saints, Margaret Street

on St. Alban's, Holborn, 124; on St. James the
Less, Westminster, 128; on S. S. Teulon, 132;
on Swedish and Italian architecture, 75n; on
urban minster, 95; on wooden architecture, 83
Eclecticism, 22, 37; as expression, 13; prepared
for by Alison, 12; Ruskin on, 47n, 49, 184; as
sign of progress, 46–47
Eclectic Magazine, The, 12
Eglinton, Ireland, lunatic asylum, 139
Egyptian architecture, 31, 76
Emmett, J. T., 116, 122, 124, 125, 150, 152
Encyclopaedia Britannica, 164
Erastianism, 44
Esotericity, doctrine of, 68
Euston Station I, London, 164
Expression: in cathedrals, 68; of chimneys, 15,
24–25, 134; in cottages, 15–16, 20–22, 24, 38–
39; in Crystal Palace, 159, 160; in Decorated
Style, 44; in eclecticism, 13; emblematic, 9,
62, 66; emotional, 1–7, 9, 12, 29; of evil, 34;
in farmhouses, 16–18, 38; functional, 12, 14–
19, 43, 60, 125, 131, 132, 134, 135, 141, 210;
in inns, 19n; irregularity resulting from, 15,
37–38; of knowledge, 10–14, 22, 182–83, 193,
196–98; of landscape, 9, 24, 26–27, 32, 41, 43,
49, 74; in materials, 26; in moldings, 31, 57;
moral purpose of, 6, 7, 18, 27–28; of nation-
ality, 25n, 44, 45; in Norman architecture, 43–
44; in the orders, 3n; in parish churches, 68;
in Perpendicular architecture, 44; in schools,
18; of sex segregation, 18–19, 39, 71; of slum
life, 66, 93–105, 122, 125, 210; of style, 20–22;
of techniques and construction, 41, 75, 179;
of ugliness, 10–11, 56; in villas, 21n, 25 and n,
26; of volumes, 39, 40, 138; of windows, etc.,
15–16, 17, 19, 25–26, 38, 142, 145, 199 and n;
vs. imagination, 10

Fardle of Facions, The, 70

Feedback, 8 and n, 22, 34–35, 117, 119, 211. *See
also* Poetry of architecture
Fergusson, James, 44n
Ferrey, Benjamin, 66, 71, 103
Filarete, Antonio Averulino, 1, 2, 6, 9
Fitzwilliam Museum, Cambridge, 40, 41
Flamboyant Gothic, 44
Flora: temples to, 1
Fondaco de Turchi, Venice, 58, 185, 191n
Foreign Offices competition, 142, 203–8, 209
Fowke, Francis, 204
Francesco di Giorgio Martini, 1
Frankfurt station, 165, 171
French Hospital, Hackney, 203

Gärtner, Friedrich von, 78n
Galleria Vittorio Emmanuele, Milan, 166
Gare du Nord II, Paris, 165
Gaudí, Antonio, 134
Genres, architectural, 2–4
Gentleman's Magazine, The, 108, 119
German theories of artistic development, 43
and n
Giedion, Sigfried, 164n
Gilbert, Cass, 144n
Gilman, Arthur D., 73n
Giotto: tower, Florence, 185
Glass roof, 163–76
Glastonbury Abbey, 192
Gloag, John, xviii
Goethe, Johann Wolfgang von, 43n
Gogol, Nikolai, 34
Goodhart-Rendel, H. S., xviii, 132
Gothic: as Christian architecture, 13; Italian vs.
English, 46 and n, 60; northern vs. southern,
32, 75; progressive, 43–44, 45–48, 102, 178;
Ruskin's definitions of, 31, 184–87. *See also*
Hyperborean Gothic; Speluncar Gothic
Great Exhibition of 1851, 178. *See also* Crystal
Palace

52–53; churches by, 73n, 125–31; compared to Lamb, 132; compared to Paxton, 158; Foreign Offices project, 142, 150; Italianism of, 131, 142; Law Courts, 135, 142, 144–46; and Modern Gothic, 46, 60; on Oxford Museum, 40, 193; on Pisan tracery, 184; polychrome of, 99, 102; Royal Academy lectures of, 43; on Ruskin, 184; on seating, 95; *Some Account of Gothic Architecture in Spain*, 43n; on structural expression, 41, 179; on town churches, 95, 98

Striped walls, 33 and n, 102, 108. *See also* Polychrome

Style, 4, 5, 15, 19–22

Sublime, the, 11n, 53

Summerson, Sir John, xviii, 115, 116, 117, 119, 150n, 168, 210

Sydenham, Crystal Palace at, 164, 168, 170, 189

Sylphides, Les, 117

Symbolism, 1, 67–68. *See also* Expression

Symmetry, 3, 29n, 191–93; in Pugin, 62, 66, 138

Teulon, S. S., 132

Thackeray, W. M., *May-Day Ode*, 156, 158, 165, 178

Thompson, Paul, xix, 116, 117

Thompson, Peter, 84n

Thomson, Alexander, 132n

Thornton, Robinson, 67, 68

Times, The, 156

Torcello cathedral, 102, 104n

Touchstone, 35 and n

Trinity College library, Dublin, 192, 204

Tuckwell, William, 198

Turner, J. W. M., 26, 66, 185

Turnor, Reginald, xviii, 115–16

Typicality, doctrine of, 68

Ugliness, aesthetic of, 2, 10, 13, 27, 28, 34, 56, 60. *See also* Ruins; Sadomasochism

Upjohn, Richard, 73

Upjohn, Richard M., 171

Urban minster, the, 93–104

Vaudoyer, Léon, 186

Vaux, Calvert, 170–76, 183

Venice: brick churches in, 102; polychrome in, 41

Venus: temples to, 1

Victoria, Queen of England, 156

Victoria Regia, 76

Viollet-le-Duc, Eugène-Emanuel, 144, 165n

Virgil, 11

Visconti and Lefuel, 203

Vitruvius, 1, 2, 22

Warburton, R. E. E., 73n

Wardell, William, 73n

Waterhouse, Alfred, 142, 176, 203; Law Courts project, 165, 166, 168, 170; Manchester Assize Courts, 201, 203

Watts, G. F., 130

Webb, Benjamin, 44, 68, 70, 74n, 102

Westminster Palace, 39, 104, 144, 145n

Whately, Thomas, 9, 10, 14

White, Edward S., 73n

White, William, 23, 34, 38–40, 60, 80, 83, 84, 145n, 156n

Wightwick, George, 23, 34–37, 47, 57, 60, 107, 150

Wild, James W., 76, 78n, 132n, 187, 191, 192

Wilkie, David, 114

Wilkins, William, 117

Wills, Frank, 73 and n, 74

Woodward, Benjamin, 182n, 192, 198, 199

Wotton, Sir Henry, 43n

Wren, Sir Christopher, 130

Wright, Frank Lloyd, 18

Wyatt, Sir James, 72

Yorke, F. R. S., 116